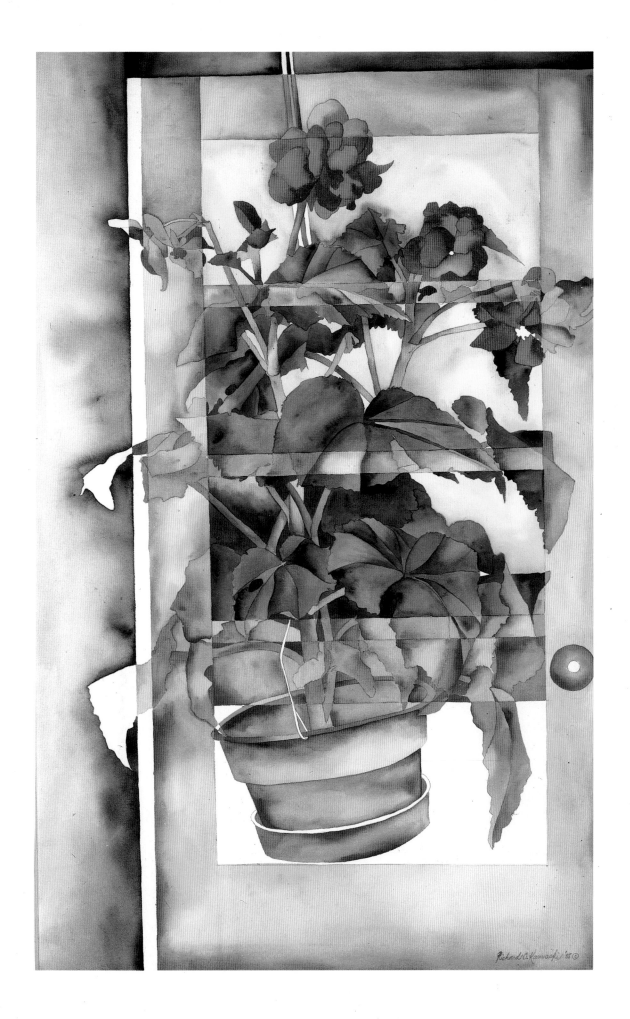

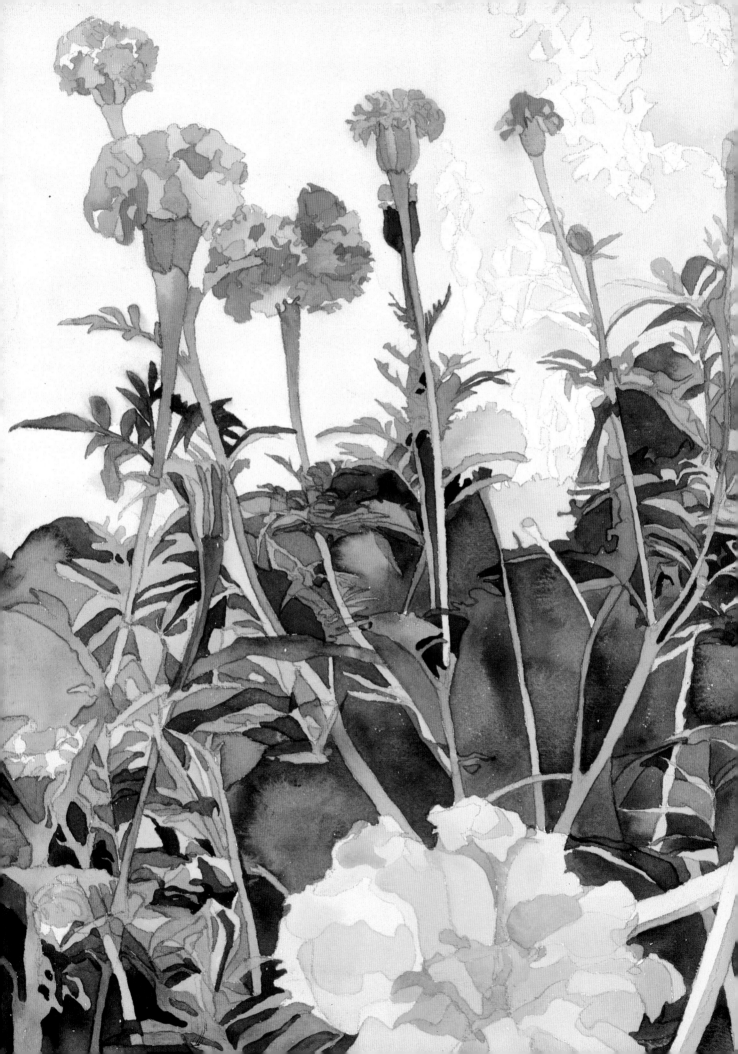

Richard C. Karwoski

WATERCOLOR BRIGHT AND BEAUTIFUL

WATSON-GUPTILL PUBLICATIONS/NEW YORK

First frontispiece
BEGONIA BEHIND THE DOOR, *20″ × 44″ (50.8 × 111.8 cm), 1985. Private collection.*

Second frontispiece
MARIGOLD GARDEN, *22″ × 30″ (55.9 × 76.2 cm), 1981. Private collection.*

Pages 6–7
WILLCURL VIEW, *22″ × 30″ (55.9 × 76.2 cm), 1978. Collection of Smith Barney Harris, Inc.*

This book is dedicated to Tony Gabriele

Copyright © 1988 by Richard C. Karwoski

First published 1988 in the United States and Canada by Watson-Guptill
Publications, a division of Billboard Publications, Inc., 1515 Broadway,
New York, N.Y. 10036.

Library of Congress Cataloging-in-Publication Data

Karwoski, Richard C.
 Watercolor bright and beautiful.
 Includes index.
 1. Watercolor painting—Technique. I. Title.
ND2420.K37 1988 751.42′2 88-10754
ISBN 0-8230-5653-8

751.422

Distributed in the United Kingdom by Phaidon Press Ltd., Littlegate
House, St. Ebbe's St., Oxford

Manufactured in Japan

First Printing, 1988

1 2 3 4 5 6 7 8 9 / 93 92 91 90 89 88

Thanks and appreciation to:

Marlene Schiller for literary guidance and inspiration.

Phyllis Stern for transcribing my taped workshops.

Mary Murray for typing and correcting original manuscript.

John Reed as well as Steve Speliotis and Bob Ghiraldini for their sensitive photography of the watercolor paintings.

Instructors, such as Shelby Schmidt, Gladys Gazarian and Donald Vogel of the High School of Art and Design and Richard Lindner at Pratt Institute, for teaching me to see and observe in a personal way.

All my friends, and especially the late Bruce Day, who reintroduced me to watercolor by buying me a new paint set in the '60s.

Mrs. Ruth Solomon, formerly of the Heckscher Museum, for giving me the opportunity to teach my first watercolor workshop, and the Huntington Township Art League, the Parrish Museum, and the Guild Hall Museum for providing subsequent opportunities.

All the collectors, including Mr. and Mrs. Kaulum and Mr. and Mrs. Markowski, for purchasing so many watercolors over the years.

Rose Millevolte and Rosemary Terribile of Gallery East, as well as Elaine Benson, Nancy Stein, and June Verzyl-Reid for believing in and exhibiting my work in their galleries.

Joseph Wysokowski, my former student and now my assistant, for being another set of eyes and hands for me.

My friend and confidant, Richard H. Steinman, for moral support throughout.

Helen A. Harrison, for all the critical praise and insight.

New York City Technical College of CUNY, for giving me a fellowship leave from all my professorial responsibilities in order to complete this book.

My editors, Mary Suffudy and Brigid Mast, for all their encouragement, assistance and support.

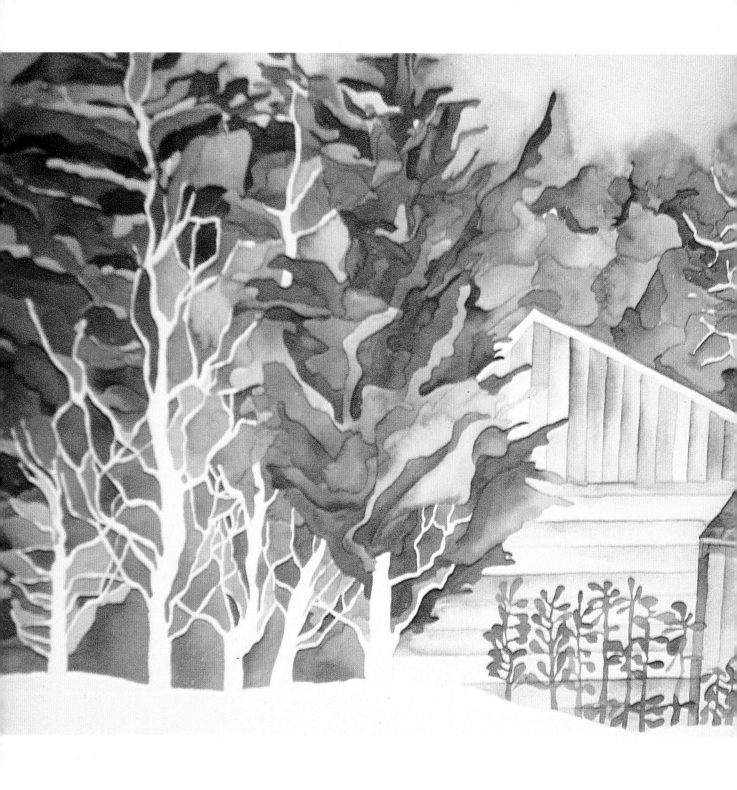

21

CONTENTS

MR. MUHAMMAD ALI. BJUR, HONS. M. JUR.
ADVOCATE · Per. Add · 63A · HART ROAD
BENFLEET. ESSEX - UK.
SS7. 3PB.
MOB. 07961827360

Per. Add
MOTHER. ROWSONARA BEGUM
ISLAMPUR. DEVISING PARA.
P.O. KAZLA. P.S. MOTIHAR.
RAJSHAHI CITY.
BANGLADESH.
Pho. 00880721-750564.

INTRODUCTION

These exercises are designed to help you get in touch with your own method of painting with watercolor—how to express your personality with watercolors, your personal color sense, your way of applying paint. You will have a chance to try several methods and decide which ones you're comfortable with. Most of the exercises are inspired by nature and may be done indoors or outdoors. Each chapter focuses on a different aspect of the locale, so you may want to do several exercises in the same area. Pick a place that is interesting to you and is easy to get to.

My own style is influenced by my years of working with oil paints and expressionist subject matter. Prior to 1976, I thought of watercolor mainly as a medium that was portable, easy to take along on vacation. I did watercolors when I was away from my studio and when I wanted a rest from oil painting.

My thinking changed quite drastically toward the end of 1975, when I made some important discoveries about my work that led to my first major watercolor, *Apples and Pears* (page 53). My change of attitude began with a dinner party in my NoHo loft/studio to which I invited about a dozen friends. My watercolor renaissance occurred the day following the dinner party. All day long, I felt the bowl of apples and pears that I had displayed on the dining table and also served as dessert was beckoning to me. The fruit was very large and very ripe; its color on that gray, wintery afternoon was like an overpowering sunset. I felt compelled to paint what I saw; since I didn't have the energy to spend a long time standing at an easel to paint in oils, I did

a watercolor instead. The still-life painting of the fruit was done in a matter of hours. I didn't realize at the time that this was a breakthrough in attitude that would affect what I would be producing in the following years. In the weeks that followed, several artist friends visited me, and they all noticed the new watercolor. Their feedback was quite positive, and I decided to do more such paintings. Working on the still life had been a wonderful painting experience; I enjoyed what led me to create it and the entire creative act as well, so why not continue? It almost seemed as if I had gone on a permanent vacation in the studio, because I had previously only done the watercolors when I went away. For about a year, I concentrated on still-life compositions of fruit; eventually, I began to branch out into other subject matter, such as flowers and landscapes. Since 1976, watercolor has been my primary focus, and I now consider all my paintings organic.

My methods are somewhat unconventional. I often use extremely large paper—up to eight or ten feet long—and I don't stretch it. I work wet on dry. I let some of my pencil drawing show in the finished painting. I work flat, so my washes flow but don't run, and I keep my colors as intense as possible. I work all over a painting, rather than starting on one side and working my way across the paper or starting in the center and working from the middle outward.

I often work in the East Hampton area of Long Island, New York, and humidity affects my materials more there than it might in other parts of the country. When I work there, I don't have to moisten the paint

pans, because the humidity does it for me. On damp days, the paper feels moist as I work, providing a surface that is nice to paint on but difficult to draw on. The paper tends to buckle on damp days and flatten out on dry days. And on damp days it takes a long time to dry, which may work in my favor . . . or it may not. Paper, especially good paper, has a life of its own.

These exercises developed out of a series of watercolor workshops that I have conducted over the last several years. The workshops have always included watercolorists on varying levels—beginner, intermediate, and advanced—working in different styles, both figurative and abstract, who came from different walks of life, including doctors, lawyers, teachers, fellow artists, homemakers, senior citizens, even teenagers. They were all able to enhance the development of their own artistic personalities through the exercises and demonstrations that were a part of my workshops.

This book will do the same thing, by presenting a variety of painting experiences to choose from without imposing one method or style on the reader. Just as there are exercises and suggestions to help beginners overcome their initial fears of drawing or composition or mixing color (particularly the first exercise), there is also a range of approaches to help the intermediate-level watercolorist overcome blocks that are often caused by bad habits. My theories and suggestions about maintaining a consistent yet individual style are designed to help advanced watercolorists who may still have certain problem areas that need strengthening.

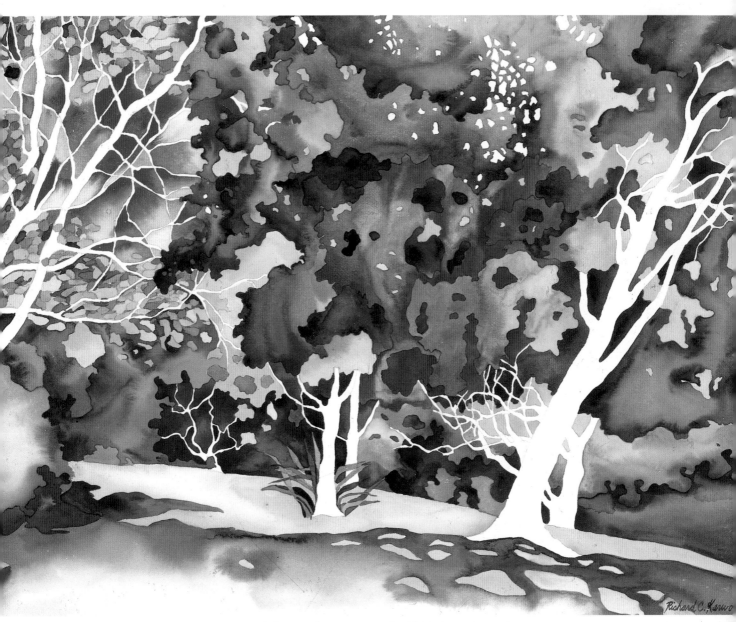

A DREAM PANG, *22″ × 30″ (55.9 × 76.2 cm), 1979. Collection of Mrs. June Verzyl Reid, Northport, New York.*

MATERIALS

You will need several large, medium, and small round watercolor brushes, preferably sable. I suggest you begin with sizes 3, 4, 7, 10, and 12. In addition, a size 1 or 2 would be good for small detail and a size 24 for large surfaces. Be sure your brush comes to a good point, especially if you don't buy sable. You can use the side of the round brush for washes and the tip for detail. If you are planning to paint large areas you might want to purchase a few flat brushes to handle broad expanses such as sea and sky, but since the rounds will give you more control for thick and thin strokes, I recommend them to start with.

If you can't afford sables, buy camel or squirrel hair brushes instead. I would recommend these over synthetic sables. However, if you have limited funds, you're better off with a few good sables—perhaps just a small, a medium, and a large size—than with a larger assortment of poor-quality brushes.

The exercises in this book should be done on 140 lb. cold-pressed watercolor paper; use D'Arches if you can afford it. I don't like to paint on smooth paper because the paint tends to sit on the surface rather than being absorbed. Rougher paper holds a wash better. I recommend single sheets rather than a pad; a single sheet of paper is more flexible than one bound into a block. The standard paper size is 22″ × 30″; for most of the exercises in this book, you can use a full sheet or cut one down to 15″ × 22″ or 11″ × 15″.

Watercolor paint comes in two forms: pan and tube colors. Either one is acceptable. I like the Pelikan 24-pan set; it has all the colors a beginner would need. If you're buying colors separately, rather than as a set, here's a good palette to start with:

cadmium yellow light
Naples yellow
yellow ochre
cadmium orange
cadmium red medium
alizarin crimson
violet
turquoise blue
ultramarine blue
cobalt blue
emerald green
sap green
permanent green light
burnt umber
raw sienna
Payne's gray
black (optional)

This is only meant as a guide; feel free to pick and choose the colors you like. The working qualities of pan and tube colors vary; in general, warm colors are easier to handle in pan form, while cool colors are easier to handle in tube form. On the other hand, warm colors are more intense in tube form and cool colors are more intense in pan form. You will have to experiment and decide which qualities are most important to you.

In addition to paints, brushes, and paper, you will need a lap board or piece of stiff cardboard to provide a firm backing for your watercolor sheet and two clips to hold it in place; some HB and 2B pencils; a kneaded eraser; a twelve-inch ruler; paper towels; a small sponge; two water jars, one for clear water and one for cleaning your brushes; and, of course, an ample supply of clean water.

BEGONIA BREAKTHROUGH
38″ × 48″ (96.5 × 121.9 cm),
1986. Private collection.

This composition incorporates a white border suggesting a window-frame, but the image seems to be forcing its way into another dimension. Because of the size and scale of the painting, I did most of the drawing as well as the actual painting while standing, working on the watercolor sheet from all angles. I used size 12 and 24 brushes for most of the washes; only occasionally would I switch to a smaller brush to indicate specific details. Notice the linear areas of unpainted white paper that I've left on the begonia to add dimension and crispness to the petals.

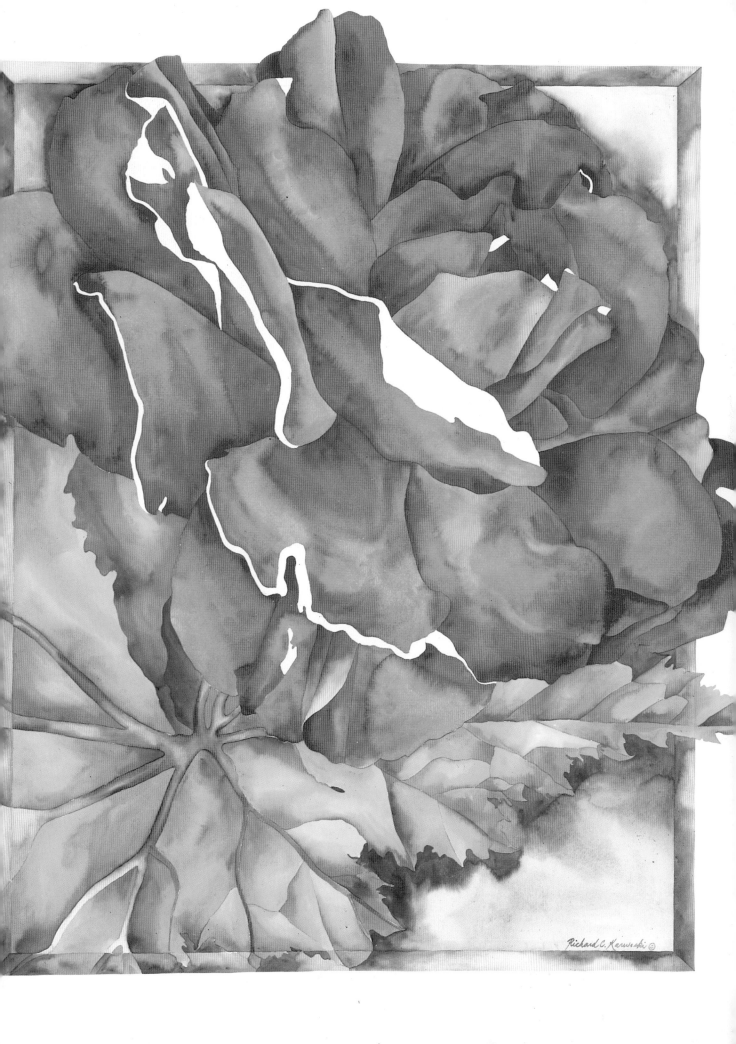

Richard C. Karwoski ©

GETTING STARTED: THE BASIC TECHNIQUES

This first exercise is important if you have never worked with watercolor or if you want to refamiliarize yourself with the basic techniques. Its purpose is to introduce you to watercolor paint and watercolor brushes. Forget about drawing and composition; they are not important in this exercise. Instead, you will focus on handling the brush, mixing paint, and recognizing different proportions.

To begin, use a pencil and ruler to divide an 11″ × 15″ sheet of paper approximately in half. Don't measure, and don't worry if one side is slightly wider than the other.

Still using the ruler and pencil, subdivide each half into geometric

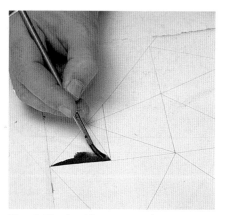

Step 1. Single color, wet on dry.

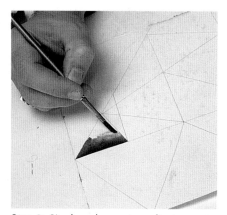

Step 2. Single color, wet on dry.

shapes. Fill one side with triangles, the other with rectangles and squares. (Think of a Mondrian-type composition.) Be creative—vary the sizes and proportions of the shapes. Make some triangles small or skinny and others large or fat. Don't hand-draw the shapes; use the ruler. Be bold. Draw shapes that go off the edges of your paper. Erasing is all right. You can redraw a shape if you are not happy with it or erase some shapes if you have too many. A variety of sizes is what you are after. Keep in mind that smaller shapes are easier to control if you are a beginner. Don't spend a lot of time on this. Three to five minutes should be enough.

Plan to use a different color scheme for each half of your geometric "drawing": one warm, the other cool. On the warm side, expect to use your yellows, oranges, reds, browns, and some greens. On the cool side you will feature your blues, blue-greens, purples, grays, and some greens. Decide in advance which half will be which.

If you are using pan colors, moisten each color with a drop or two of clear water. If you are using tube colors, lay out your complete palette. Keep the warm and cool colors in their own areas.

Now you are going to paint each geometric shape, one at a time. To simplify this task and make the squares and triangles easier to compare, use the wet-in-wet technique for the warm side of your composition and the wet-on-dry (paper) technique for the cool side

To paint wet-in-wet, dip your brush, a size 10 or 12 round, into a container of clear water and moisten one of the outlined areas.

Allow the water to flow across the paper. Next, load the brush with one color and glide it across the moistened area of the paper, allowing the color to get lighter as you move the brush along. (You can also work from light to dark by pressing down as you move the brush across the paper.) Use the side of the brush. Don't scrub. And don't be afraid to go back for more paint if you didn't get enough the first time. If, instead, you have used too much pigment, either thin it down with water or lift some off with a sponge or a paper towel. See what variations in value you can get with just one color. An area where all the values are the same tends to

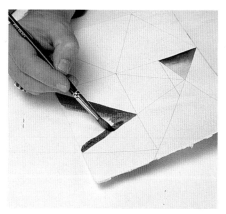

Step 1. Mixing colors, wet on dry.

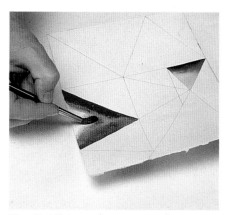

Step 2. Mixing colors, wet on dry.

look flat. Keep the area you are working on moist so the color doesn't streak. Pick another area somewhere else on the paper—always leave space between areas until they are dry—and fill it in with a different color. Go directly from palette to paper and see what happens. Continue filling in the shapes until you are comfortable working with a single color.

Now try using two colors in a single area. Begin by moistening the entire shape, then apply the color as before, gliding it on, working from the edge of the shape toward the center. When you have filled about half the area, stop. Rinse your brush and load it with another color. Working from the opposite edge of the shape (turn the paper around if necessary), brush on the color, again moving it toward the center. Where the colors meet, they will combine to form a new color; brush over this area a few times to soften the transition. Allow the washes to blend without overwhelming each color. Work

directly, without mixing your colors on a separate sheet; this will help you maintain both the intensity of the color and the spontaneity of your brushwork. Keep the paper moist throughout this process.

For the cool side of your composition, work wet-on-dry. In other words, load your brush with color and apply it directly to the paper by laying the brush on its side and gliding it across one of the outlined areas. Using the side of the brush creates a smoother, broader area of color. The tip is for details or nooks and crannies.

Now, choose a color, glide it halfway across a shape, then rinse the brush and dip it into another color. Apply this second color to the other side of the same outlined area so both cool colors merge in the middle and create a third color. If necessary, turn your paper to move the color. Some of you may feel hesitant about doing this. Don't be afraid. You're the boss. You are in control of the paper.

Try not to overload your brush. The beauty of watercolor is its transparency and the variation available within each color. If an area becomes too opaque, either thin it down with water or remove some of the color with toweling.

Soften the blending between the two colors and keep the transition between dark and light as smooth as possible.

If you feel you have made a mistake with a color, it is possible to change it by painting over it with a different color, provided the underlayer is light in color and value *and* you paint over the entire area.

As you are doing this geometric painting exercise, let your imagination conjure up actual subject matter. Allow some of the geometric shapes to suggest realistic subject matter. For example, a yellow and blue combination might suggest a sunset; a green and yellow combination could suggest a landscape. What could these little geometric shapes represent if they were in a landscape or still life? Also, try leaving some white areas

of unpainted paper to add interest.

By the time this exercise is completed you should have done four things: applied one color directly to the paper; applied one color on a moistened area; applied two colors directly to the paper; and applied two colors on a moistened area. One side should have the overall feeling of warmth and the other a sense of coolness, even if a few colors in each area are different. Squint to check overall color. If one color, say a green, looks out of place, cool it down by adding blue or warm it up with yellow.

Now try a second sheet, varying your method. You might use wet-in-wet for the cool colors, for instance. Repeat this exercise as often as you can until you feel comfortable. It requires a lot of concentration because you are dealing with pattern, color scheme, and different techniques. Each time you do the exercise, you will have better results. Don't throw out these paintings; I will refer to them in future chapters.

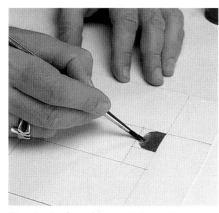

Step 1. Single color, wet into wet.

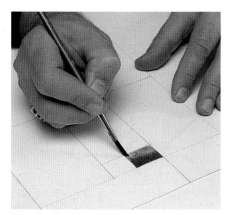

Step 2. Single color, wet into wet.

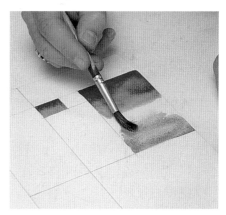

Step 1. Mixing colors, wet into wet.

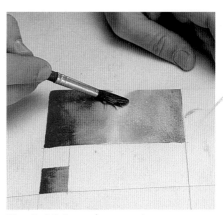

Step 2. Mixing colors, wet into wet.

1 I subdivided a 7½″ × 11″ sheet of D'Arches 140 lb. cold-press paper into triangles of various shapes and sizes. I also decided on a warm color scheme and created washes of different values and intensities. Note that I began by using only one color per shape and scattered the shapes to allow them to dry before painting the adjacent ones.

2 I have begun to add more than one color per shape but have maintained an overall luminosity and transparency within each area. Notice the contrasting sizes and the introduction of the green area. Remember that certain colors, such as green and red, may be used in a warm as well as a cool composition.

3 I continued to paint in all of the triangular shapes with one, two, or even three colors. Feel free to leave areas unpainted; I left a few white areas near the center of the composition for added interest.

4 This is the completed warm geometric painting. Notice that I decided to fill in the white area with a color. Also, note the variety of warm color combinations and the different shapes and sizes of triangles in this exercise.

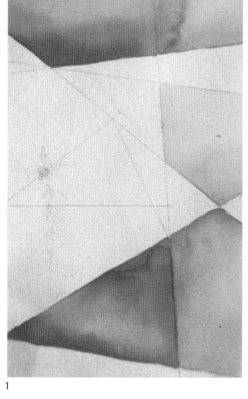

1

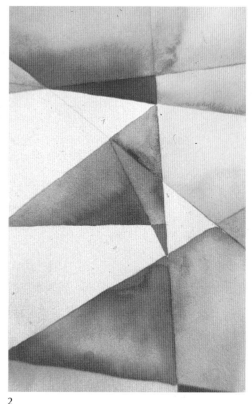

2

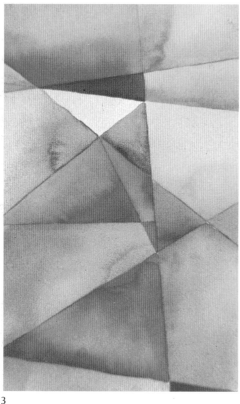

3

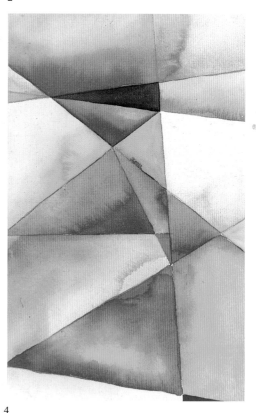

4

1 The first stage of the cool geometric painting was to subdivide the 7½″ × 11″ watercolor sheet into squares and rectangles of various proportions and sizes. I have begun to paint in the shapes with one or two cool washes. I allowed each area to dry before I painted the shape beside it.

2 I've begun to add a third color to an individual area. Notice that colors such as red and green now appear cool when surrounded by blue and violet.

3 Now, I've closed up the white space except for one area. Observe how I've varied the direction of the washes within each shape as well as throughout the overall composition.

4 I have filled in all the shapes. It's important to notice the overall impact of this type of composition, in which little drawing is required. Both the cool composition and the warm composition may be referred to in future exercises that deal with mixing color, whether the subject is a still life or a landscape.

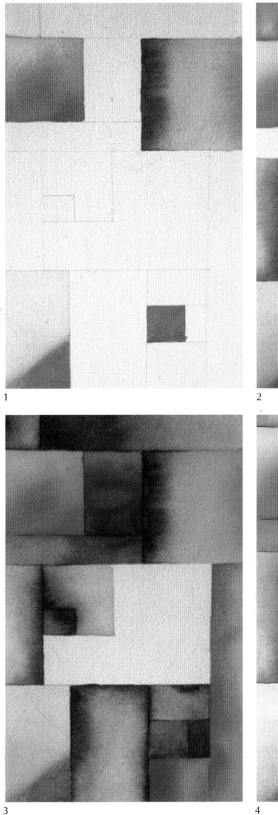
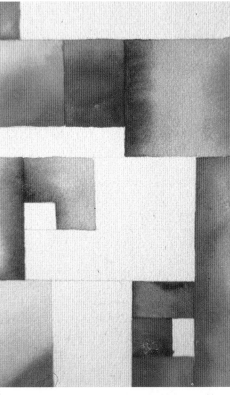

1

2

3

4

THE PANORAMIC LANDSCAPE: FOREGROUND AND BACKGROUND

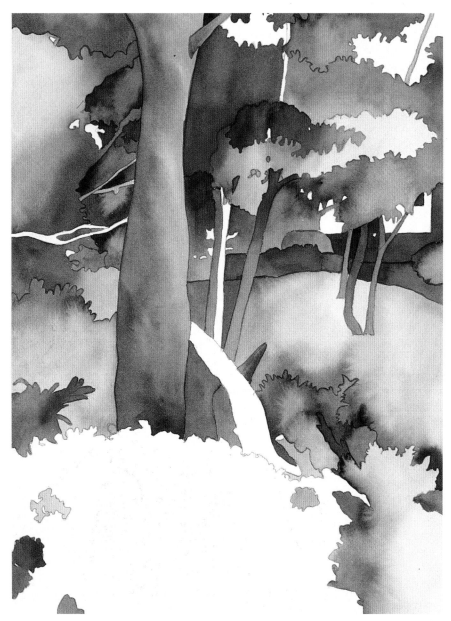

ON THE HILL, *11" × 15" (27.9 × 38.1 cm), 1987. Private collection.*

In this landscape, I used only washes of Payne's gray to create the different values. This is a good first step toward overcoming the fear of working in color. Notice that I purposely left some of the pencil line visible; I also left part of the watercolor paper unpainted.

Choose a landscape that has an obvious background (hills, mountains, sky), a definite middle ground (a row of trees or a house), and an interesting foreground (a single tree, flowers, a bird, or even a manufactured object). Decide which area of the foreground will be your primary center of interest and which will be your secondary interest. Then set up your paper either horizontally or vertically, depending on the direction of your subject.

The first step in this exercise is a preliminary pencil drawing with an HB pencil. Keep a kneaded eraser handy to remove unwanted lines. Don't become self-conscious because you have to do a drawing; it can be very loose, perhaps just a sketch. It doesn't have to be a tight or complex rendering—the HB wasn't designed for that kind of drawing anyway—but it is important to block in the basic shapes before beginning to paint.

Look closely at your subject matter, analyzing it in terms of a foreground, a middle ground, and a background, then draw what interests you. Don't worry about capturing a photographic likeness. When the painting is finished, and is shown publicly, only you will know where it was done. No one is going to say, "I saw ten leaves on that branch and you only have eight." You do the editing, the interpretation; you can take liberties with what you see. Allow the pencil to flow freely on the paper. If you are tempted to spend time perfecting

small details, force yourself to keep the pencil moving and don't raise it from the paper. This will help you to create broader shapes.

Keep your pencil point sharp for a cleaner drawing. The drawing should take anywhere from five minutes to half an hour.

Once you are pleased with the composition, it is time to think about painting. Remember to moisten any colors you plan to use with a drop or two of clean water while you are getting ready to begin painting.

Use a size 10 or 12 round brush with a good point to block in some of the larger masses, such as the background sky. Work around the details—behind the leaves, behind the foliage. Save your center of interest until later. After the background or middle ground is dry,

come back with a smaller brush, a size 3 or 6, and paint the foreground and other details. When that is dry, you can go back to the larger areas, provided you've painted them light enough.

Mix your colors directly on the paper, not on the palette or a test sheet. If you feel timid about working with a lot of color or mixing color this way, then limit your palette. Using only shades of green or blue for an entire landscape might be easier than working with a full color spectrum, especially if you are just beginning. In fact, you might prefer to do your first painting in black and white washes, then introduce one color in your next painting, two colors in the third, and so on, continuing to add colors until you are ready to graduate to a full watercolor palette.

Keep the color fresh by changing the water regularly and rinsing your brushes frequently. If you want a color that is not on your palette, say a special green, dip your brush in the yellow and apply it to your paper. Then do the same with a blue, mixing the green just where you want it.

Another thing to keep in mind is that you can draw as you are painting, even after you have been painting awhile, if you decide you need more detail. You can add to the painted or unpainted surface.

I often leave areas of unpainted paper to create positive white shapes or represent specific subject matter such as snow or small highlights. A positive white area suggests an object by silhouetting it with color rather than by defining it with color.

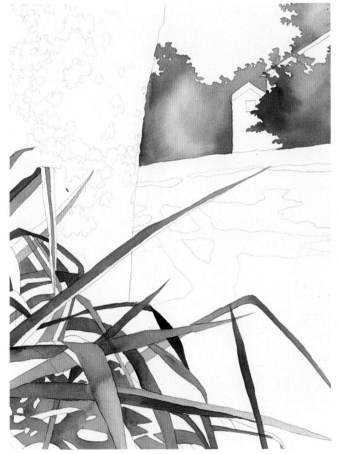

In the first stage of this watercolor composition, I did a preliminary line drawing and added only the gray washes. As I worked, I kept in mind the areas of the watercolor sheet that would remain unpainted as well as those that would receive a color in the next step.

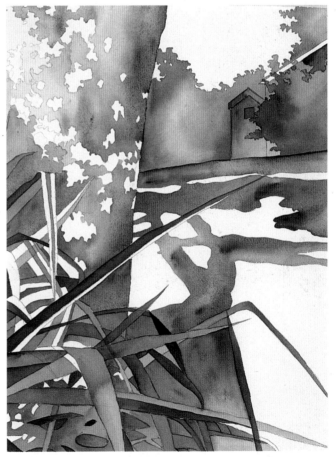

TOWARD THE GARAGE
11″ × 15″ (27.9 × 38.1 cm), 1987. Private collection.

I chose burnt umber as the single color in this painting, primarily because it's a neutral color and thus a logical progression from black and white.

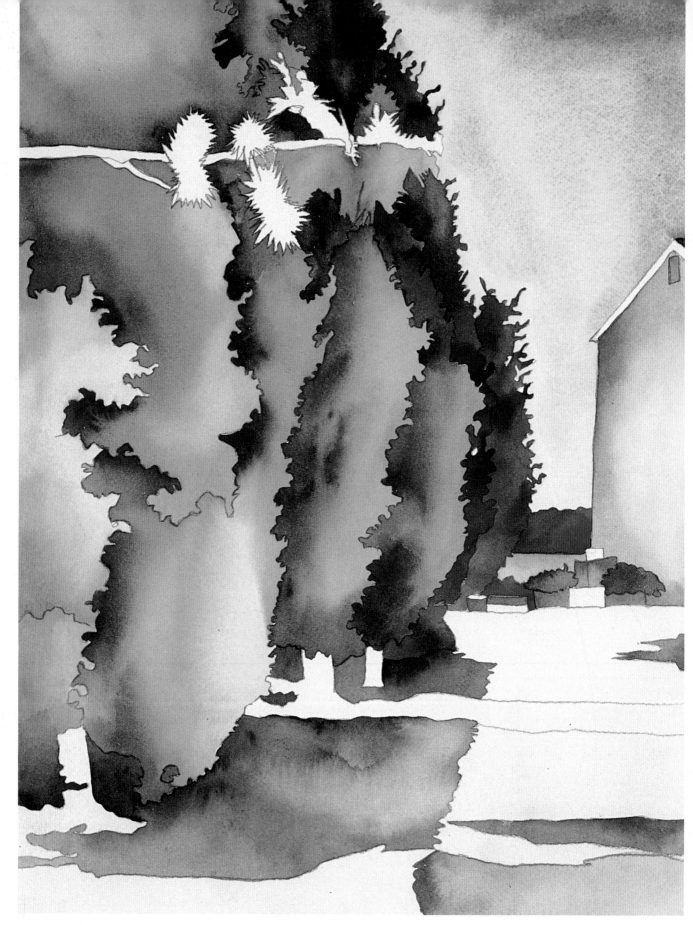

TOWARD THE BAY, *11" × 15" (27.9 × 38.1 cm), 1987. Private collection.*

In this exercise, I chose to use viridian and ultramarine blue in combination with Payne's gray. This limited palette allowed me to concentrate on composition and washes before introducing a full color scheme in a watercolor painting.

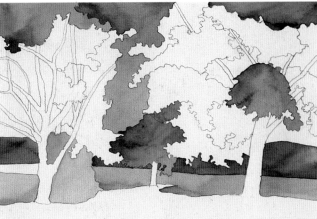

I used an HB pencil to do a preliminary drawing with a definite foreground, middle ground, and background.

I painted the larger areas first, including some of the background, with size 10 and 12 brushes.

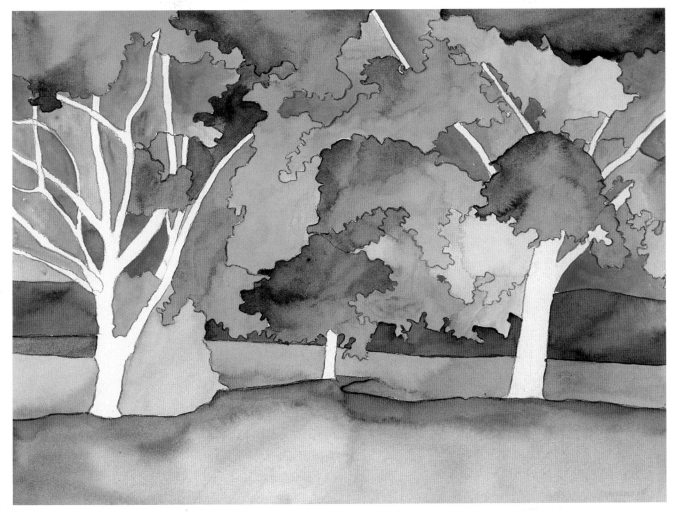

THROUGH THE TREES, *11" × 15" (27.9 × 38.1 cm), 1987. Private collection.*

In the last stage, I painted in the rest of the composition. I used ultramarine blue in the sky area to define the silhouettes of the branches but left the branches themselves and the trunks of the trees unpainted.

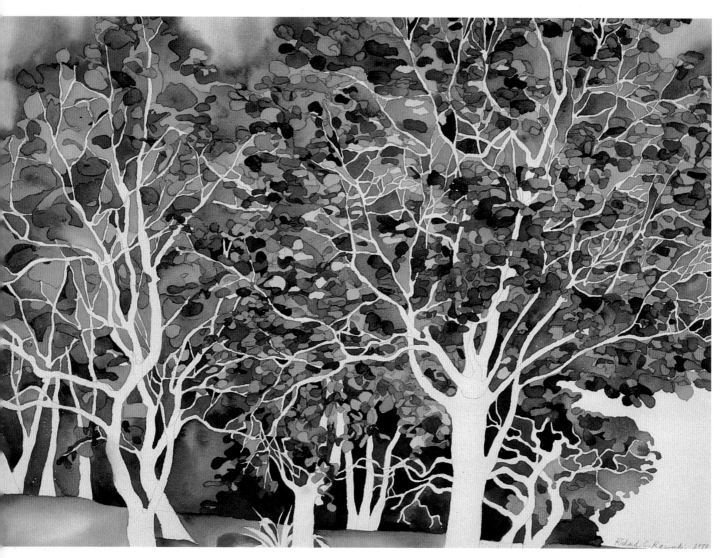

BREEZE HILL SUMMER
22" × 30" (55.9 × 76.2 cm), 1978.
Collection of Mr. and Mrs. Plitt,
East Hampton, New York.

This watercolor was one of the first I painted after I moved to my
home in East Hampton, New York, in the summer of 1978. It
was one of a series inspired by the natural environment
surrounding my home and studio. Notice that I left areas of
white paper unpainted, including the lower right-hand corner of
the composition.

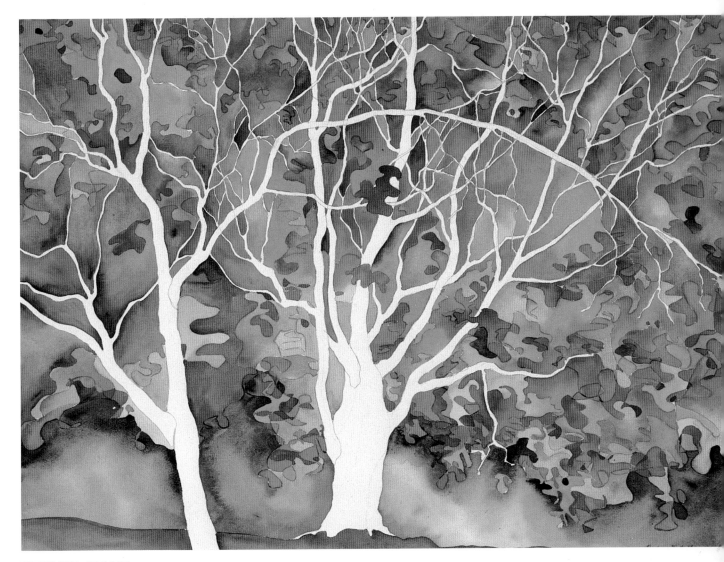

BREEZE HILL AUTUMN
22" × 30" (55.9 × 76.2 cm), 1978.
Private collection.

This painting was one of several inspired by the changing seasons. Again, it was inspired by the trees surrounding my East Hampton home as summer gave way to fall. The definite foreground, middle ground, and background in this composition create a sense of depth and space without perspective.

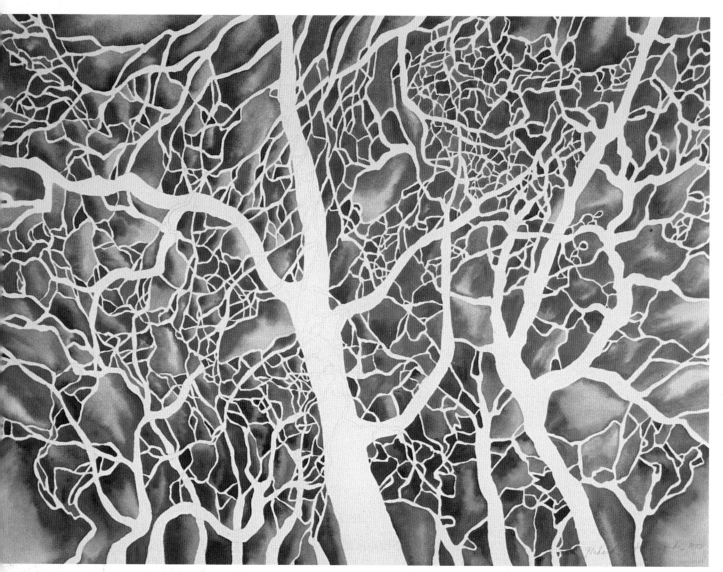

TREES IN WASHINGTON SQUARE (WINTER)
22" × 30" (55.9 × 76.2 cm), 1977,
Private collection.

This particular painting was one in a series inspired by the trees in Washington Square, which is near my NoHo loft-studio; the series, in turn, led me to do other paintings of the trees as they changed from season to season. All in all, I must have done about twenty of these paintings, depicting winter, spring, summer, and fall. I began with a pencil line drawing and chose to leave the branches and trunks of the trees unpainted to suggest snow.

BREEZE HILL WINTER
22" × 30" (55.9 × 76.2 cm), 1979.
Private collection.

In this painting, I have created still another view of the seasons, based on what I saw when I looked out the window of my home on a snowy day. Note how the shapes and color washes between the branches almost become the visual interest in the composition, rather than the trees themselves. I introduced a lemon yellow near the top of the watercolor sheet to contrast with the general cool look and feeling of the painting.

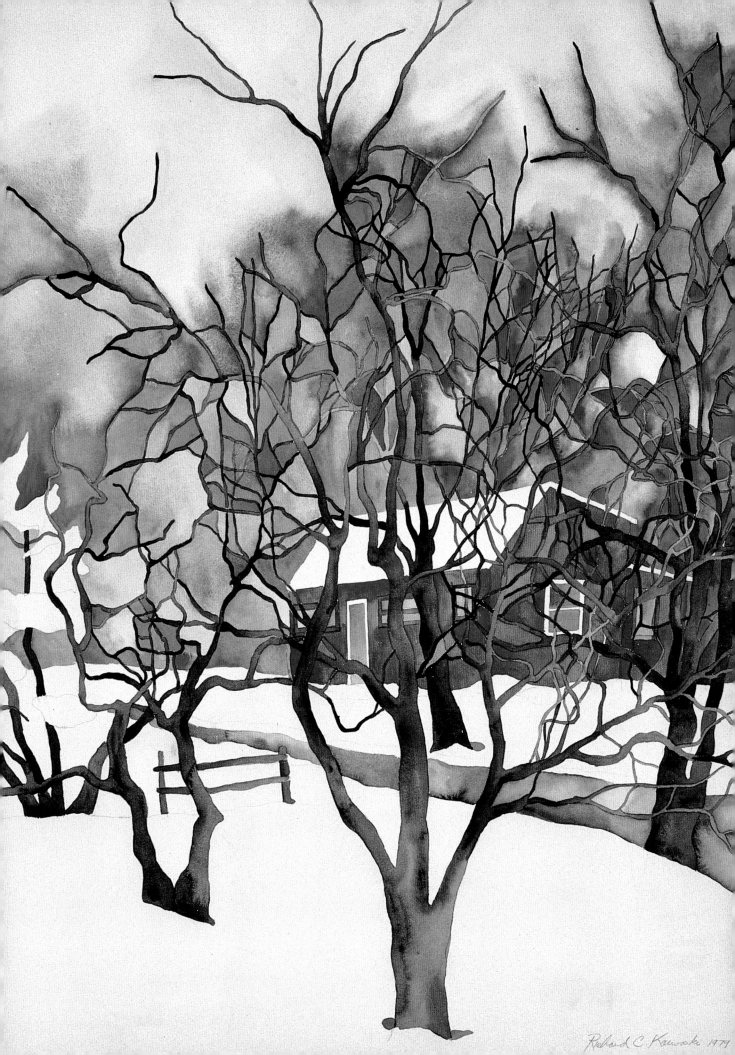

Richard C. Karwoski 1979

WORKING FROM THE GENERAL TO THE SPECIFIC

Your subject matter for this exercise should consist of a distinct center of interest set against a suggested background. You can work in a horizontal or vertical format, whichever accommodates your subject matter best. Instead of beginning with a preliminary pencil drawing, you are going to create areas of paint that represent images you want to capture. Once these areas are dry, you will bring in additional detail with a small brush or a pencil. You will be working wet-in-wet to establish the forms.

The painting shown here began with the primary subject matter, a cluster of orange lilies. First the area to be painted was moistened with pure water, using a fairly large brush, a size 10 or 12 round sable or camel hair. Next, I painted in the color that surrounded the flowers. Look carefully—there is a great deal of green and blue, representing foliage and sky (background), behind the lilies. Finally, I added the orange for the flowers.

Your technique for this exercise should be broad. Only wet an area when you are ready to work on it. Try to keep the color and values light so you can go back and change them if you have to and still keep the washes as fresh as possible. Incorporate as much of the background as possible while developing a particular subject area.

After you have painted most of the sheet with areas of color, allow it to dry and then come back with an HB pencil or a small round brush, such as a size 3, to define specific subject matter. If you wish, you can combine the wet-in-wet technique with areas of wet-on-dry.

Evaluate your composition by checking the corners. Are they treated differently from each other in terms of color, value and subject matter, or are they all the same? How does your treatment of each corner contribute to the overall composition?

I chose lilies to be my center of interest. This exercise was done on location with a specific composition in mind. I moistened the paper, then painted quite spontaneously with size 10 and 12 brushes.

In the second stage of this painting, I expanded the composition into the foreground and background. Still working only with the brush, I introduced other colors that suggest foliage as well as sky.

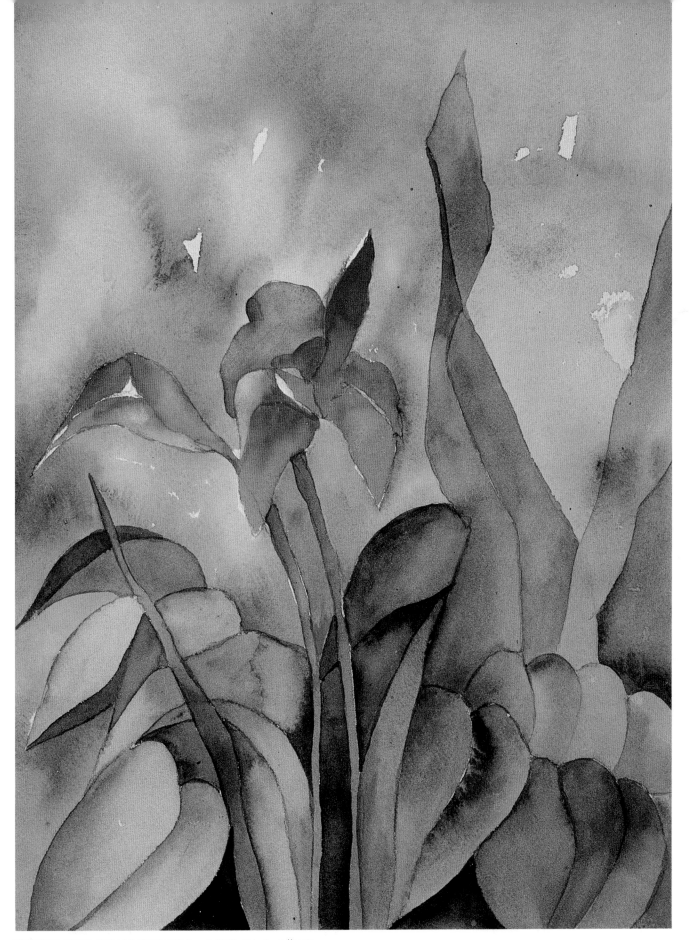

EAST END LILIES, *11" × 15" (27.9 × 38.1 cm), 1986. Private collection.*

After the washes had completely dried, I went back with an HB pencil and a size 3 brush to define specific subject matter. I also combined wet-in-wet technique with wet-on-dry in some areas.

DEVELOPING DETAIL WITH PENCIL AND BRUSH

In this exercise, as in the previous one, your composition will have a definite foreground focus, a sort of close-up of the primary subject matter—a specific tree trunk, for instance. This time, however, you will paint it with a wet-on-dry technique. Choose a subject that looks interesting close up and provides you with a variety of details, textures, and shapes to choose from.

Once you've selected your subject matter and set yourself up, begin painting with a fairly large brush, such as a size 12. Sketch in the larger masses and suggest the background. After this sketch has dried, block in the background with color and washes. Use the side of the brush. Don't apply pressure and don't scrub the paper; you want the washes to flow. Work broadly, without getting too specific. Defining your subject matter comes later.

Once the background is in place, begin to develop the details and the center of interest. Use an HB pencil to add specific detail that calls for precise lines—a branch, a fence, a few stones. Feel free to return to your painting with a pencil at any point in the painting process.

Next, use a small brush, perhaps a size 3, to suggest other details such as flowers or blades of grass and to isolate or define specific areas. In the example shown here, I isolated the shape of the fence because I wanted it to stretch part of the way across the painting. Instead of filling it in with a brown, I left the fence white; it is defined by the colors around it rather than its own color. I used the tip of a brush to accent specific details.

Now you can add the shadows, using a blue or a gray or a blue-purple. I prefer Payne's gray to a gray mixed from black because the latter tends to kill the intensity of the colors. Mix all your colors directly on your paper to keep them fresh and intense.

If you are unhappy with one of the initial washes you put down, you can change it by painting over it with a darker color. Remember to paint the entire area, not just part of it. If it's already dry, rewet it before painting over it—otherwise the brush will leave visible marks. You can only paint over a light, fairly subdued color. I could not repaint the grass in this painting, for instance, because I began with an intense green. If the color had been less intense, I could darken or intensify it.

Textures can also be changed or added as the painting progresses. Once you've blocked in the entire composition, you can go back with a smaller brush to create a texture on the tree trunk or elsewhere.

1 I sketched in the tree trunk and the ground with a size 12 round sable brush, working directly on the paper without a preliminary pencil line drawing.

2 I used the same brush to suggest the background on the right side of the composition. I drew the outline of the fence in pencil but defined this shape by painting the areas around it and leaving the fence itself unpainted.

3 I used an HB pencil and a size 3 brush to develop detail and a center of interest. The pencil was used to draw precise lines such as those that define the gravestones. The brush, on the other hand, was used for details with a lot of thick-and-thin variation, such as the blades of grass and the texture on the tree trunk.

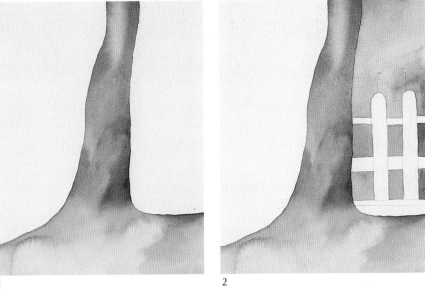

1

2

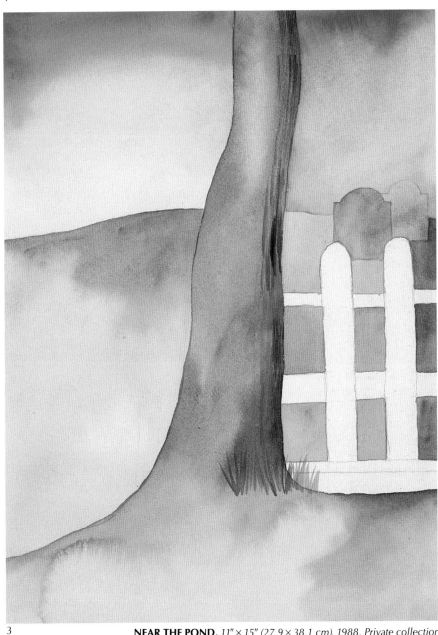

3

NEAR THE POND, *11" × 15" (27.9 × 38.1 cm), 1988. Private collection.*

PLACING OBJECTS OUT OF CONTEXT

In this exercise, you will combine a landscape background with an out-of-context object, natural or artificial, in an interesting composition by editing subject matter, reorganizing nature, and applying both wet-on-dry and wet-in-wet techniques. This surrealistic painting gives you the opportunity to integrate a landscape composition with objects that are foreign to the natural setting.

My fascination with such an approach dates back to a time in my career as a painter when I was primarily involved with creating works with oil paint on canvas. Occasionally I would do a watercolor painting of real objects in an unreal setting; this afforded me a mental challenge and the chance to get away from what I was currently painting on the easel.

The first step in this painting is a pencil line drawing. Begin by establishing a setting for the object or objects you have chosen to use in the composition. Draw a real landscape, either on location or from a photograph or slide that you have

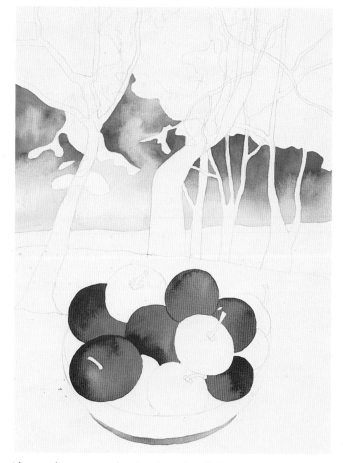

I began this exercise by drawing a bowl of apples resting on the ground outdoors. This object is foreign to the rest of the composition, and the surreal quality is emphasized by the scale of the fruit bowl compared to the landscape in the background.

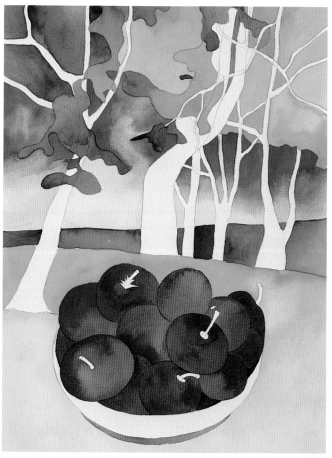

The next step was to apply watercolor washes to the apples and the background leaving an area of unpainted white paper to represent the fruit bowl. I simplified the leaves in the trees by suggesting overall shapes instead of individual leaves.

taken. Then set up a still life in your studio and incorporate it into the painting by placing it in the foreground of the landscape as primary subject matter.

You can work on a vertical or horizontal format, depending on the shapes of the elements in the composition. Simplify the pencil line drawing as much as possible, and feel free to edit not only the background but also the primary subject matter you have placed in the landscape.

Begin painting by applying color washes to the background and foreground with round brushes of various sizes, mixing the pigment directly on the watercolor sheet. Any detail that may exist in the foreground may be left for last and painted in with a small (size 3 or 6) round brush.

One possible approach to this exercise is to use warm colors for the primary subject matter and cool colors for the background, or vice versa. For instance, you might use the white of the unpainted paper to represent snow and paint in the natural or artificial objects with warm colors representing the color of fruit or vegetables. Or you could use Payne's gray for the hills in the background and place red and green apples in the foreground. These approaches emphasize the playfulness of this watercolor composition.

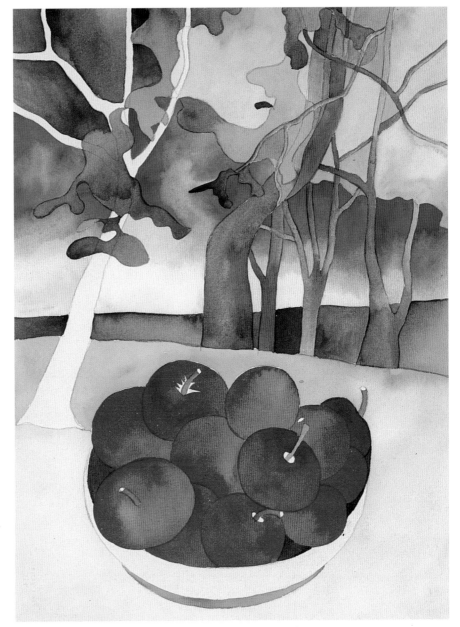

FROM THE APPLE TREE, *11" × 15" (27.9 × 38.1 cm), 1986. Private collection.*

Finally, I painted all the foliage and tree trunks, except the tree on the left side of the composition. I felt that this could represent another type of tree, such as a white birch. I painted the apple stems but left the tips of the stems and the centers of the apples unpainted, to act as white accents in the overall composition.

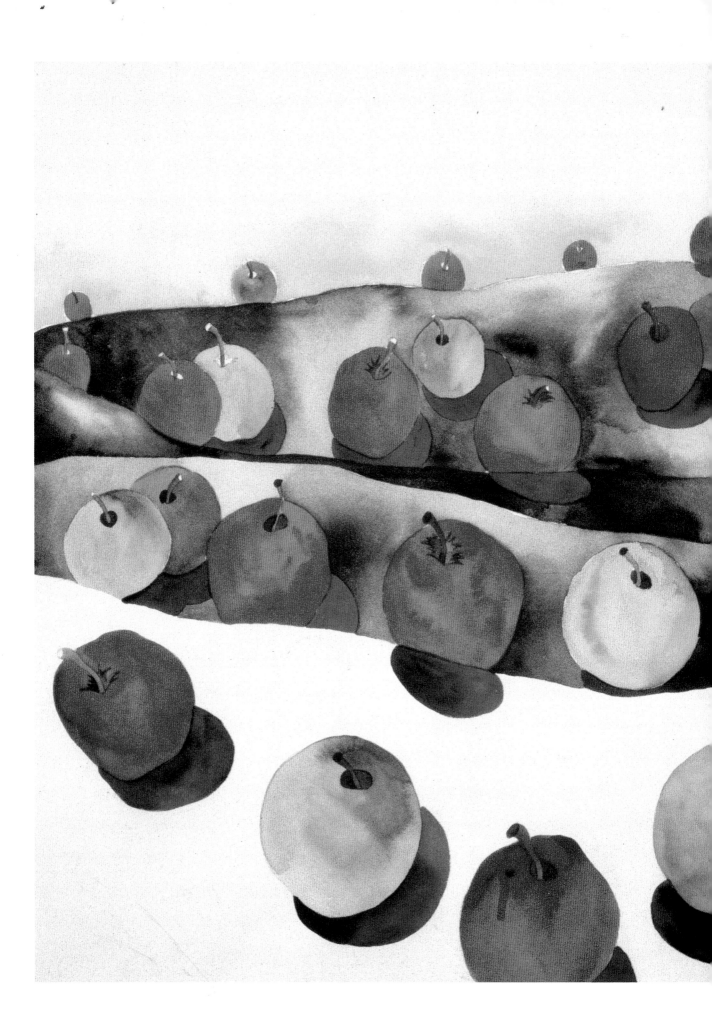

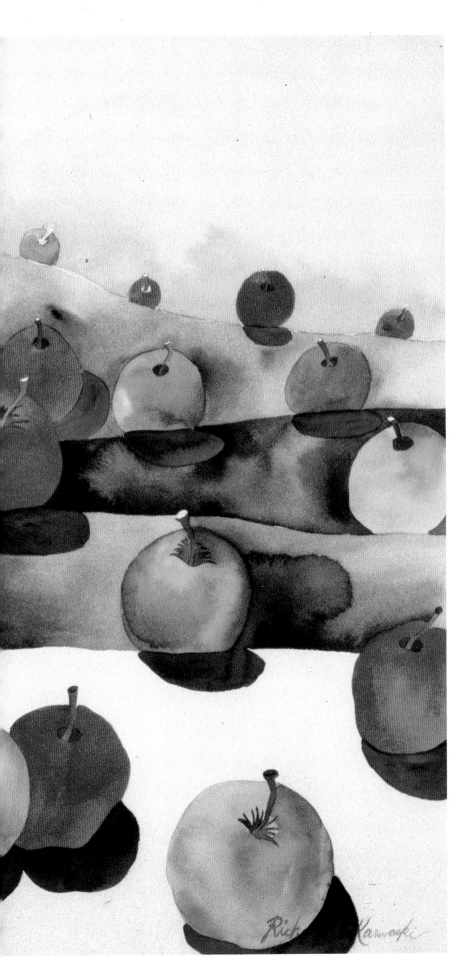

APPLE LANDSCAPE

22" × 30" (55.9 × 76.2 cm),
1981. Private collection.

This surrealistic imaginary landscape combines the cool Payne's gray hills and mountains with the warm red and green apples and the hot yellow sky. The landscape was completely imaginary, but I did refer to several red and green apples while I did the preliminary pencil drawing as well as when I painted the apples.

Overleaf
ROSES IN THE SNOW

22" × 30" (55.9 × 76.2 cm),
1981. Private collection.

This particular painting is a good example of a surreal landscape that combines a warm and a cool color scheme in a single composition. The white of the paper, representing snow (cool), and the natural roses (warm) set up an interesting juxtaposition of elements. I painted the hills from imagination but referred to reproductions of roses in rose catalogs for accuracy.

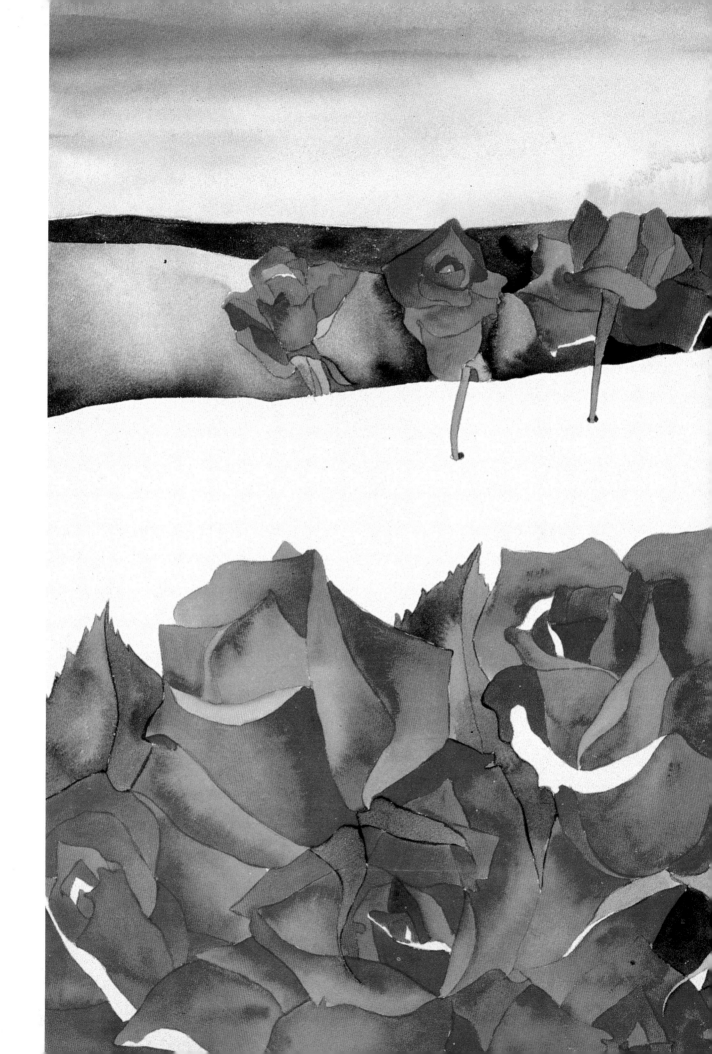

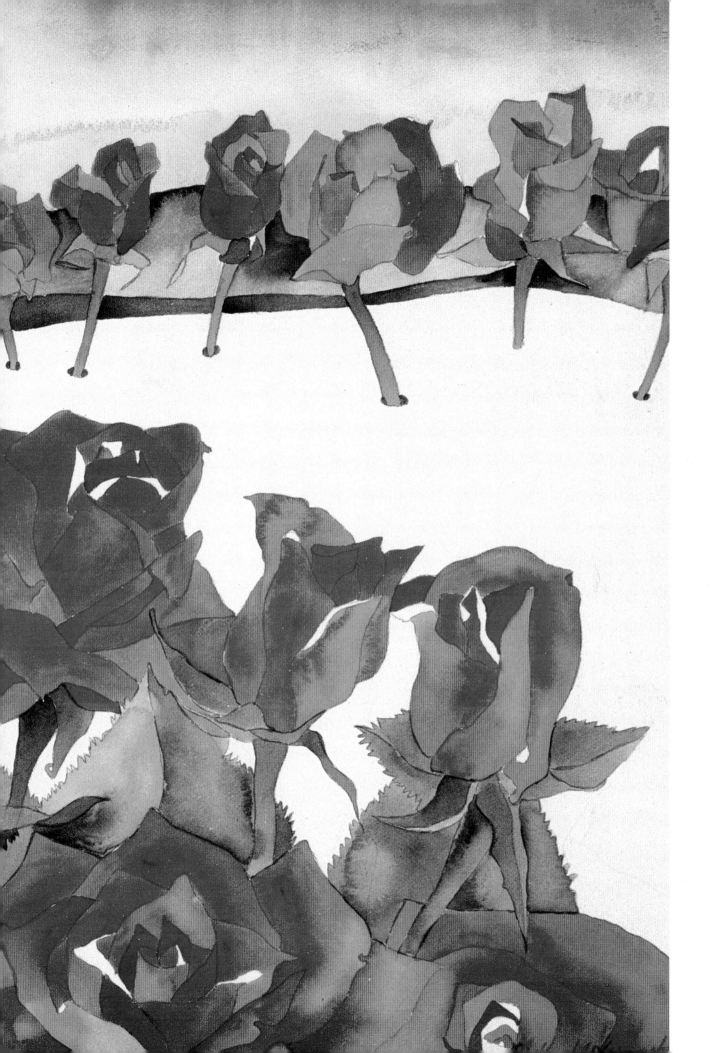

A GARDEN VIEW: EDITING THE LANDSCAPE

Begin by choosing a scenic garden, one that contains a background (trees, hills, sky), a middle ground (a variety of flowers), and a foreground (a single flower, a plant, or a row of flowers). In painting the panoramic garden, your primary center of interest will be the flower or flowers in the foreground.

Drawing and Painting Outdoors: Pros and Cons

When an artist goes outdoors to draw and paint, there are certain *new* variables that have to be dealt with as far as the forces of nature are concerned. Sun, shade, wind, dampness, and insects, to mention a few, can be quite distracting, especially to the beginner who is barely coping with the basics of learning how to paint in a difficult medium like watercolor. On the other hand, many artists find tremendous inspiration working outdoors, despite the distractions.

What I like to do is sketch a particular subject and then bring the drawing back to the studio and develop the composition at length by reinterpreting what I remember seeing, rather than creating a photographic likeness. In the case of the garden watercolors, because of the subject matter, I sometimes work from slides or photographs. In a way, the camera is able to simplify the subject matter by reducing variations in value, and it automatically edits my composition. (One

of the major pitfalls of working outdoors, especially for beginning and intermediate students of watercolor, is the editing of subject matter.) After I use a photograph or a slide as a reference, I go back to the locale and compare it with what I have drawn or painted. If I have not begun the painting, I can modify the drawing against the actual setting. If I have begun the painting, a certain amount of modification is still possible, but it will be limited to the unpainted areas of the watercolor sheet and some of the painted areas that are still light in value and therefore can be changed. Remember that the methodology an artist employs varies a great deal depending on his or her needs; what really counts is the end result—a finished watercolor painting that satisfies both the artist and the viewer.

The Composition

If you choose to work outdoors, you will be dealing with the elements, so try to concentrate as much as possible on what's before you. Begin by doing an overall drawing on a sheet of watercolor paper. Don't be concerned with excellent draftsmanship; instead, create a general impression of the subject. Don't worry about how your preliminary drawing looks. Whether you're doing a landscape or a panoramic garden composition, you have the right to do

anything you want as far as the interpretation is concerned. You are not a photographer but a painter who is depicting a particular setting in an individualistic way. Feel free to pick, choose, and edit whatever you are drawing or painting. No one will judge you in terms of how it is supposed to look. You're not doing an editorial story about the garden; you're using it as a source of inspiration. You can approach it realistically or abstractly, depending on your personal style. If you've worked in watercolor (or oils or acrylics) before, and you tend to paint abstractly, then by all means approach the exercise that way. If you're the kind of artist who feels more comfortable working realistically and doing a microscopic nature study of a single flower in the garden, allow that approach to establish your subject matter. Think of yourself as a camera. You're editing by isolating a particular area in the garden; it could be small and detailed or it could be very broad.

Choose a dominant area (not necessarily in the center) that you want the viewer to look at first when studying the painting. Don't isolate your subject matter by creating an island of interest in the center and nothing else. Work all over the paper. Let the pencil lines wander to the edges of the watercolor sheet and into all the corners as well.

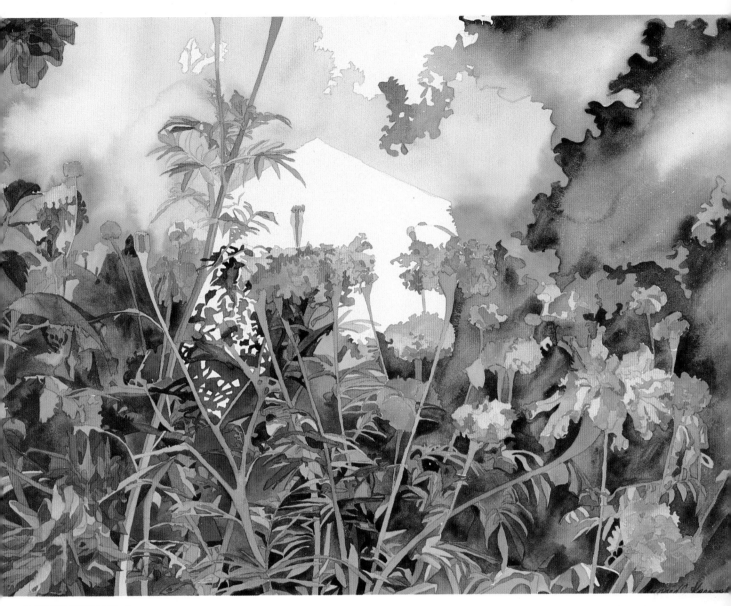

GARDEN SERIES NO. 4
22″ × 30″ (55.9 × 76.2 cm), 1981.
Collection of Richard H. Steinman, New York.

This watercolor was the fourth in a series of about fifty paintings (to date) inspired by the garden at my East Hampton home and studio. Note the use of the positive white space to suggest a structure in the background. This is a good example of what I consider a panoramic garden scene.

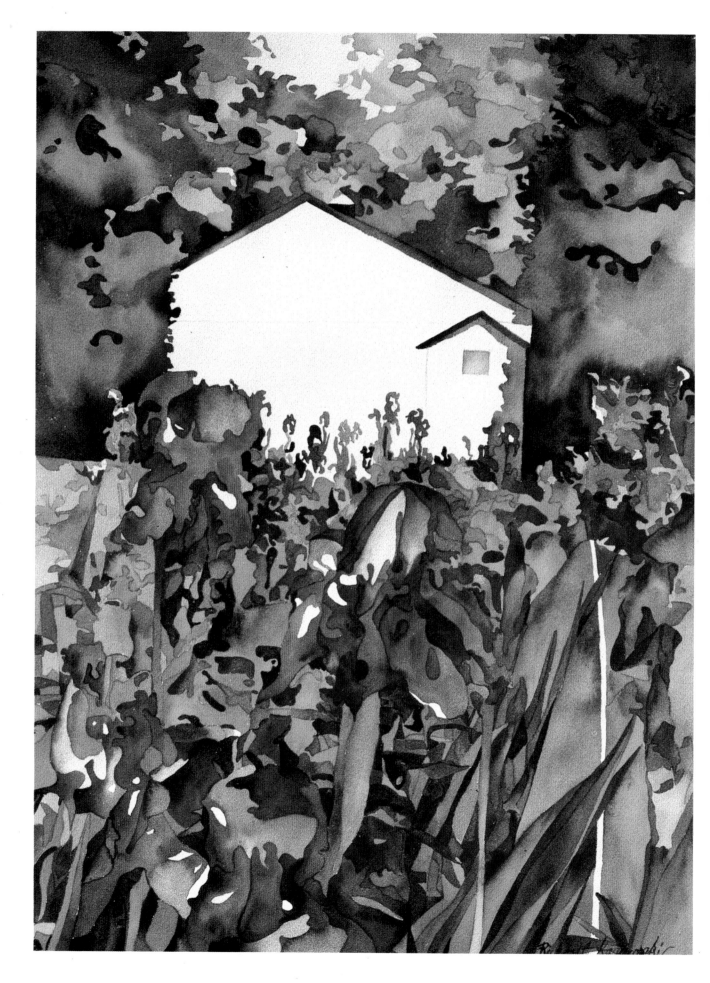

The Painting

Begin to paint as soon as you are satisfied with the preliminary drawing. You may paint the background before the foreground, or you may do the foreground first and then the background. Try to work all over the watercolor sheet. Begin at one end, then turn the paper upside down and work on the other end instead of working from left to right or from the middle out. Details may be added toward the completion of the painting. Massive areas, such as the sky, trees, and ground, may be painted first, followed by smaller shapes, such as flowers, stems, and leaves. Occasionally step away from what you have been doing in order to visualize the total composition and keep it from getting too overworked. Remember, the drawing is an ongoing thing. You can continue to draw as you paint.

When I paint a composition like this, I begin with the large, massive areas of color, such as the sky and the ground. Then I paint the individual flower, plants, or flowers by applying my lightest wash first and gradually adding more pigment to areas where I want deeper values. I will sometimes moisten an area first with pure water so that the paint will blend more quickly when I apply the pigment.

Look carefully at the colors in your subject matter; they may be more complex than they seem. For instance, a flower may appear red, but if you examine it more closely with a sensitive eye, you may see yellow, orange, purple, and other colors, depending on the lighting conditions. The same is true of the stem and leaves. They may appear green at first, but there are many variations of that same green. That's why I feel it's important to mix pigments directly on the watercolor sheet, rather than mixing a big batch of a single, consistent color on the palette or test sheet. If you mix your colors on the paper, the washes will create many subtle variations as they merge and flow together on the painting surface, and this will cause them to retain a certain luminosity.

Another device I employ is to leave small areas of watercolor paper unpainted to represent highlights, especially on leaves and flowers in a garden setting. These accents of pure white paper seem to reflect the intensity of the sun. Remember, the absence of color can be as effective as a strong primary color. You alone are the best judge of color. If you have the eyes of an impressionist, you certainly will see more color in a garden setting than you will if you look with the eyes of a Wyeth.

My forte happens to be color, but other artists may use less color and still create a painting that is quite effective. You're not doing a rendering, you're doing a personal interpretation of the garden.

A student once asked me what to do if you choose the wrong color by not testing it first. I replied that there is no wrong color. If it's wrong in your mind, then it's wrong in the mind of the person looking at it. If it's right in your mind, it's right in the mind of the viewer. That's my philosophy. You're the best judge and critic of your own work.

IRIS GARDEN
*22" × 30" (55.9 × 76.2 cm),
1981. Collection of Mr. and Mrs. Bier,
Plainview, New York.*

This is a good example of a panoramic scene composed in a vertical format. In this painting, the light source is suggested by the shadows and the unpainted areas of paper that represent the building, sky, and highlights on the flowers.

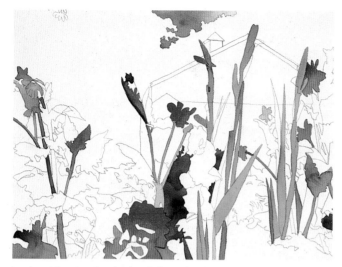

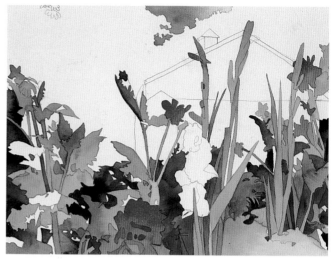

I selected a site that had a definite background, middle ground, and foreground. I filled the entire watercolor sheet with a casual pencil line drawing and began to paint in the primary areas.

In the next stage of this composition, I painted in the entire foreground except for the gladiolus blossoms that are my center of interest.

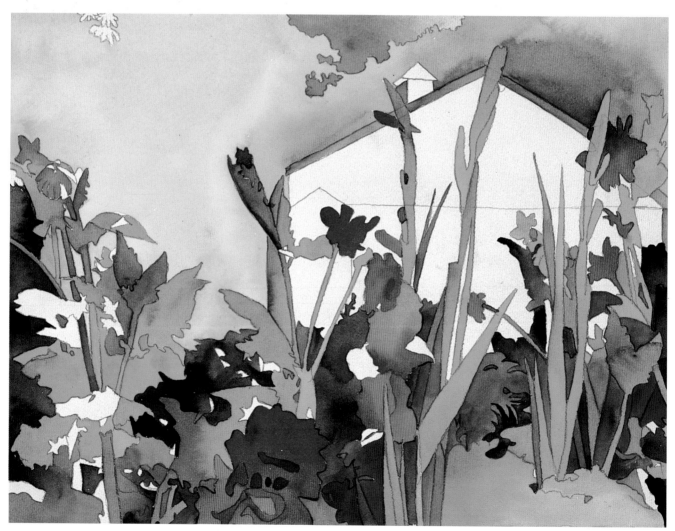

GARDEN SERIES, *11" × 15" (27.9 × 38.1 cm), 1987. Private collection.*

I suggested the foliage with an overall wash created by mixing Naples yellow and phthalo green directly on the watercolor sheet. Note that I left the middle ground (in this case, a house) unpainted. Positive white areas act as highlights or accents throughout the composition.

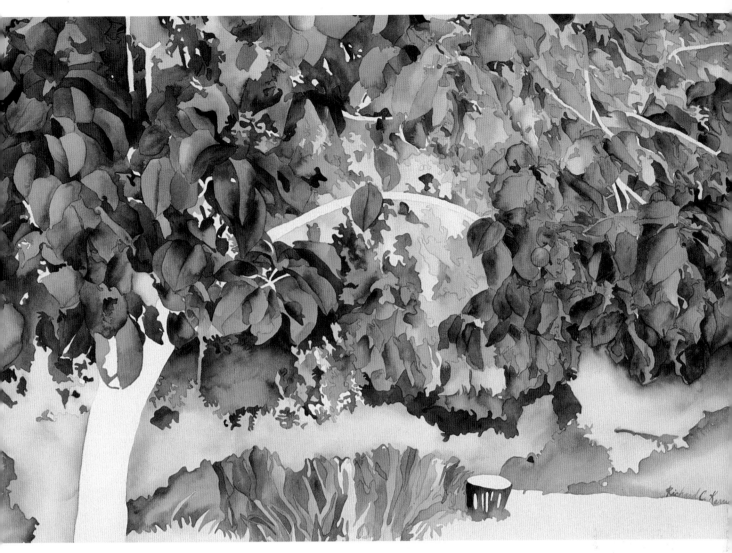

A GOOD VIEW
30" × 40" (76.2 × 101.6 cm),
1982. Private collection.

This is a continuation of the landscape series that I began in the 1970s, but in this painting I concentrated on the apple trees that grow outside my home in East Hampton. It's a different kind of panoramic composition: the apple tree is in the foreground and hugs the top of the watercolor sheet instead of the bottom. Note the use of the positive white space to represent the ground in the lower right-hand corner and the trunk and branches of the tree.

Painting Tips

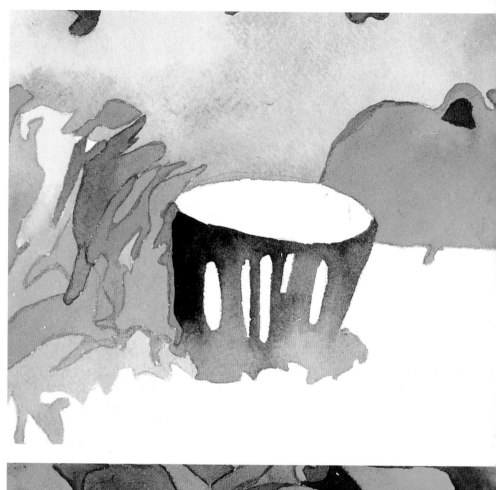

Unpainted areas can be used to define certain kinds of subject matter as well as bring a variety of shapes and forms to the overall composition. In this case, the unfinished quality of the bushel against the surrounding background adds to the drama.

A cluster of leaves can be painted by merely suggesting the whole cluster with shape and color, rather than drawing and painting each individual leaf. Note the variety of sizes and the value contrasts between the forms.

This section of the apple tree is quite dense with leaves and branches. Once again the subject matter has been simplified by using a variety of shapes and sizes. I left the branches unpainted, and used every green on my palette, including sap green, viridian, and emerald green, to create transparent washes of different values.

In order to create contrast, it is necessary to create large areas of watercolor washes next to small, defined areas when painting complex subject matter such as a tree. Using a variety of large and small shapes also establishes a sense of depth in the composition.

A GARDEN VIEW: THE CLOSE-UP

A specific detail in a garden setting can make an interesting watercolor composition. Several leaves, branches on a tree, or a few flowers can be considered appropriate subject matter for this exercise.

Begin by doing a fairly casual pencil drawing on a sheet of cold-press paper. Don't attempt to draw an exact likeness of each leaf, branch, or petal, but draw an overall impression of the subject matter. I tend to improvise as I draw by working all over the watercolor sheet. When drawing a tree, for instance, most people would begin by drawing the trunk, but I usually begin with the branches.

As you do the drawing, remember everything that I've discussed so far: begin with the composition and work all over the paper blocking in your primary areas first in pencil. Don't get bogged down with detail, but draw in large sections of subject matter and then rework them by adding detail. Remember to be free with the pencil, as if the right side of the brain is doing the work for you.

When I was in a life drawing class at Pratt Institute, we would close our eyes and draw the model. Some of the drawings were quite interesting; they seemed a lot freer than drawings done from sight,

because they recorded a visual impression rather than an exact likeness of the model.

Once you have created a pencil composition that pleases you, it's time to begin painting. The first step is to apply pigment washes with a large brush to the most prominent areas in the foreground, middle ground, or background. Next, use a smaller brush to isolate specific details such as branches and leaves. When I paint this type of subject matter, I tend to see what's behind the branches. For instance, I see shadows and other branches that isolate the shapes of the leaves; these are not necessarily drawn but may be suggested with a color like burnt umber. In describing the branches you may choose to do what I do: leave them unpainted to create positive white areas on the paper. Remember to paint the secondary areas, such as the background, the branches, or the areas behind the leaves, before the primary areas. I know it's tempting to paint the flower before the leaves that surround it, but I find it easier to work around an important shape and then come back to it.

As I continue to paint, I mix and dilute the pigment on the watercolor sheet rather than on the palette. I'm having fun with the

leaves by suggesting the shapes with the tip of the brush. I'm also painting clusters of leaves, not necessarily each individual leaf. By reducing complex forms to an overall shape or shapes, leaving some of the paper unpainted, and mixing my colors on the paper, I build up the forms as I go along. Remember, if you're painting trees or a cluster of leaves, you should work with a variety of greens such as viridian, emerald green, and yellow-green, to mention a few. You may add some yellow or blue for greater variation.

Always make sure you work in such a way that most of your shapes go off the edges of the paper. Work quickly with the brush so the pigment doesn't dry too fast on the watercolor sheet. Feel free to mix the pigment as you go along. Try not to wash out the color; you can avoid this by mixing directly on the paper rather than diluting the paints on your palette.

If you prefer to suggest the subject matter with a more impressionistic technique, especially when suggesting leaves, that is also valid. It's possible to block in all the major areas with simple shapes filled in with washes of various light and dark values, as I described earlier, then go back with a smaller brush to suggest texture.

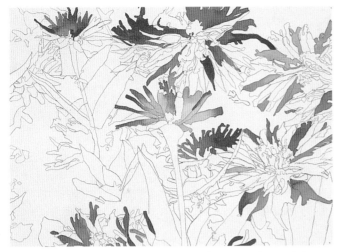

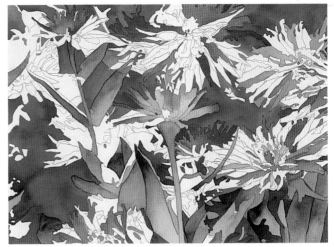

I focused on a cluster of zinnias in the flower garden and drew my subject in pencil. I singled out one flower in particular to represent the center of interest and began to paint some of the petals on the zinnias.

I painted in the areas around the flowers, using greens, blues, and violets to suggest the leaves, stems, shadows, and sky. I also painted more petals on the zinnias. Notice how the color and value vary on each petal.

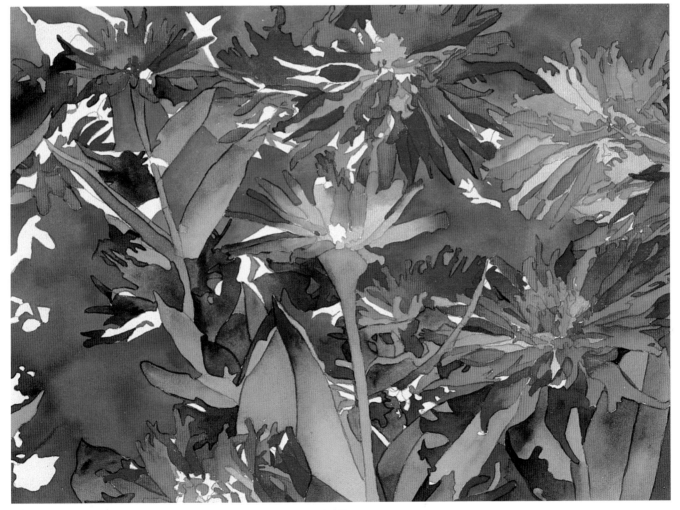

A MINI MEXICAN GARDEN, *11" X 15" (27.9 X 38.1 cm), 1987. Private collection.*
I continued to alternate between painting the subject and painting the background, developing them both simultaneously until I reached a pleasing composition. I retained several areas of white to represent highlights on the zinnias as well as in the background.

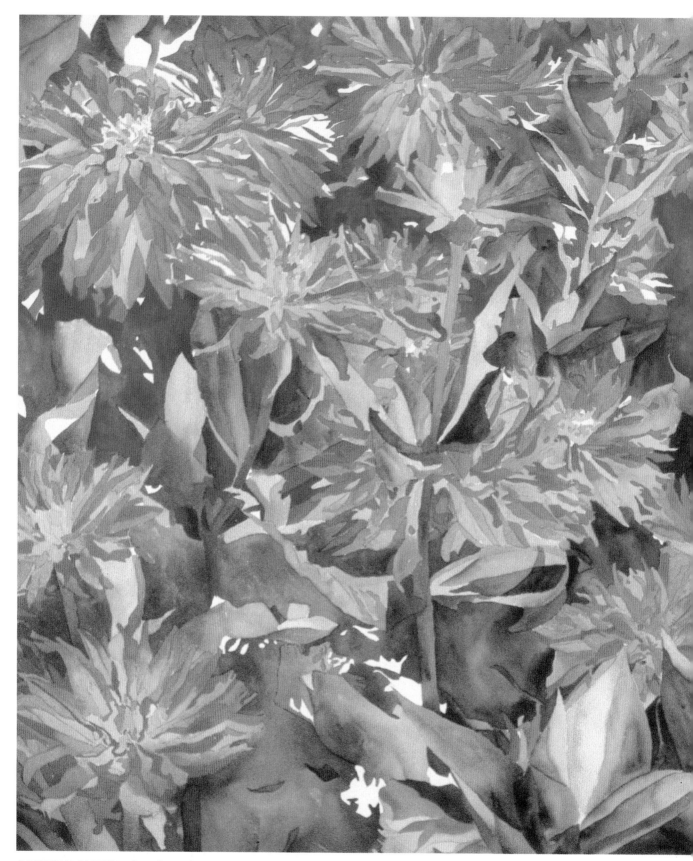

A MEXICAN GARDEN *36″ × 44″ (91.4 × 111.8 cm) 1981. Collection of Gallery East, East Hampton, New York.*

The zinnias that inspired this composition were the colors of hot chili peppers, which gave me the title for this watercolor painting. It's a good example of a close-up study of a garden. Note the contrast of the warm flowers against the cool blue-violet background.

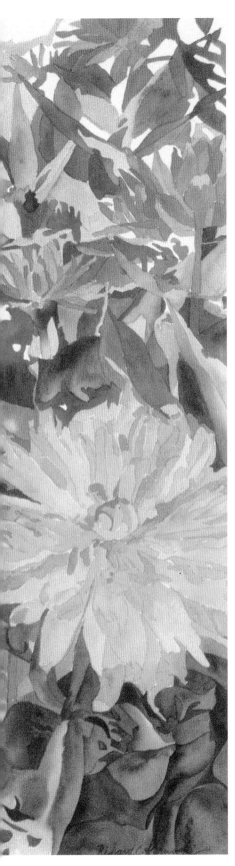

(Left) In the first stage of this exercise, I not only attempted to draw the foreground, middle ground, and background, but also painted in all the areas around my primary subject, the irises.

(Below) My next step was to paint the stems and leaves of the irises as well as the ground in the lower right of the composition. I chose to leave the individual flowers unpainted to depict white irises. I considered painting them in a specific color, such as yellow or violet, as I have in other paintings, but I finally decided to leave them white.

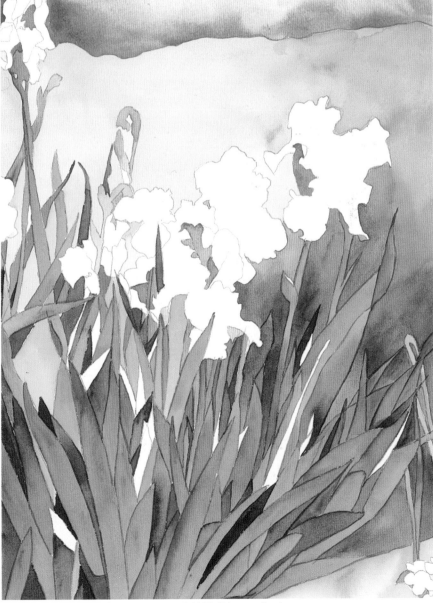

WHITE IRISES, *11" × 15" (27.9 × 38.1 cm), 1987. Private collection.*

COMPOSING WITH SEVERAL OBJECTS

Begin by choosing at least three related objects of different sizes and proportions; they may have some personal significance to you or they may just be pleasing to look at. Select a piece of cloth to use as the background; this material may be a solid color or patterned.

Arrange your objects on the background material so that they overlap, to create a greater sense of depth and space. The background cloth should be arranged so that the folds become an integral part of the painting. The light source can be natural, from a nearby window, or artificial and quite close to the subject matter, so that the objects cast shadows onto the background.

If you don't have background material, rather than resort to working with a table as a background, I suggest you use paper towels; the folds and shadows will add interest to the overall composition. If you crumple the towels so that they look three-dimensional, they can become another element of the still

life. Or you can keep them fairly smooth, so no one will know the nature of the background material after you finish the painting.

Begin by doing a casual line drawing on a sheet of watercolor paper with an HB pencil. Create a center of interest in your composition, an area you want the viewer to focus on when the painting is finished. Remember, when you're drawing or painting, you may work outward from the center or inward from the edges. I tend to work from the middle out to the edges of the watercolor sheet. Be casual, not rigid, when doing the drawing. You're not trying to achieve a photographic likeness of the subject matter but interpreting it in your individual way. Make it look convincing. A rose should look like a rose; a marigold should look like a marigold. Your drawing doesn't have to be an exact likeness of what's before you, but it should look like the object it's supposed to represent.

Introduce a horizon or ground line to create depth and space in your composition; this will make the painting more interesting. Varying the shapes in the corners of the paper will also create more interest throughout the surface of the painting. Remember not to overwork the drawing with excessive pencil lines, and feel free to erase with a kneaded eraser any part of the drawing that is not relevant to your still-life composition. Also, bear in mind that the drawing can change even after you have begun to paint.

I usually begin painting somewhere near the center of the watercolor sheet, but you may begin anywhere on the surface. The background could be painted first, before the primary subject matter, or you might do it the other way around. Just keep in mind, wherever you begin, that you should work your washes, values, and color into the overall composition. Don't stall by getting stuck painting just one area of the composition.

I arranged some fruit against a cloth and began the preliminary drawing. Notice that many of the pencil lines extend beyond the edges of the watercolor sheet. I began painting by creating a wash of Payne's gray directly on the background.

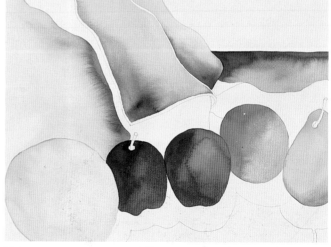

Using a variety of reds, yellows, and oranges, I painted the apples, pear, and grapefruit, as well as a section of the table on which all of the objects are resting. Notice how the horizon line adds a sense of depth to this scene.

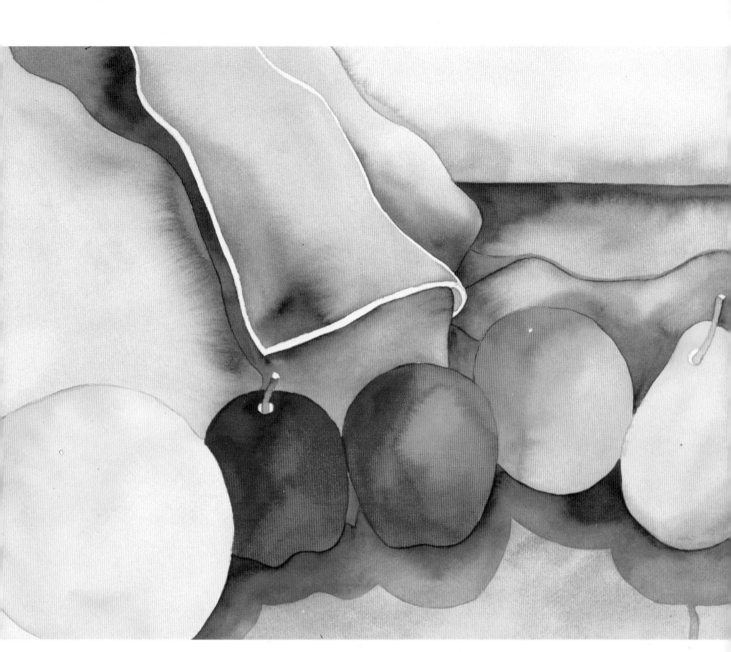

MIXED FRUIT STILL LIFE, *11" × 15" (27.9 × 38.1 cm), 1987. Private collection.*

I continued to paint in all the areas of the watercolor sheet except on the cloth, where I left a white edge to describe the contour and shape of the fabric. I also introduced shadows below the fruit to define a light source. I outlined each shadow first in pencil, then painted over the background wash.

1 I arranged a plant in a flowerpot with a cloth draped over it against a simple background of a table and a wall beyond. The preliminary pencil drawing helped me not only to compose the subject matter but also to simplify it, especially the pattern on the cloth and the leaves on the plant. I began painting by applying washes of light but contrasting values to the cloth. When that dried, I went back with a pencil to indicate stripes and then chose a blue for the color.

2 In the second stage, I began painting the leaves, the distant background, and the edge of the flowerpot.

3 Note how I continued the stripe pattern on the cloth by following the contour of the folds. What makes this approach to the still-life composition different from the painting on page 43 is the close-up approach to the subject matter, which fills three of the four corners of the watercolor sheet; the background is merely suggested in the lower right-hand corner.

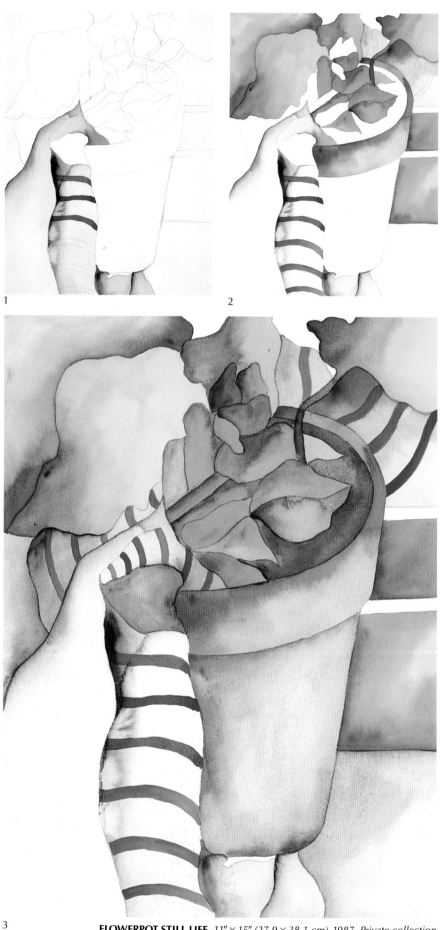

1

2

3

FLOWERPOT STILL LIFE, *11" × 15" (27.9 × 38.1 cm), 1987. Private collection.*

1 This bird's-eye view of a fruit plate is a challenging approach to the still-life composition. The first step was to select a plate and several red and green apples. Then I did the preliminary pencil line drawing, looking at my subject matter from above. I painted the plate and three of the five apples. Notice how buoyant the plate looks against the stark white background of the watercolor paper.

2 I completed the other apples, including the stems and centers. I might add that I've done other plate compositions in which the background was left unpainted.

3 In the last stage, I used cobalt blue for the overall background wash, which I applied with a large round brush. Note how the blue varies in value throughout and how the darkest value describes the edge as well as the shape of the plate.

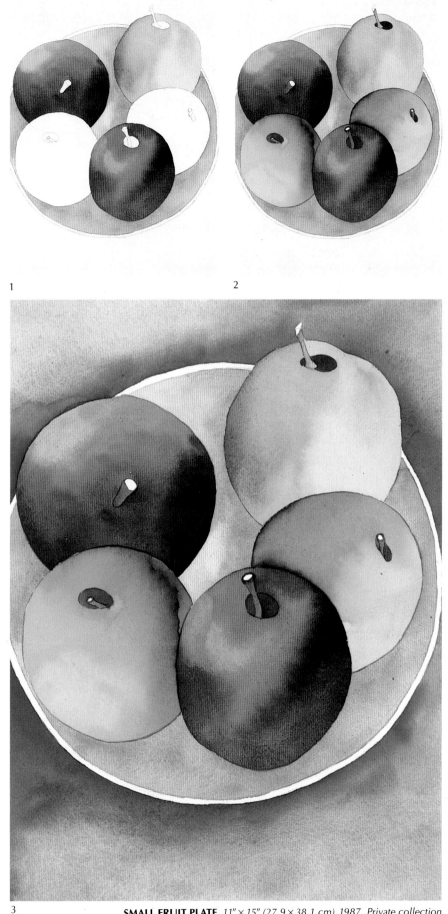

1

2

3

SMALL FRUIT PLATE, *11″ × 15″ (27.9 × 38.1 cm), 1987. Private collection.*

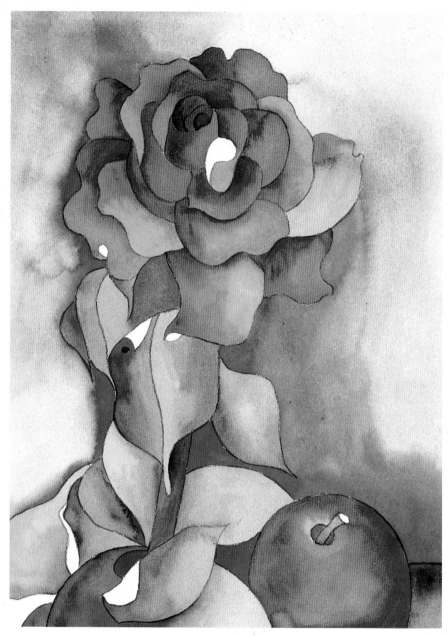

I arranged all three of the related objects that were chosen for this composition in the foreground so there is a sense of very little space in the background. After I completed the preliminary pencil line drawing, I proceeded to paint in the background with a cobalt blue wash. I varied the overall value by keeping the upper portion of the watercolor sheet light and transparent, the lower portion opaque and dense.

STILL LIFE ON BLUE, *11" × 15" (27.9 × 38.1 cm), 1987. Private collection.*
I painted all the petals on the rose (note the variation in color as well as value on each one) and then finished the leaves, vase, and apple, in that order. I also suggested that all of the subject matter was resting on a flat surface by indicating a table in the lower right-hand corner.

STILL LIFE, *11" × 15" (27.9 × 38.1 cm), 1981. Private collection.*
This composition is a good example of how natural and artificial objects can be arranged to make dramatic effects in watercolor painting. There is a certain surreal quality throughout, especially in the upper right-hand corner, where we see what looks like a window with a landscape beyond. Note that I've used unpainted areas as well as shadows to accent the fruit and suggest a light source. Also, notice how the apples and oranges merge through the use of free-flowing multicolor washes.

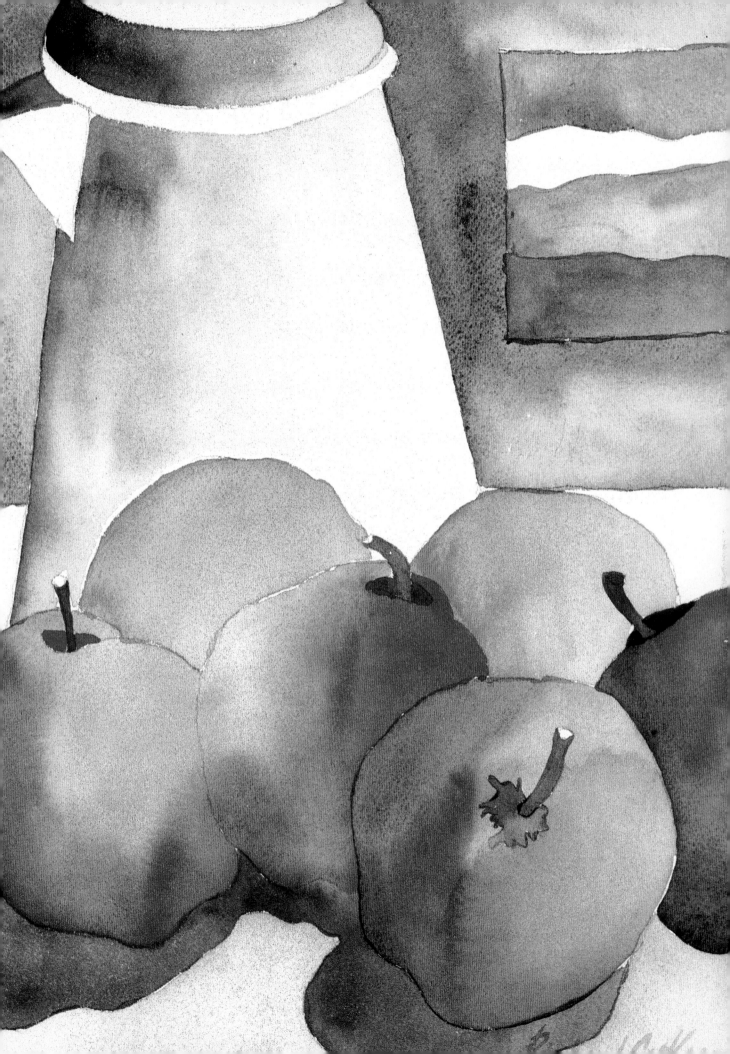

VARIATIONS ON A PIECE OF FRUIT: SPACE IN A STILL LIFE

A fruit still life can be developed by multiplying one or two pieces of fruit to create an overall composition; *changing positions* and *overlapping* are only two of the methods you can use to make one object look like many. This exercise requires very little in the way of subject matter—just a single piece of fruit.

Changing Positions: An Overall Composition of Floating Fruit

Begin by choosing an apple, pear, or orange. With an HB pencil, draw the piece of fruit somewhere near the middle of your watercolor sheet. Now draw it again in another area, but this time, rotate the fruit so it is on its side, or upside down, or just seen from a different angle. Keep repeating this step, filling the entire sheet with the same fruit. Draw so that the fruit runs off the top, bottom, and sides of the paper. Keep the background flat—a table-top if you're working indoors, the ground if you're working outdoors. After you have created this overall floating-fruit composition, begin painting. Paint the fruit first in this case, then the background, integrating the two so the fruit does not look as if it has been cut out and attached to the background. Continue to refer to your original subject matter and vary the values, washes, and color as much as possible. This will happen automatically, provided that you continue to turn the fruit while you paint.

After you have finished painting the fruit, add a wash to the background. When doing an overall fruit composition, I generally use Payne's gray or Winsor blue as a background color, but the choice is yours. Do vary the values in the background, moving from dark at the top to light at the bottom, or vice versa; or you might use dark-and-light wash patterns throughout. These value shifts will create luminosity, depth, and movement in your painting. You are trying to avoid a static composition.

Overlapping: An Overall Composition of Rolling Fruit

Begin this composition, as before, by choosing another piece of fruit and drawing it from different angles and positions, but this time, concentrate on overlapping the pieces of fruit and varying their proportions to create a sense of depth and space. For instance, the fruit in the foreground would be larger than the fruit in the background. Keep in mind the possibility of using a horizon line and a background cloth, as you did in the still-life composition. Draw to all the edges of the surface, and don't hesitate to run certain elements of your composition off the sides and bottom of the watercolor sheet. When you have arrived at a pleasing arrangement of subject matter, proceed to begin painting. Build up the image by working all over the sheet, incorporating background and subject matter simultaneously. If necessary, change the drawing while you paint. Concentrate on luminous color washes and contrasting values and create a strong center of interest for the viewer.

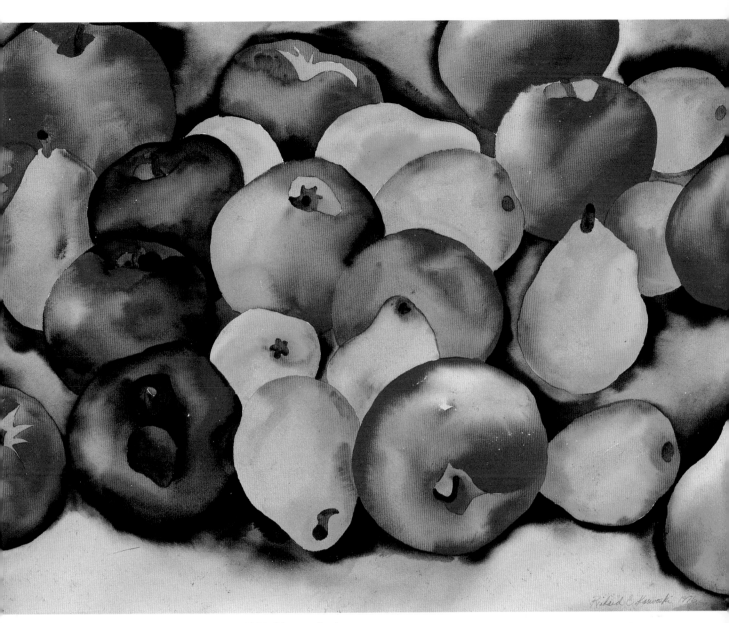

APPLES AND PEARS, *22″ × 30″ (55.9 × 76.2 cm), 1976. Private collection.*

This is one of the first multiple-fruit compositions I ever did, and I remember using only two apples and two pears to create the illusion of more than two dozen pieces of fruit merging, separating, and rolling on a flat surface. This is also a good example of how it's possible to mix and create vivid color combinations directly on the watercolor sheet. Note the value variations created by the wash of Payne's gray in the background. I used the deepest values to describe the individual size and shape of each piece of fruit. The only unpainted white areas in this painting are the accidental speckles occurring in the washes in the red and purple apples in the front row.

I used a single apple as my primary subject matter for this overall fruit composition and started out with a preliminary pencil line drawing. It was important for me to change the position of the real apple, as well as to overlap the drawn apples and vary their sizes, to achieve the best results in this composition. I made sure that some of the apples touched the edges of the watercolor sheet or extended beyond them, to give the viewer a sense of continuity. As I painted the fruit, I continued to look at the original apple, turning it as necessary.

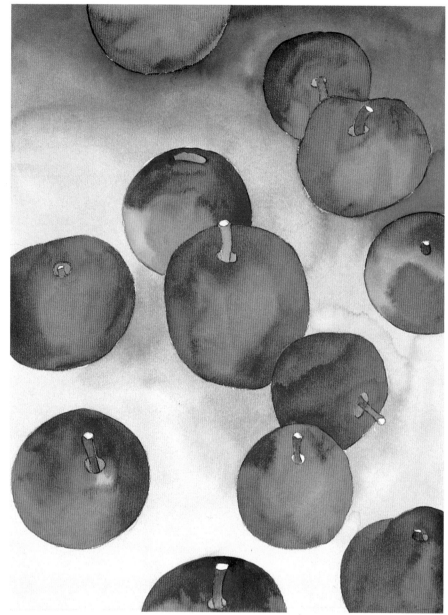

FLOATING APPLES, *11" × 15" (27.9 × 38.1 cm), 1987. Private collection.*

I continued to paint the other apples in the composition to complete the painting. I used ultramarine blue, applied with a size 12 brush, for the overall background color, but I deliberately varied the overall value from the top to the bottom of the watercolor sheet. I did this to create a sense of air or sky, so the apples would appear as if they were falling or floating in space.

(Right) In this exercise, I concentrated on overlapping and varying the proportions of the apple to create a sense of depth and space in the composition as I multiplied my subject matter. At this stage, I also introduced a horizon line. Because I saw this as an outdoor situation, I used ultramarine blue to suggest the color of the sky.

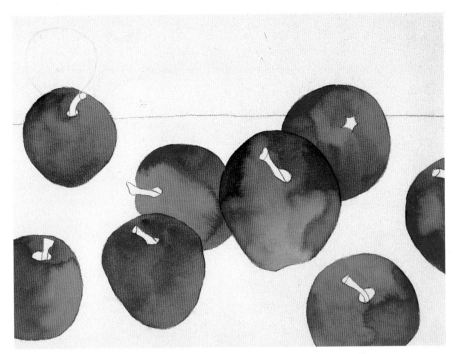

(Below) For the foreground, I chose burnt umber to represent the color of earth and created an overall light-and-dark wash with a size 12 brush. Notice how the deeper values hug some of the edges of the apples as well as the edge of the horizon line. I did this to create a sense of depth and density without painting special shadows.

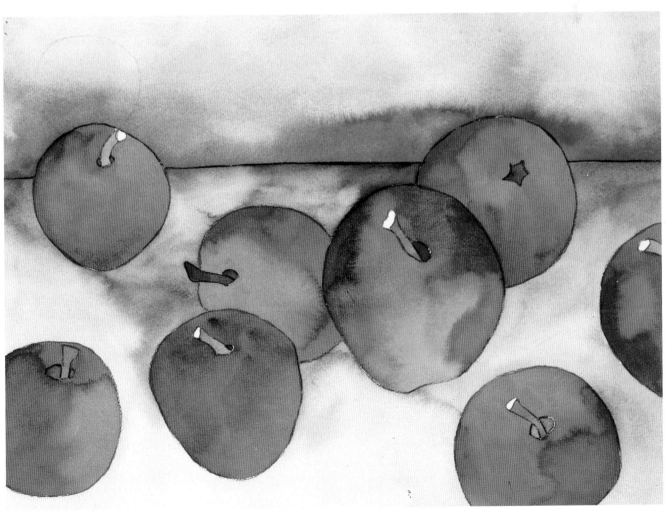

RESTING APPLES, *11" × 15" (27.9 × 38.1 cm), 1987. Private collection.*

COMPOSING AND EDITING YOUR SUBJECT MATTER

This exercise consists of three floral compositions; a single flower, several flowers, and a whole bouquet. The purpose is to learn how to draw and paint directly from flowers and to practice simplifying a composition or subject by editing and painting in a more fragmented way. Work may proceed from the center of the flower outward or from the outside inward.

A Single-Flower Composition
Choose a single flower with multiple petals such as a zinnia, a marigold, or a rose. Place the flower in a container, or hold it, and continue to observe it carefully as you develop the drawing.

This type of composition works best on a large scale, 22″ × 30″ or larger. Many of my single-flower compositions are done on a 36″ × 44″ format, which I take from a 44″-wide roll of D'Arches 140 lb. cold-press or rough paper. Such rolls can be obtained at most major art supply stores and distributors. If this is your first attempt at such a composition, try a 22″ × 30″ format.

The drawing in this case should start from the middle and expand outward. Begin by positioning the smallest petals somewhere near the center of the sheet. Draw with an HB pencil, using a light hand; as your pencil moves closer to the edge of the sheet, the petals you are drawing should increase in size and proportion.

When you complete the drawing, begin to paint by building up your color washes in small shapes that are scattered all over the surface. Don't begin by painting from the center outward; you may get bogged down in details. Vary the washes and color values from petal to petal. Try not to be repetitious, treating all the petals the same way and using the same colors and values. This type of composition does not call for much of a background. In fact, in some instances I have left the white of the paper as the background, instead of a colored or gray wash. I've shown both types of background here so you can consider which is best for your particular situation.

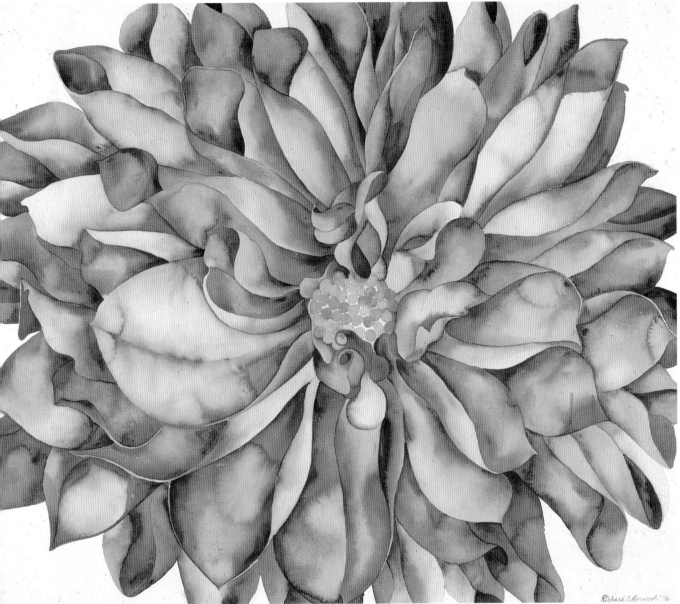

THE FIRST DAHLIA
36" × 44" (91.4 × 111.8 cm), 1978.
Collection of Redlands Community
Hospital, Redlands, California.

This painting is historically important because it portrays the first
flower that bloomed in my first flower garden, during the
summer of 1978. I remember that it was difficult for me to cut it,
but I was told that it was important to take this step if I wanted
my dahlia plants to grow out instead of up, even though I was
eliminating the first bloom of summer. I remember bringing the
single dahlia bloom indoors and placing it in a vase and being
very anxious to begin painting it. I chose to work on a large
scale, so I cut a 36" × 44" section from a roll of D'Arches cold-
press watercolor paper and placed it flat on a dining table. I
began the composition with a preliminary pencil drawing,
standing up at times to establish the correct proportions, filling
the entire area and extending the petals to the edges. I worked
with size 12 and 24 brushes, and my palette consisted primarily
of alizarin crimson, rose madder, cobalt violet, and cadmium
yellow. The background was left unpainted.

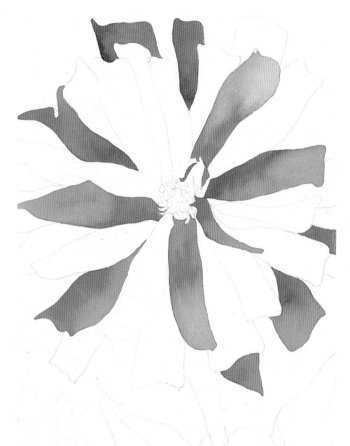
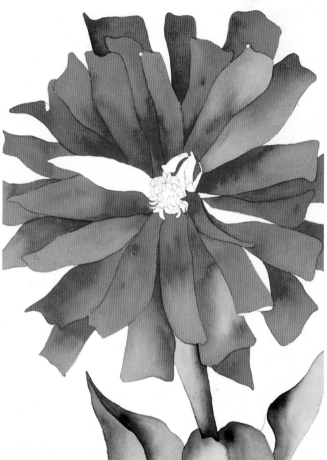

I chose a zinnia as my subject. I began by holding the zinnia in my hand and drew the individual petals, beginning with the center of the flower. I began painting with several reds such as alizarin crimson, cadmium red light, and rose madder, working all over the paper with a size 6 brush.

I continued to paint most of the flower, including the stem and leaves near the lower part of the watercolor sheet, but I left the center and background for last. Notice that the petals on the zinnia reach to all the edges in the composition. The colors and values vary along with the washes within each petal.

ZINNIA, *11″ × 15″ (27.9 × 38.1 cm), 1987. Private collection.*

In the last stage of this exercise, I painted the remainder of the petals, as well as the center of the flower and the background. I chose ultramarine blue for the background color and used a size 12 brush to create the value variations in the wash. Notice that the lower portion of the background is darker in value than the upper part. I did this on purpose to create a sense of a blue sky and a natural setting for the single-flower composition.

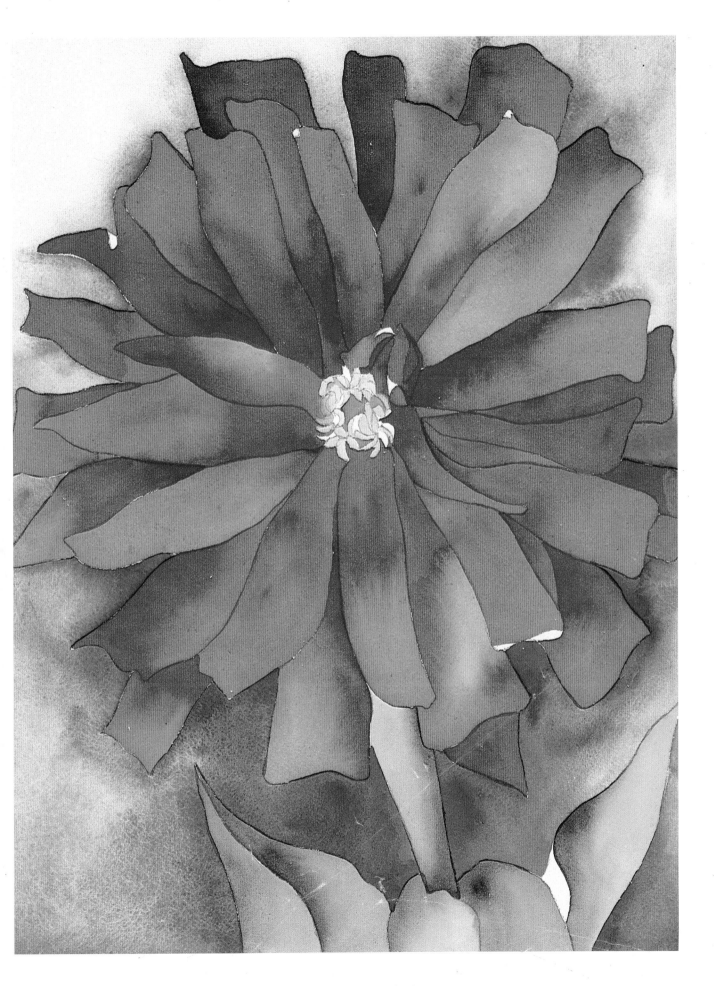

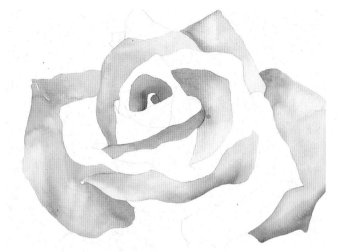

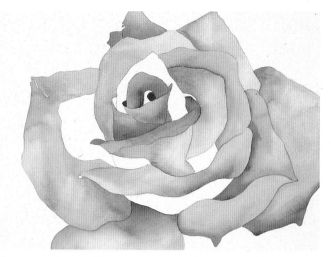

I chose a golden yellow rose for my next subject; as I worked, I held it close to me so I could study its structure. I drew the smallest petals first; as I moved away from the center, I increased their sizes. I then began to paint the individual petals, using size 3, 5, and 10 brushes, varying the color and value of each one and allowing each to dry before painting the adjacent petals.

No two petals are alike, just as no two flowers are alike, although they may appear that way at first glance. Notice that cadmium orange describes either the outer edge or the inner portion of each petal. I also mixed cadmium yellow and Naples yellow directly on the watercolor sheet to achieve the luminosity that exists throughout the flower.

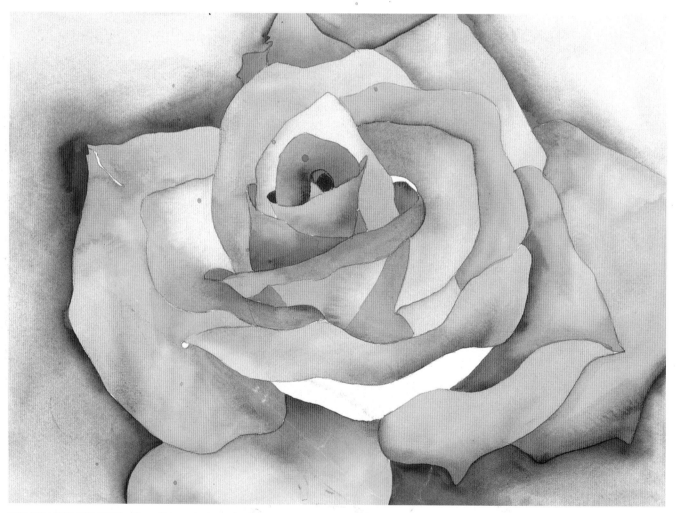

GOLDEN YELLOW ROSE, *11" × 15" (27.9 × 38.1 cm), 1987. Private collection.*
I chose to leave one petal and the edge of another unpainted for accent and highlight purposes. The intense cobalt blue that I used for an overall background color establishes a frame of reference for the single flower. Notice how the deepest value of blue describes the overall shape of the rose.

1 The subject of this single-flower composition is another rose; this time, the overall shape required me to use a vertical format and to draw from the center out toward the edges, especially along the left and right sides. When I was satisfied with my preliminary pencil line drawing, I began to paint the individual petals. Notice how I fragmented the flower by painting small shapes all over the watercolor sheet rather than working outward from the center.

2 Notice how I varied the watercolor washes from petal to petal to avoid the repetition that would result if I treated all the petals the same way with the same colors and values. Observe the suggestion of a stem and leaves at the lower right; this gives the single flower and the overall composition a sense of continuing or even growing from below the surface of the painting.

3 This painting is finished. I chose to leave the background unpainted because of the size as well as the intensity of this flower. Note the tiny accent of white paper near the center of the composition.

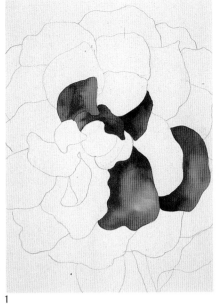

1

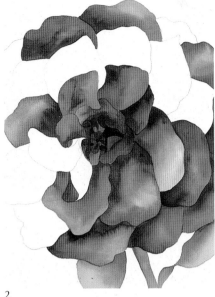

2

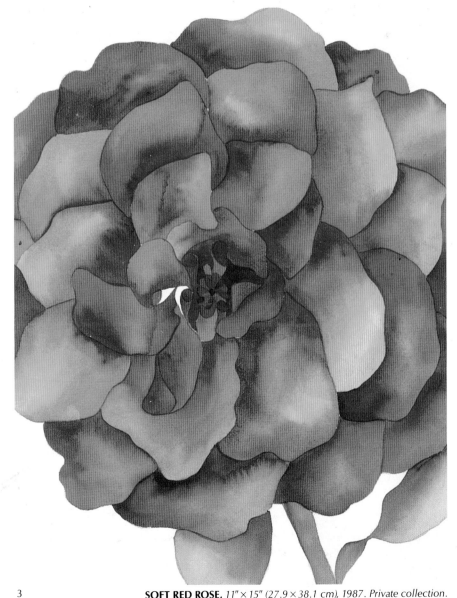

3

SOFT RED ROSE, *11" × 15" (27.9 × 38.1 cm), 1987. Private collection.*

A Bouquet

The bouquet close-up makes an interesting composition, for it can hug all the edges of your watercolor sheet and look quite abstract.

Choose several kinds of flowers, place them in a container, and arrange them in a cluster so the petals and colors mesh and inter-twine. Move as close to them as possible without distorting their proportions and shapes.

Use a rather large vertical or horizontal format for this painting. I work on a 22" × 30" or larger scale when I do this type of composition.

Create a free-flowing pencil drawing that reaches all the edges of your watercolor sheet.

Begin to paint by isolating each petal with value and color; keep the edges crisp and the inner areas loose and flowing. This particular approach to painting flowers becomes more abstract than the other two methods in this exercise. There is no background to consider, but I've left unpainted areas of white paper to represent highlights or accents in some of my watercolor compositions.

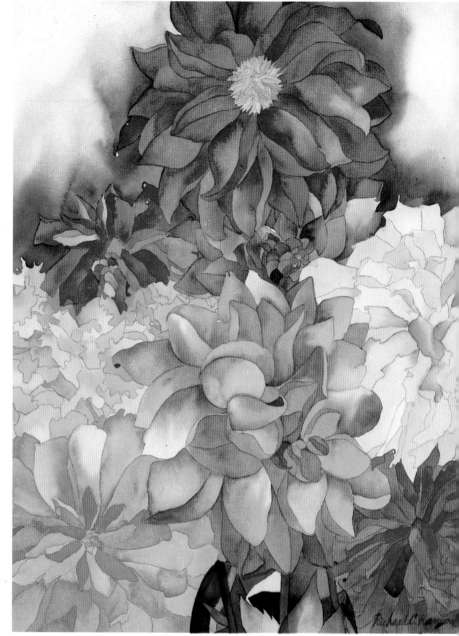

BOUQUET NO. 2 *22" × 30" (55.9 × 76.2 cm), 1980. Private collection.*

This watercolor painting is one in a series I've done depicting bouquets of flowers. Unlike the example on page 48, I arranged the flowers (dahlias, zinnias, and mari-golds) as a close-up study and allowed the image to run off all the edges; note the two petals of the red dahlia at the top. As you can see, I incorporated a wide range of colors and values to make this bouquet convincing. The background color was left for the last step; there, I chose cerulean blue to suggest the color of the sky. Note how the deeper values in the background wash trace the overall outline shapes of the flowers.

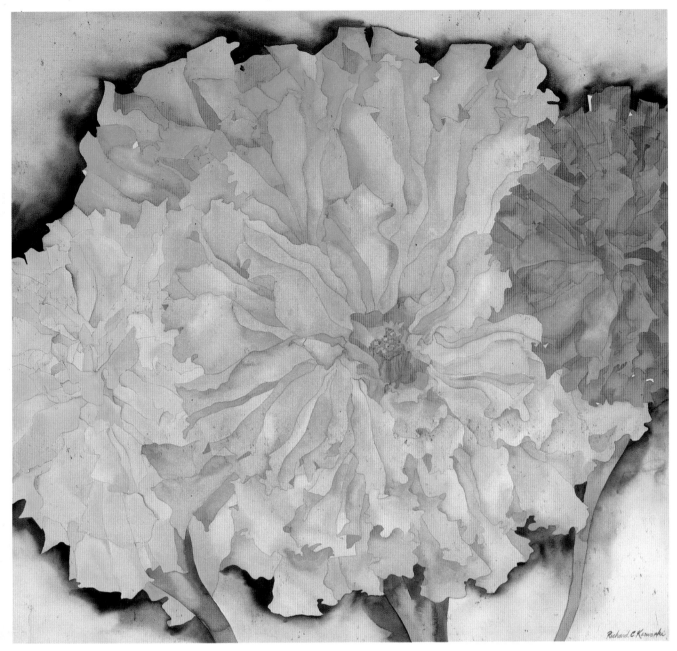

THREE MARIGOLDS *44" × 48" (111.8 × 121.9 cm), 1980. Collection of Mr. and Mrs. Markowski, Little Neck, New York.*

This painting of three different-colored marigolds was done late in the summer of 1980, just before the first frost. This was the first time I had attempted an all-marigold composition on such a large scale. I held each flower individually as I did the preliminary pencil line drawing, but I overlapped the petals to create a sense of the intertwining of shapes in the composition. I used a variety of colors on my palette, including several yellows, oranges, reds, and greens, to achieve the best results. Although I worked flat on a long dining table, I turned the large watercolor sheet a number of times in order to reach all of the areas in the composition. I used a size 24 brush, to apply the background wash of Payne's gray, plus smaller size 6 and 12 brushes to define the outer edges of the petals. I might also add that I stood and walked around the painting surface in order to work quickly as I painted the background. At times, I had to wet the paper before painting an area to prevent the background washes from drying too quickly.

A Composition with Several Flowers

This composition calls for several long-stemmed flowers in a vase against a background. In this situation, the background could be a color or an area of a room, such as a wall or window. Remember that in this composition the flowers are the primary subject matter; the background is incidental.

The painting can vary in size from 11″ × 15″ to 22″ × 30″ or even larger. Assuming you work 22″ × 30″, a vertical format would be more appropriate, considering the subject matter.

Begin with a simple line drawing; as it progresses, add the details of the flowers such as the stems, petals, and leaves. Background information may be included at this stage, but it should be suggested instead of emphasized. Remember to leave the viewer with a strong impression of your primary subject matter, not the background.

Begin painting by applying the background washes that silhouette the flowers. Paint the flowers, leaves, and other elements after the areas around the flowers have dried. Save the details of the painting until you have applied all the primary areas (foreground and background) of your composition.

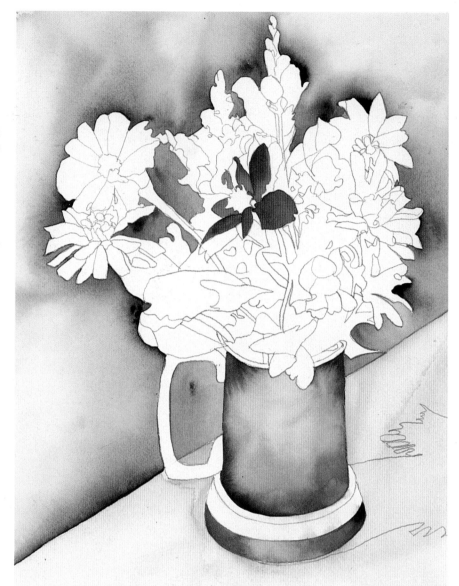

I decided to use a vertical format for this bouquet composition in order to fit the overall shape of the flowers in the container. I purposely left more space than usual around the subject matter to give the viewer a sense of proportion and scale. Notice that I've completed the preliminary pencil line drawing and have already begun to paint the background. I decided to subdivide the background with a diagonal line first, to separate the ground (table) from the wall behind it; I used two different-colored washes for these areas. I added a gray wash to the metallic container and began to paint one of the flowers in the bouquet with alizarin crimson.

SMALL BOUQUET
*11″ × 15″ (27.9 × 38.1 cm),
1987. Private collection.*

I completed the bouquet composition by painting the variety of flowers with an assortment of colors from the palette, including cadmium yellow, cadmium red, carmine, violet, and several greens for the leaves and stems. I left several unpainted areas of white paper to represent highlights on the flowers, leaves, and container. The last step was to indicate a light source by drawing the overall shape of a shadow in pencil over the yellow ochre background, then painting it in.

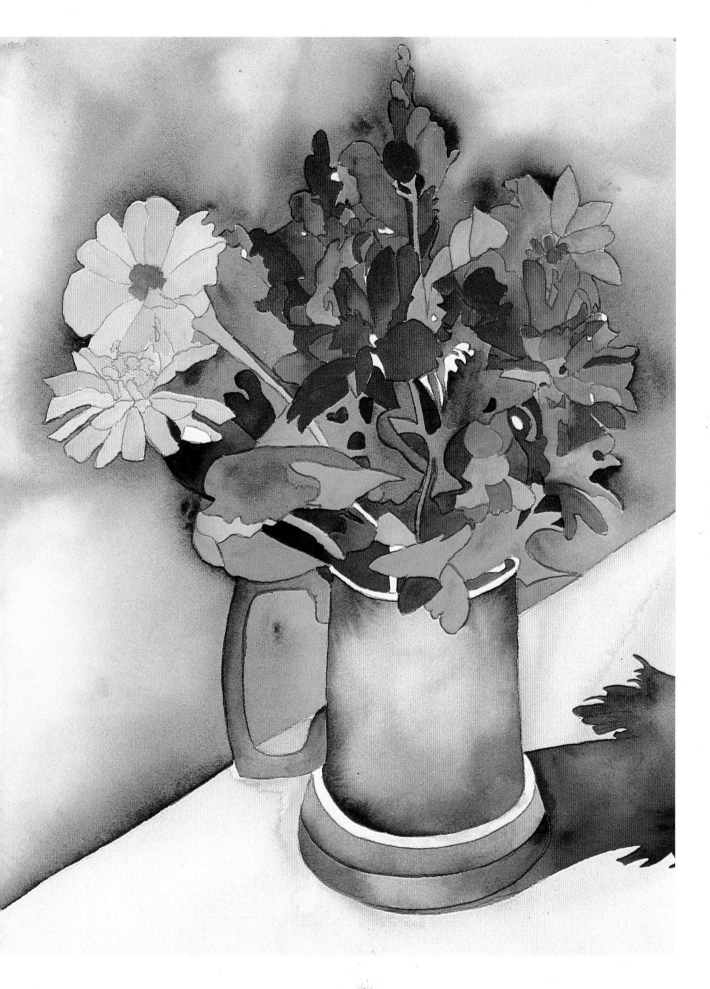

1 The subject matter consists of three roses, all in various stages of bloom. I arranged the flowers in a pleasing way on the watercolor sheet by doing a simple pencil line drawing of the petals, stems, and leaves. Because the roses were light in value and low in intensity, I worked primarily with Naples yellow and permanent rose red to achieve the desired color combination. At this first stage, I alternated the washes on the individual petals and worked all over the watercolor sheet.

2 I continued to paint the rest of each flower but left several unpainted areas near the centers to accent and highlight each bloom. I painted the leaves and stems of the roses, using a combination of greens such as viridian, sap green, and permanent green deep. I also paused at this stage and asked myself whether this composition called for a background color.

3 Well, the answer to that question was yes, and I proceeded to paint the background with a very light Payne's gray wash, again making the lower portion of the composition darker in value than the rest. I also defined the outer edges of some of the petals with the same gray.

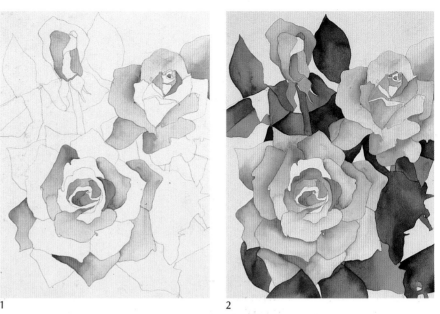

1

2

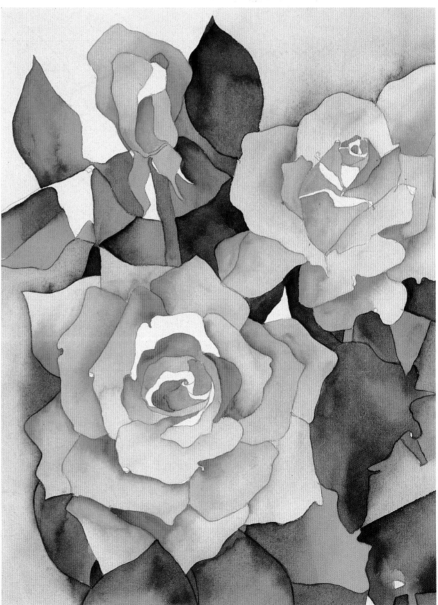

3

THREE ROSES, *11" × 15" (27.9 × 38.1 cm), 1987. Private collection.*

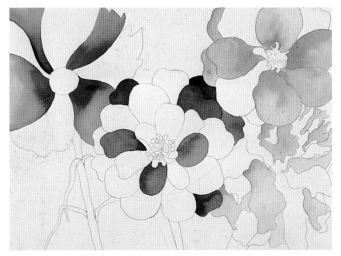

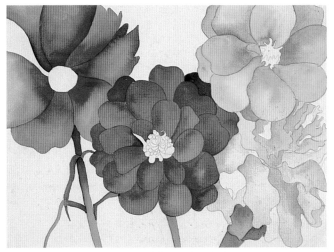

Here, I worked in a horizontal format to make the flowers appear to be growing in a row from below the bottom edge of the paper. I overlapped the flowers to give a sense of the meshing and interlocking of the petals and made sure that they all touched the edges of the paper.

I continued to paint all of the flowers in the composition with a variety of colors including cadmium yellow light, magenta, carmine, permanent orange, and permanent green light. I chose to leave the centers of the flowers unpainted until I applied the gray wash to the background.

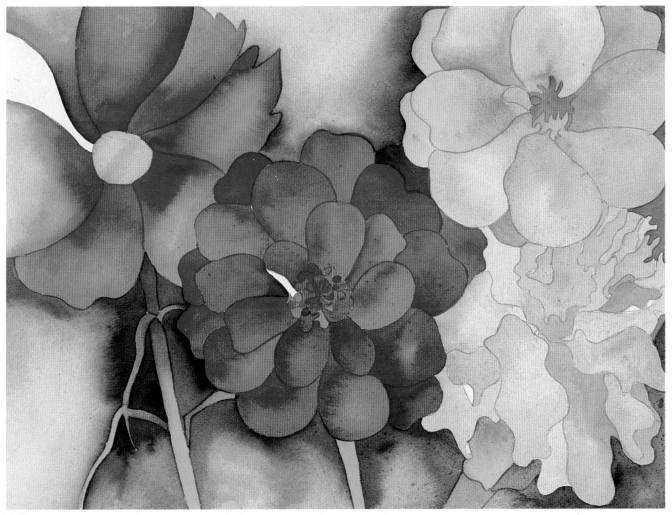

MIXED FLOWERS, *11″ × 15″ (27.9 × 38.1 cm), 1987. Private collection.*
I completed this painting by adding an overall wash of Payne's gray to the background, with the deeper values surrounding the edges of the flowers. Notice that I left one petal of the cosmos flower unpainted. I wanted to lead the eye off the watercolor sheet so sharply that the viewer might even be startled at first glance. Several smaller white areas were also left unpainted for accent and highlight purposes.

CHANGING YOUR POINT OF VIEW

An outdoor fruit and vegetable stand can be an excellent subject for a painting, as it combines elements of still life and landscape. In this exercise, you will do two paintings, one a close-up that emphasizes the still-life aspects of the fruit, and one a panoramic view that treats the market as part of a landscape. In both cases, you may do your initial drawing from life or from a photograph.

The Close-up Composition
If you choose to draw directly from the subject matter, get close to it for the first composition, so that the fruit fills the page and touches the edges of the paper. After completing the drawing, go back to the studio to paint. However, you should refer to an actual fruit or vegetable for shape, texture, and color.

If it's difficult or inconvenient to draw a market on location, simply photograph it and do the drawing in the studio. You may use either print or slide color film; take close-ups in which the frame is filled with fruit. The photographs will be a good reference for the line drawing, but study the real fruit or vegetable for specific detail. Begin to paint in the manner that has been described previously, working all over the watercolor sheet, paying attention to color freshness and intensity, using strongly contrasting values. Constantly refer to your live subject matter as you paint. It's also a good idea to pause occasionally,

tack the painting up on a white wall or easel, and view it from a distance. If you skip this particular step, you risk losing sight of the overall composition and the objective of your subject matter.

A Panoramic Composition
Once again do a preliminary pencil line drawing of the fruit stand. If you choose to draw directly from the subject matter, work at a far distance. This means that you will be drawing not only the market but also the immediate environment—buildings, sky, street. Your composition should have a distinct foreground, middle ground, and background.

If you prefer, do your drawing from a color photograph, allowing it to help you to simplify and edit what you are drawing. Avoid shading, but feel free to individualize the composition. In other words, what you are trying to do is not a photographic likeness of your subject but an interpretation. If convenient, go back to the original site to focus on any detail left out by the camera.

All the watercolor principles already discussed may be applied again here, but allow your reference material (slides and photographs) to guide you when determining color and value. Paint in a fragmented way, applying color washes all over the watercolor sheet. I usually begin with the most intense color areas, then gradually apply the darker, more subdued values.

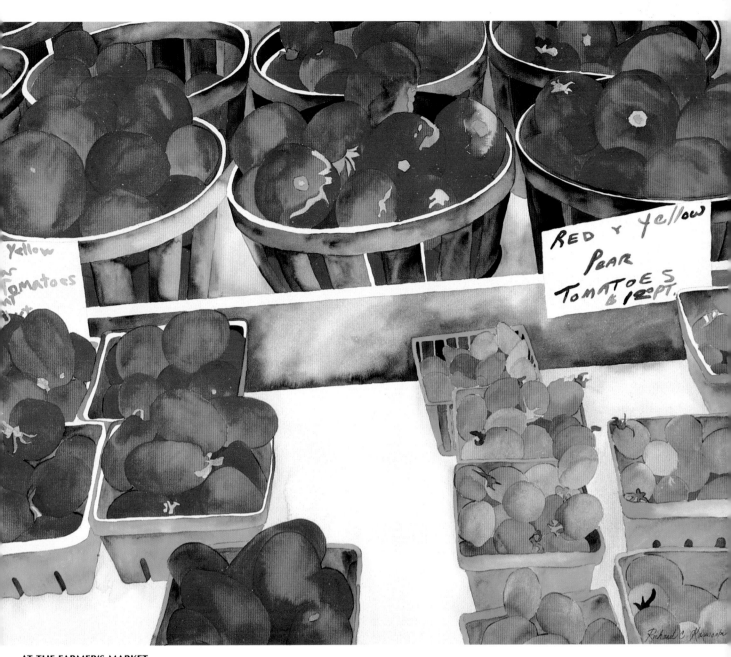

Within the image, the following handwritten text appears on signs:

Yellow Tomatoes

RED & Yellow PEAR TOMATOES lb 12⁰⁰ PT.

AT THE FARMER'S MARKET
36" × 44" (91.4 × 111.8 cm),
1981. Private collection.

This painting was inspired by an outdoor farmer's market in the
vicinity of East Hampton. What excited me here was the variety
of different sizes, shapes, and colors of the tomatoes, as well as
the bushels and baskets that contained them. I might add that
this is an example of how it is possible to use a 35mm slide as a
reference to set up an imaginative composition without creating
a photographic likeness.

For this composition, I used a 35mm slide as a reference to establish the overall structure, including the boxes, signs, and of course the tomatoes.

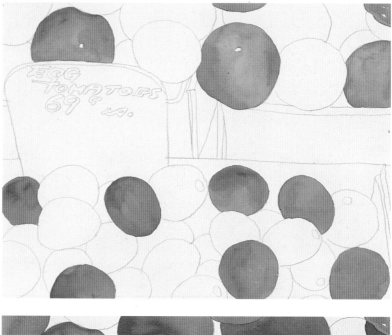

In the first stage, I did a preliminary pencil line drawing to all the edges of the watercolor sheet. But before I began to paint, I referred to several actual tomatoes to determine the right shapes and colors, as well as any details that I might have missed in the slide. I used cadmium red deep, cadmium orange, and alizarin crimson, mixing them directly on the watercolor sheet to create intense colors and capture the likeness of the tomatoes.

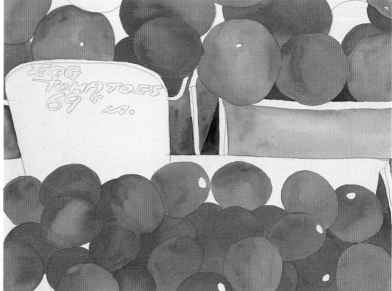

I continued to paint the tomatoes without making any two alike in appearance and color, although I continued to use the same colors. Notice how the values, as well as the colors, vary from tomato to tomato. I've also begun to paint the cardboard and wooden boxes with several shades of brown, including burnt umber and raw umber.

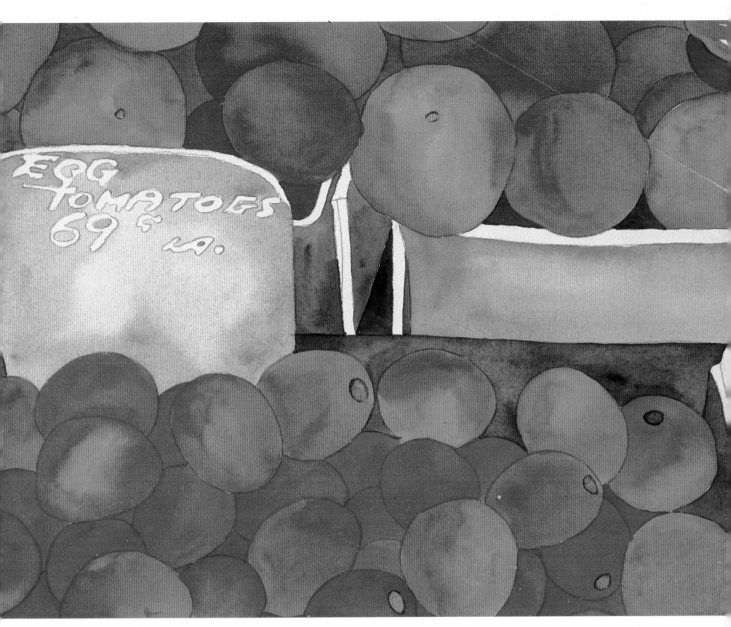

TOMATOES AT THE MARKET,
11" × 15" (27.9 × 38.1 cm), 1987.
Private collection.

I completed the remainder of the tomatoes, as well as the
boxes and sign, but left the white of the paper for the letters
and words advertising the tomatoes. The last step was to paint
the stems with permanent green light and a size 3 brush.

I used a 35mm slide for my subject reference but edited the composition by using only the left side of the image and increasing the size and scale of the fruit. I also decided to eliminate the sign in front of the oranges and reverse the order of the green and red apples. Remember that a reference photograph may be altered depending on the situation called for in the painting.

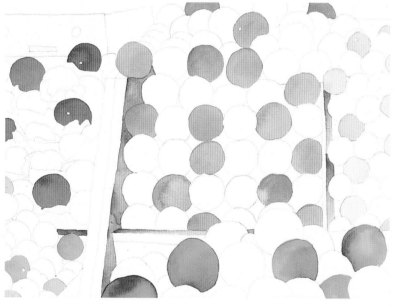

After I completed the preliminary pencil drawing, I began to paint in a fragmented way all over the watercolor sheet, using a variety of colors to depict the fruit in the boxes.

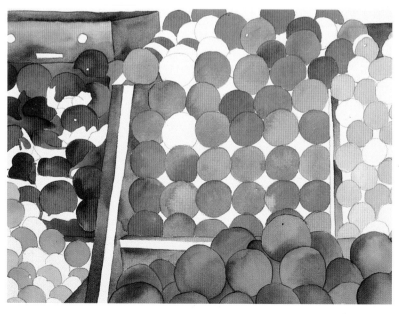

I continued to paint the fruit as well as the wooden boxes that contained it, referring to the 35mm slide and several samples of actual fruit to determine the correct colors as well as any details that could not be seen on the slide.

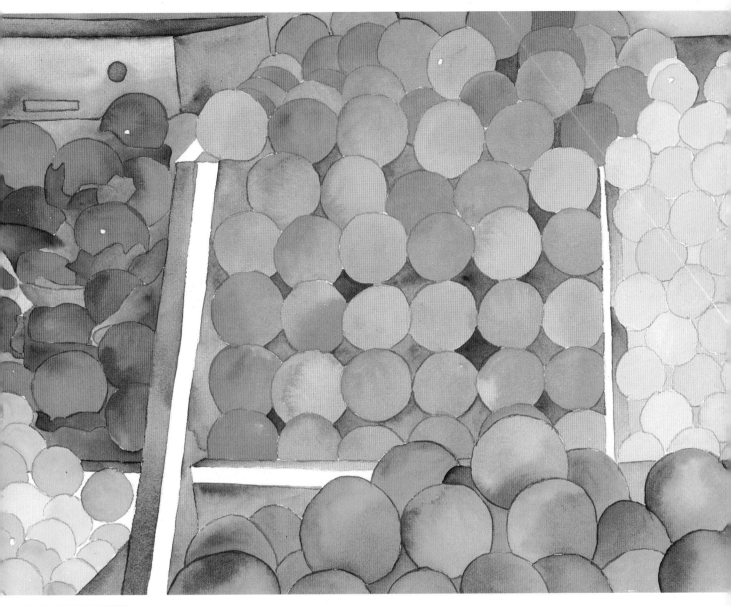

FRUIT AT THE MARKET,
11″ × 15″ (27.9 × 38.1 cm), 1987.
Private collection.

I finished painting all the fruit and the spaces behind it, including the violet tissue paper surrounding the red apples. I also suggested the space above the edge of the market with cerulean blue, to give the impression of open air and the sky beyond.

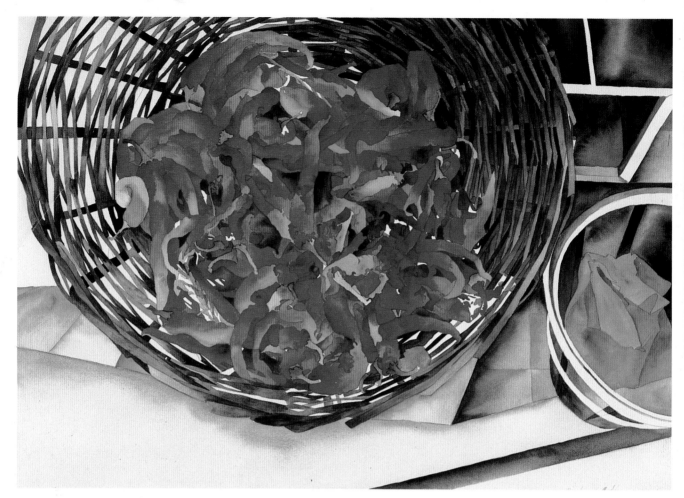

PEPPERS NO. 1
22" × 30" (55.9 × 76.2 cm), 1983.
Collection of Mr. George Huntington,
East Hampton, New York.

This painting of peppers in a basket was one in a series of six I
have done to date that were inspired by chili peppers sold at the
farmer's market near my East Hampton home. I worked directly
from a slide; notice the bird's-eye-view angle I used to heighten
the drama of the composition. I also used the various angles to
break up the space. This is a good example of a watercolor
painting in which I contained the most intense colors in the
center of the composition. I referred to several actual peppers to
capture the likeness needed to make this kind of subject matter
convincing. I used a large assortment of warm colors to describe
the peppers, but I left unpainted white areas to highlight and
define the shapes and suggest the density of a large amount of
peppers at the bottom of a basket. The unpainted white areas
play an integral part in making this a successful composition.

AT THE FARMER'S MARKET,
36" × 44" (91.4 × 111.8 cm), 1981.
Private collection.

This is another painting inspired by an outdoor farmer's market
in the vicinity of East Hampton. What excited me here was the
variety of different sizes, shapes, and colors of the tomatoes, as
well as the bushels and baskets that contained them. I might
add that this is another example of how it is possible to use a
35mm slide as a reference to create an imaginative composi-
tion without creating a photographic likeness.

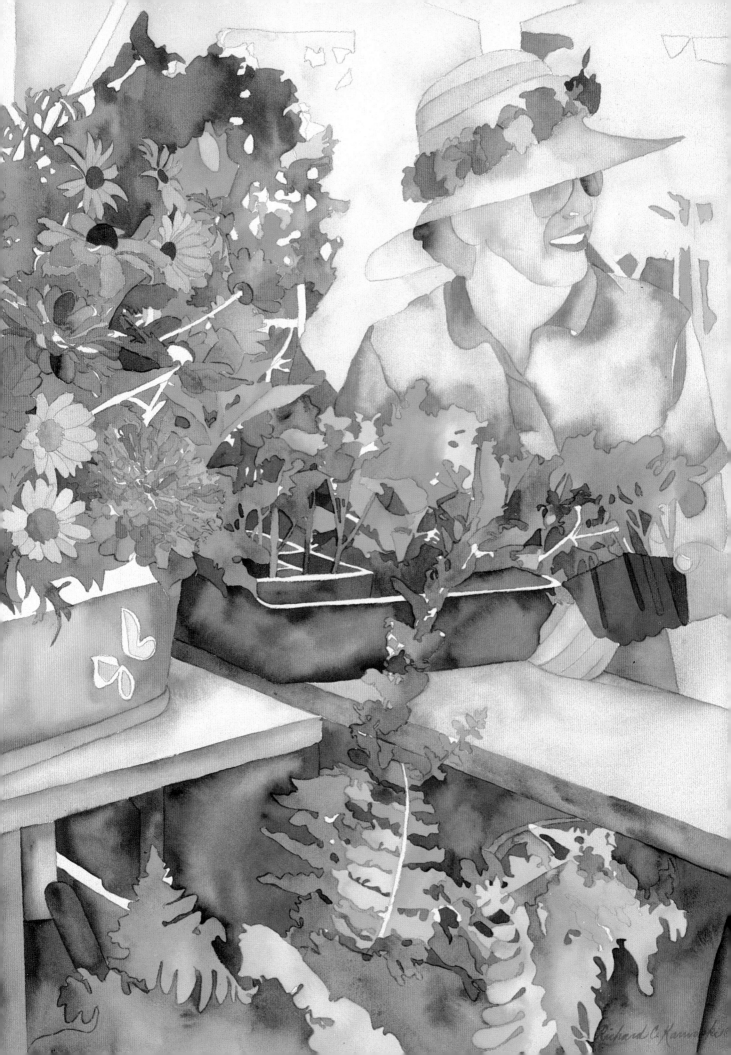

PAINTING ORGANIC FORMS

My earliest watercolors were inspired by the bay and ocean shorelines of the Atlantic. What intrigued me most were the various seashells and crab claw fragments that I would discover on the beach. I was fascinated by the various one-of-a-kind organic shapes characteristic of these natural treasures.

In this exercise, you will do your own organic watercolor composition, a close-up study of a seashell or shell fragment. If you live near a beach, you have a wide variety of potential subject matter around you; look around and select an appealing form. If the shore is not readily accessible, beg, borrow, or steal a shell, claw, or other natural form to create your composition.

Once you've chosen the shell or claw fragment, place it on a flat white surface, such as a white cloth or a sheet of drawing paper, and study its overall shape and inner structure. Isolating the form allows for less distraction by the natural or studio environment. You may also consider using a magnifying glass to enlarge the detail if what you observe with the naked eye does not offer enough of a drawing challenge. I've never resorted to this, but it is perfectly acceptable.

Begin by doing a line drawing of your subject to get a sense of its scale and its placement on the watercolor sheet. Draw the object large, so that it almost fills the paper. You may be magnifying the shell or claw fragment 25 to 100 times its normal size, depending on the size of the shell and the size of the watercolor sheet.

After you have completed the outline or overall shape and you are satisfied with the way it looks,

you must make a compositional decision. There are several possibilities: to complete the drawing by adding detail to the inner surface of the object; to add another shell fragment that is smaller or larger than what has already been drawn; to suggest a background, such as a sky, sea, or beach. These possibilities are not mutually exclusive, of course. You may choose to use one, two, or all three of these strategies.

I usually choose the third approach, but first I concentrate on drawing my primary subject matter, the shell fragments, in as much detail as possible. I then incorporate a background by merely drawing a pencil line separating sky from sea and sea from land. When that has been completed, it is time to proceed with the painting.

I begin by painting in the background with washes of color: ultramarine blue for the sky; cobalt blue, perhaps, for the sea; burnt sienna or yellow ochre for the land. I use a large brush, such as a size 12, for this stage of the painting.

After the background washes have dried, I go back with a smaller round brush, such as a size 5, to begin painting the flat areas of color and tone on the individual shell fragments. The next and last stage is to come back with an even smaller brush to accent specific details and linear aspects of these natural forms. Usually, as far as I'm concerned, the background is completed after the washes have been applied. However, there is no rule that says you cannot add more details or even change values if it's necessary to make the painting more successful.

1 I found these two shell fragments along the seashore; I chose them for this painting because they were very different in size, appearance, and color. The next step was to study the details, such as the various levels and widths of veins that run through and wrap around the fragments and give them an almost anatomical look.

I chose to hold the watercolor sheet horizontally because I was incorporating a natural setting in the background, including beach, sea, and sky. I then did an overall contour drawing of the shell fragments, overlapping one against the other to create a sense of depth and superimposition in the composition and to make it more interesting to the viewer. At this stage, I've already begun to paint in my background with watercolor washes, using a size 12 brush. I used ultramarine blue for the sky, cobalt blue for the sea, and burnt sienna and yellow ochre for the sand. I also began to paint the flat areas of color and tone on the shell fragments with a size 5 brush.

2 I switched to a larger brush for some of the wider veins on the shell fragments. I also painted over the sky with a second ultramarine blue wash to darken it and increase the contrast with the color of the sea below.

3 I completed the painting by working with an even smaller size 3 brush to accent the specific details and linear aspects of the natural forms. I might add that this demonstration shows that it is possible to paint over an existing background with watercolor, provided the first layer is light in value. The transparent qualities of this medium are very evident in this composition.

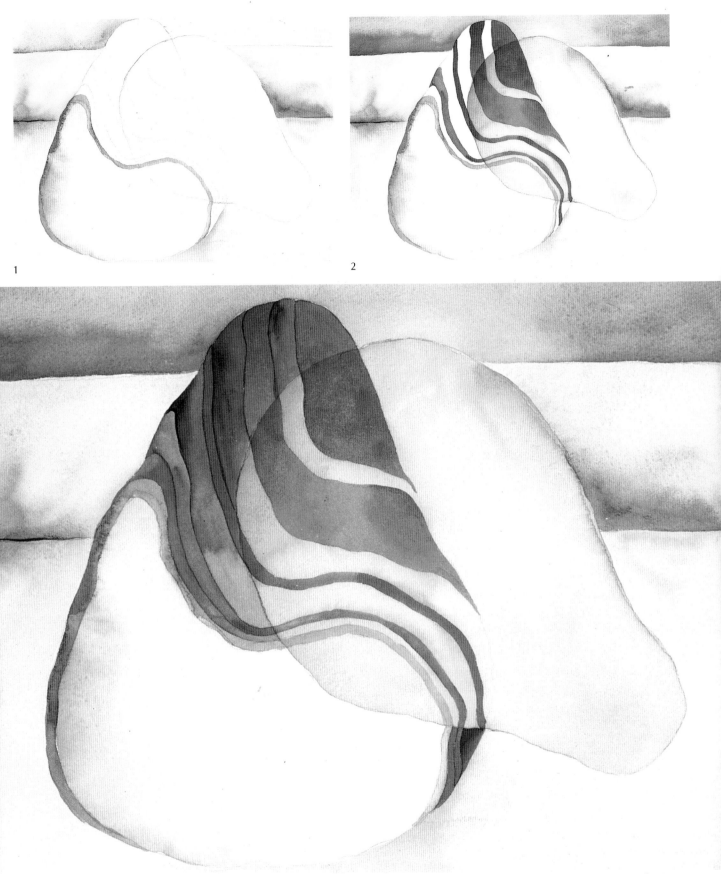

1

2

3

TWO SHELLS BLENDING, *11" × 15" (27.9 × 38.1 cm), 1987. Private collection.*

1 In this example, I have taken three different compositional approaches to the close-up study of a shell fragment and combined them.

In the first example, I isolated a single shell fragment on a vertical watercolor sheet, leaving only white space in the background. My first step was a preliminary pencil line drawing of the overall contour and the individual details. I then painted the forms, using violet, magenta, and Naples yellow for the basic colors. I used several round brushes of different sizes, including a size 3 for specific details.

2 In the second example, I combined two shell fragments by adding one that was a different size, shape, and color than the first one. I also decided to make the shell fragments opaque instead of transparent, as they were in the first series. This approach represents another use of white space for the background; the shell fragments appear to be floating on the watercolor sheet.

3 In the third example, I added a background consisting of land, sea, and sky. Notice how the entire appearance of the watercolor composition changes as a result of this last step. Note, too, the pale yellow wash representing the sky in the upper portion of the watercolor sheet.

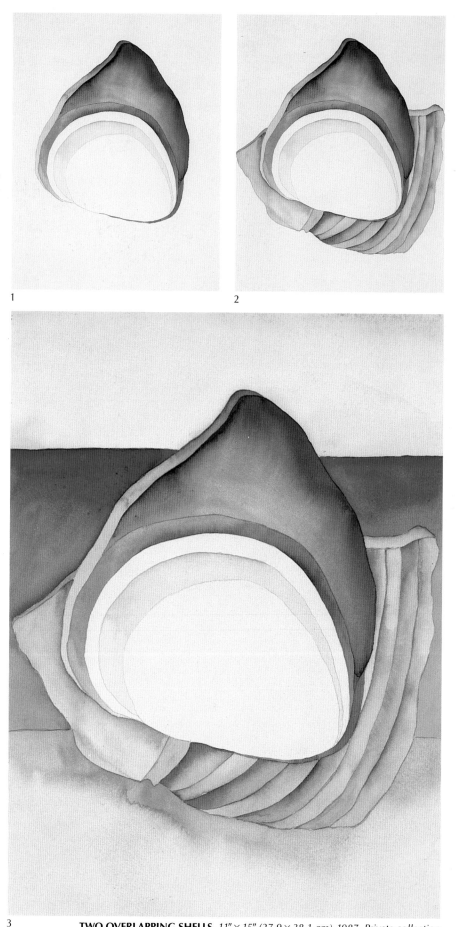

1

2

3

TWO OVERLAPPING SHELLS, *11" × 15" (27.9 × 38.1 cm), 1987. Private collection.*

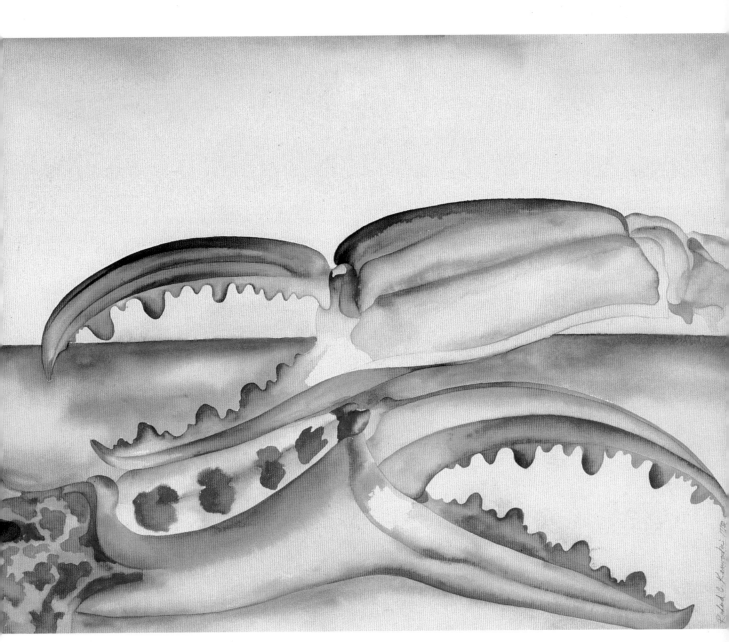

TWO CRAB CLAWS
22" × 30" (55.9 × 76.2 cm), 1970.
Private collection.

In this composition, I enlarged two crab claws that I found along
the shore while on vacation during the summer of 1970. I
arranged the claws on the watercolor sheet as if they were
having a dialogue, although they are pointed in different
directions. This is also a good example of how organic forms
may suggest human anatomy, an impression that is reinforced by
the fleshlike color. Except for the separation of sea and sky with
a defined horizon line, the background is less defined in this
painting than in the others.

SUNSETS OVER WATER: FLOWING, LIQUID COLOR

I have been painting sunset water-colors for over a decade, ever since I saw the Turner watercolors at the Tate Museum. Although I may average but one or two sunset paintings a year, they play an important role in my work. I enjoy doing them because they represent a departure from the way I usually approach a watercolor painting, and that in itself can be a challenge.

In this exercise, you will paint the sun setting over the ocean (or other large body of water). When I work with this subject matter, I generally refer to a slide or photograph, because the sunset changes constantly. I usually work on a big watercolor sheet—22″ × 30″ or larger, up to 38″ × 44″. If the paper is larger than 22″ × 30″, I tape it down to my working surface with some masking tape so it's less cumbersome to work on. The large format gives me more freedom to experiment with washes of different colors.

Wet-in-Wet Method
Begin this exercise by just indicating the large areas of the composition; don't do a preliminary line drawing this time. The only pencil line on the watercolor sheet might be the horizon line separating land, sea, and sky.

Wet the entire sky area with a size 24 brush or a sponge; then, working quickly, add the appropriate colors with a smaller brush, such as a size 12. Start at the top of the sheet with a dark ultramarine blue or Winsor blue. As you work downward, slowly lighten the values and make color transitions to violet, red, orange, yellow, or whatever hues you see. Concentrate on mixing a variety of colors directly on the paper. Keep the paper moist so the colors will blend smoothly. The paint behaves less predictably when you're mixing colors over a large area than when you are filling in a small, defined shape. When I work on a large scale, I find that I have more control over the painting surface if I paint standing up. Be careful not to overwork this area.

Stop painting when you reach the line where the sky meets the land or sea. If you have indicated a narrow land mass near the center of the paper, leave it unpainted for now; it acts as a division between sea and land and prevents the color washes created in the sky from merging with the color washes in the sea.

Wet the other large area, representing the water, and proceed to paint in the colors that would be reflected by the sky. Begin with your lightest color just below the horizon line or land mass, and gradually add more colors and values as you work downward toward the bottom of the watercolor sheet. Remember that the colors that exist in the sky will be reflected in the body of water below. Adding yellow, orange, red, violet, and blue, in that order, to the sea would be one method of establishing a proper spectrum for a sunset painting. While the body of water is still moist, use the tip of a smaller brush and some fresh blue or Payne's gray to highlight ripples or waves on the surface of the water. Be careful not to overwork this area.

When the large areas have dried, the last step is to paint in the strip of land separating sky and sea. Do not begin by moistening the paper this time; instead, paint this area with a wet-on-dry technique, using a small brush. I might use Payne's gray, sap green, or even violet for this area, depending on the subject matter and the overall effect and mood I have decided to establish in the painting.

(Right) I did no preliminary pencil drawing on the watercolor sheet except to indicate the strip of land separating the sky from the sea. I moistened the sky area with a size 24 brush, then painted it with a size 12 round brush, starting at the top of the watercolor sheet with cool colors that got warmer as I continued down to the hills on the horizon. When the sky was complete, I painted the body of water, using the same warm-and-cool combination but beginning with the warm tones and slowly adding the cool tones.

(Below) I used a size 6 brush and a combination of Payne's gray, sap green, and violet to represent the land at the horizon. Using a size 3 brush, I suggested the reeds in the foreground with a combination of sap green and Payne's gray. I painted these directly over the body of water with quick brushstrokes that began at the bottom of the watercolor sheet and tapered about midway up to where the water meets the body of land.

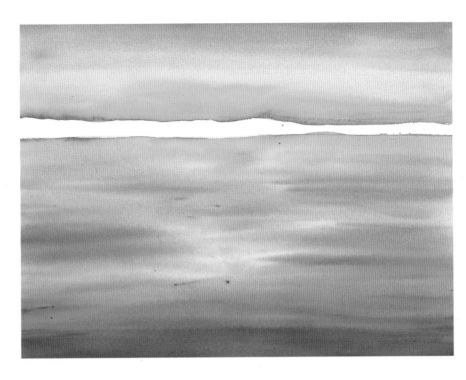

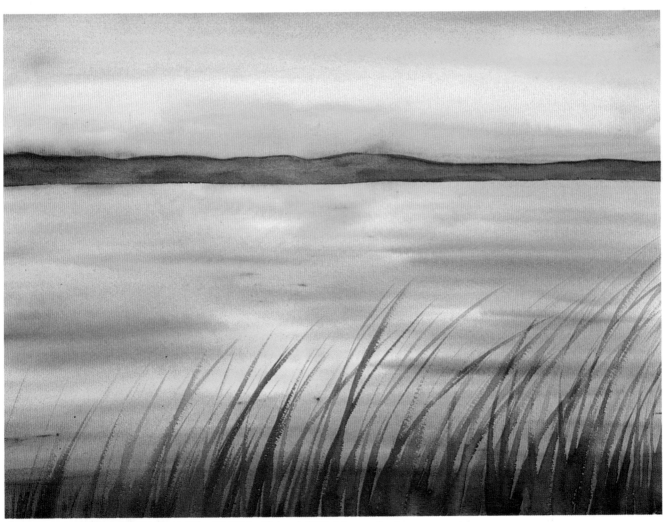

THREE MILE HARBOR SUNSET NO. 11, *11" × 15" (27.9 × 38.1 cm), 1987. Private collection.*

Wet-on-Dry Method

This second watercolor exercise is similar to the first in that the wet-on-wet technique is used to establish an overall liquid effect; the wet-on-dry technique is incorporated in the final stage of the painting to create detail and interest in the foreground. The first step is to establish a separation between sky, land, and sea with one or two pencil lines. Moisten the sky area with a brush or a sponge and, while your watercolor sheet is still wet, paint it in with as much variety of color as possible. Then paint the sea, leaving any land area for the next stage. The procedure so far is the same as the wet-on-wet technique described earlier.

After the watercolor sheet has dried, come back to it with an HB pencil and draw in any foreground subject matter that is relevant to the overall composition. In my own paintings, I might add trees, blades of grass or reeds, rocks, or even a boat or two.

Incorporating the wet-on-dry approach into a wet-on-wet painting enables you to paint over areas of color washes that were overworked or did not convey the feeling or mood you wanted. It also allows you to add specific details that you might have overlooked when you were working wet-on-wet with large brushes. Furthermore, this method permits you to return to the scene that originally inspired the painting and draw in from life any information that was distorted or overlooked by the camera.

THREE MILE HARBOR SUNSET NO. 10,
22″ × 30″ (55.9 × 76.2 cm), 1987.
Private collection.

This is the most recent in the series of sunsets employing the wet-on-dry technique. This particular painting also represents an example of a window-frame concept that I've been incorporating into my watercolor compositions over the last several years. Notice that I've left unpainted areas in the center of the painting as well as along the left and right sides of the watercolor sheet.

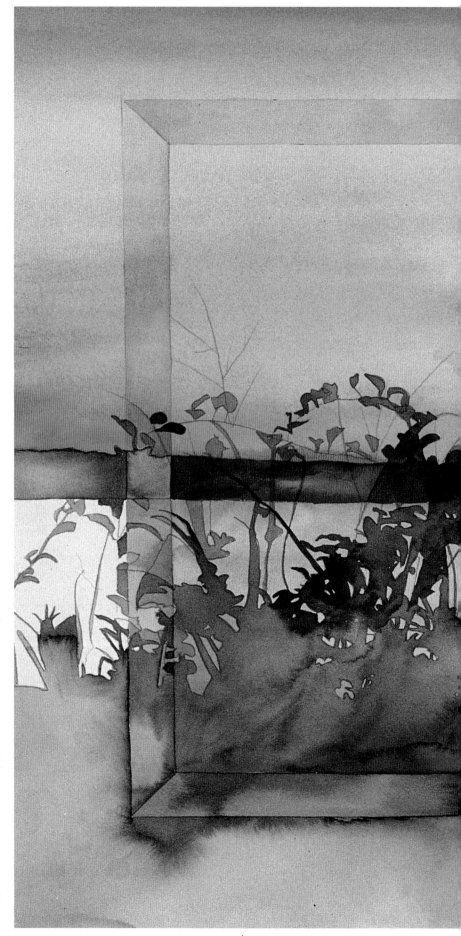

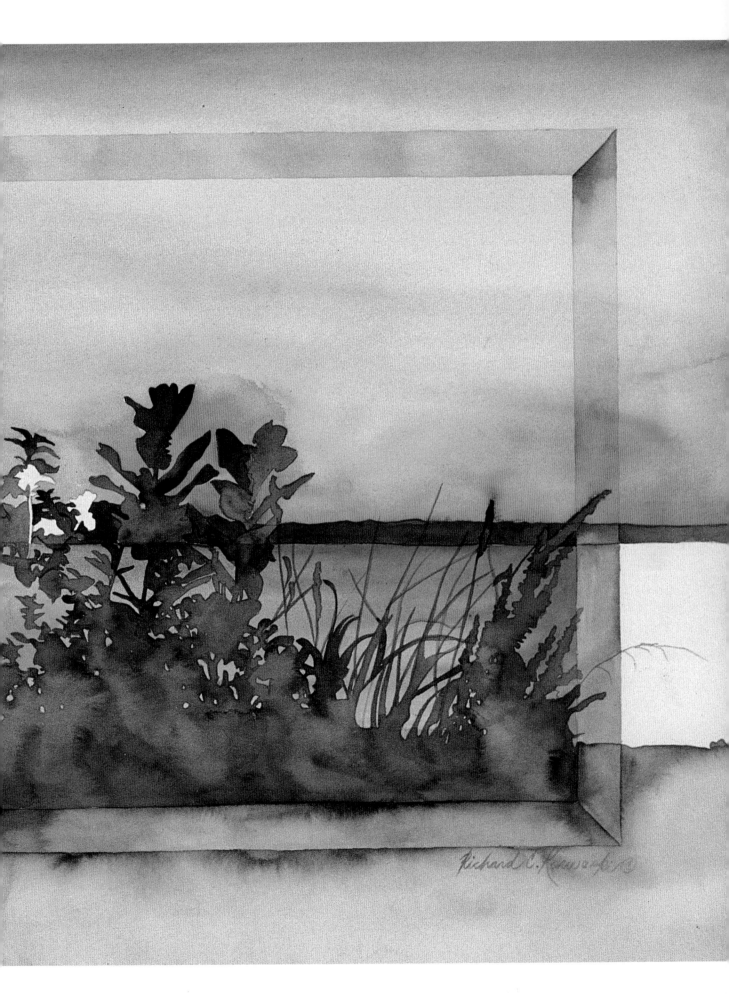

(Right) I used the wet-on-wet method for the sky and water areas, leaving the strip of land unpainted. After this first step dried, I took an HB pencil and began to outline the reeds and foliage in the foreground. Notice how the color combinations in the sky are similar in mood and feeling to the colors in the body of water, with the darkest and coolest values at the top and bottom of the composition.

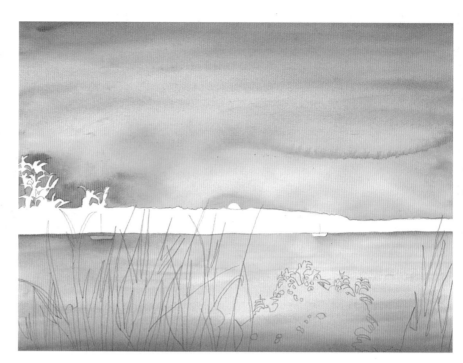

(Below) I painted in the land mass separating the bay and sky with a combination of violet and Payne's gray, using a small brush. I used the foreground grass to cover areas of washes that I felt were either not necessary or unsuccessful. I was also able to draw with pencil any detail that I might have overlooked while working wet-on-wet with a brush.

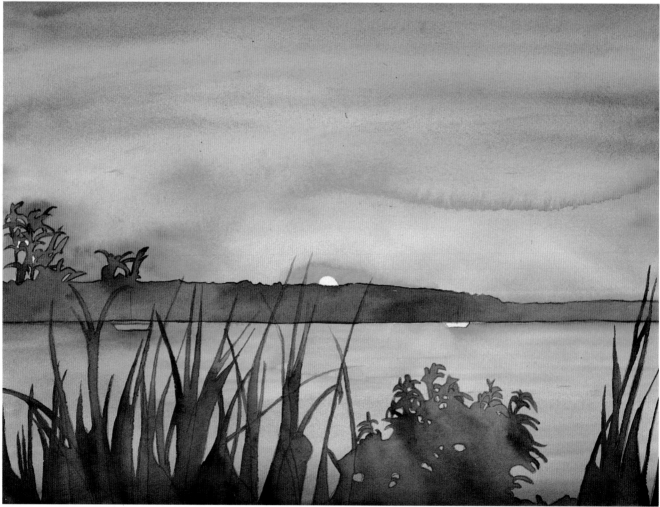

THREE MILE HARBOR SUNSET NO. 12, *11" × 15" (27.9 × 38.1 cm), 1987. Private collection.*

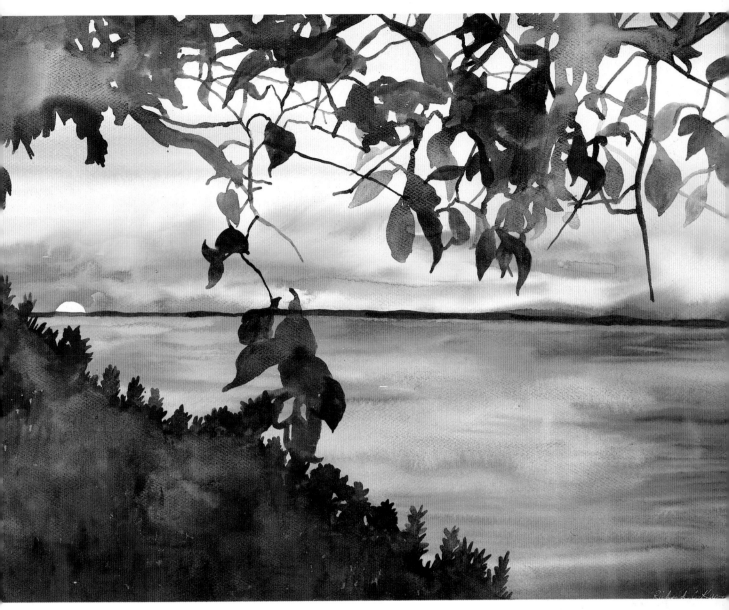

BAY SUNSET NO. 1
22" × 30" (55.9 × 76.2 cm), 1976.
Collection of Mr. Richard H. Steinman, New York.

This painting is the first in what became a series of sunsets that I've done since the summer of 1976. Once again, I used a wet-in-wet technique for the background, let it dry, then went back over it to add the details. What I did here that's different was to simplify all of the branches, leaves, and greenery in the foreground by silhouetting them directly over the existing background with Payne's gray. A round sable brush was used to draw as well as to paint; there was no pencil outline to rely on to capture the detail.

THE MARINA: CLOSE-UP AND PANORAMIC VIEWS

The subject matter for this exercise will be a harbor or a marina. You will do two paintings of the subject, approaching it from both a panoramic and a detailed point of view. The panoramic watercolor will be a broad view that might include a body of water, a pier, boats, and land and sky in the distance. In this painting, you will integrate different techniques by using wet-in-wet for the background and wet-on-dry for the foreground. In the close-up painting, which will be done entirely wet-on-dry, you will focus on a small area—the interior of a boat, for example—and concentrate on the abstract qualities that become apparent in an extreme close-up.

You may do both these paintings on location or from photographs, whichever you prefer. If you use a photograph, it should be one you took yourself.

The Panoramic Composition
Begin by doing a preliminary line drawing of the overall composition on a sheet of watercolor paper. When you're painting a body of water, whether it be a boat basin or an ocean, paint in the large masses, such as sky and water, first, and always keep in mind that they are never all the same color and value. The sky may consist of several shades of blue as well as some yellow or purple, depending

on the time of day you are trying to capture. The same holds true for any body of water. No harbor, lake, pond, river, or sea is the same color throughout, so don't attempt to paint it that way—it won't look convincing. To achieve this subtlety and variety, wet the paper first and then add pigment, mixing colors and values directly on the paper. Paint whatever colors you happen to see—purple, gray, blue, or a combination of colors.

When the background is finished, let it dry, then go back and paint in any details that are already indicated in pencil. You can also draw in, over the background washes, any subject matter or detail relevant to the composition—a boat, waves and ripples in the water, even the wood-grain texture on the pier. In essence, what you're doing is painting in the background and then adding boats and other information over it, first with pencil and eventually with watercolor paint.

The Detailed Composition
The marina composition that focuses on specific detail can make an unusually interesting painting. As you zoom in to do an extreme close-up, the subject matter becomes simpler and more abstract.

The subject matter can be anything you like, from a close-up of a

boat to a cross section of the pier; concentrate more on the lines, angles, and planes than on the object itself.

Begin by doing a line drawing on the watercolor sheet. I have found that for this type of composition, a large format makes for a more dramatic painting.

The painting may be done on location or at home in the studio, provided all the information is thoroughly drawn out in pencil. First, apply color washes to the most prominent areas. I work with my largest brushes at first. As I begin to touch all the edges and corners of the watercolor sheet, I determine which areas will require more definition with a smaller brush.

It's very important to establish a center of interest in the painting, especially if the focus is so tight that the page is filled by a single object, such as the side or top of a boat. Such a subject may have little spatial or color variety, which could result in a very static and monotonous painting. I overcome this by accenting some detail, by leaving the white of the paper showing, or by taking the liberty of adding color not natural to the subject matter. Remember, you're the boss, and you are free to distort things and take liberties with the composition as well as the colors of what you are painting.

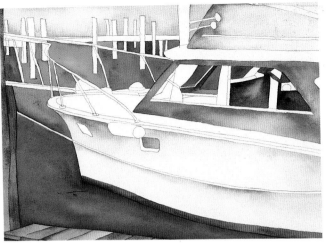

I did the preliminary line drawing of a boat basin, including my primary subject (the boat in the foreground), on location, but I did refer to a slide in order to complete the painting once I returned to my studio. I painted the water by wetting the paper, then applying a variety of blues, greens, and even purples, mixing the colors directly on the watercolor sheet.

I painted the sky with a wash of cobalt blue and cadmium yellow light to create the cool/warm glow on the horizon; I also began painting the pier. I went over portions of the boat with light blue washes, even though in reality it's pure white. Payne's gray is another good color choice if you are painting an all-white object; I used it for the interior of the boat.

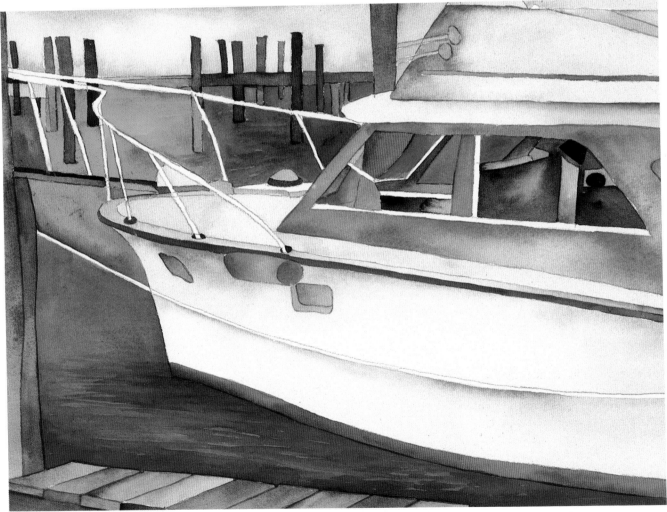

AT THE DOCK, *11" × 15" (27.9 × 38.1 cm), 1987. Private collection.*

I continued to paint the boat until it was completed and defined the pilings in the background with burnt umber applied with a small brush. With a deep ultramarine blue, I suggested the ripples and waves in the water, paying particular attention to the area where the bottom of the boat meets the surface of the water. Note the linear areas of unpainted white throughout.

Painting Tips

1. When painting a body of water, begin with the most vibrant color, such as ultramarine blue, then slowly add less vibrant colors, such as viridian or emerald green.

2. Darken a value by adding another color. Gray or black will make the washes look muddy.

3. If you are afraid to use more than one color at a time, keep colors pale and light in value at first and eventually darken them or heighten their intensity by overpainting.

4. Don't scrub the brush into the paper; allow the paint to flow as you gradually heighten the color.

5. A body of water usually appears more intense in the distance, especially on a sunny day, as well as deeper in color in the foreground. This color variation makes the water appear three-dimensional. Blue, green, and purple are good color choices for accomplishing this effect.

6. Feel free to edit and distort your subject matter. You're not trying to achieve a photographic likeness (although there is nothing wrong with that) but creating a more personal interpretation of a special scene. Don't be afraid to change what you see if it suits your artistic purposes.

7. If you begin the marina painting on location but won't be able to complete it there, bring along a camera to record the scene. You can use the photograph as a reference when you return to the painting in your studio or home.

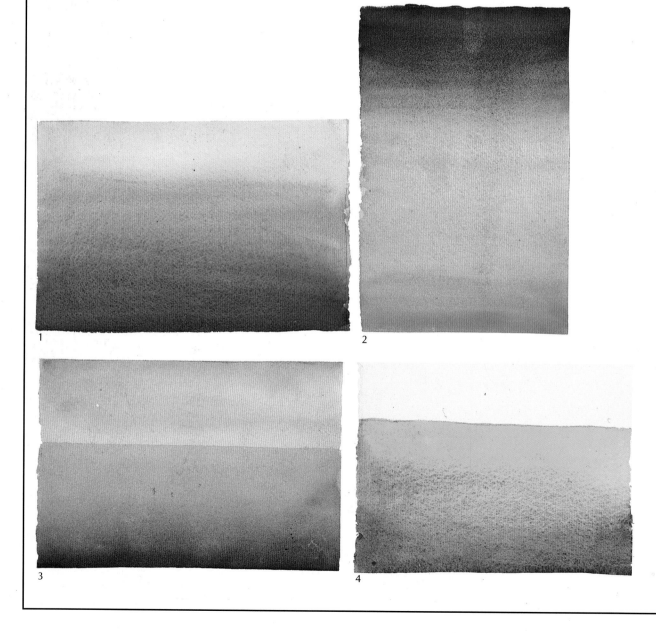

1

2

3

4

1 Working on location as well as from a slide, I was able to move into my subject matter by drawing sections and fragments of boats that were docked at the marina. As I drew, I concentrated on lines, angles, and planes rather than the actual subject matter. After I felt satisfied with what I had done in pencil, I began the painting by applying color washes to the most prominent areas, keeping in mind an area of interest somewhere near the center of the watercolor sheet.

2 I continued to paint all over the watercolor sheet with a variety of colors and values, making sure to retain several small linear areas of pure white for accent as well as spatial purposes. After all, I was dealing with an almost abstract watercolor composition, so the interest here relates more to depth, color, and shapes than to representational subject matter.

3 I completed the painting by adding raw umber to the rope gathered around the hull of the boat in the foreground. Note how the white linear elements integrate as well as fragment the overall composition. Color intensity and value contrast are exaggerated but remain secondary to the overall structural appearance in this watercolor painting.

1

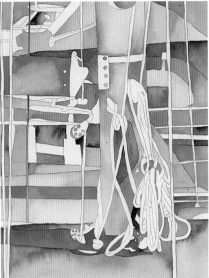

2

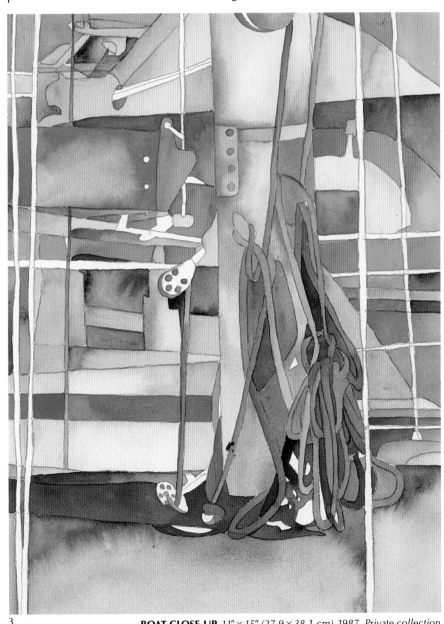

3

BOAT CLOSE-UP, *11" × 15" (27.9 × 38.1 cm), 1987. Private collection.*

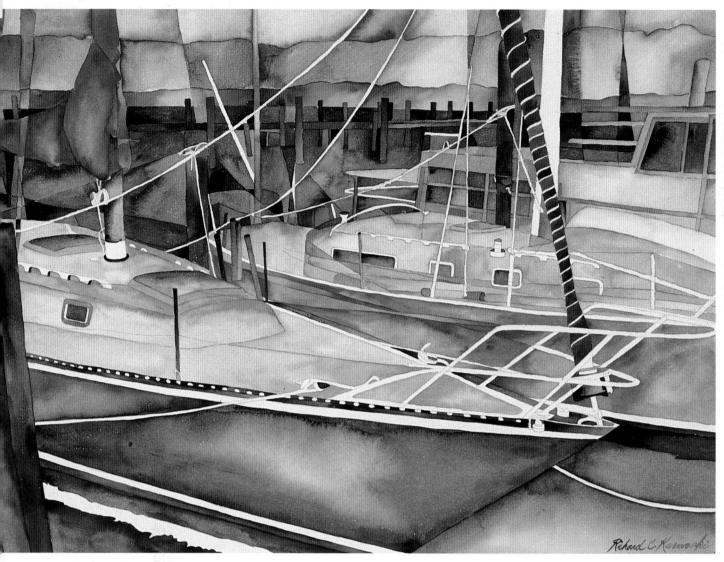

THREE MILE HARBOR BOAT BASIN
22" × 30" (55.9 × 76.2 cm),
1982. Private collection.

This panoramic view of a boat basin is one of several in a series inspired by the marinas near my East Hampton home and studio. Observe the complexity of the composition as well as the sense of deep space and perspective. There is a suggestion of a landscape in the background. The color throughout is rather subdued compared to the color in some of my other watercolor compositions.

GARDINER'S MARINA (TWO VIEWS)
22" × 30" (55.9 × 76.2 cm),
1982. Private collection.

This composition is one of the first I did in which I incorporated more than one image on the watercolor sheet. The gray border would reappear in my paintings in the years to come. Again, note the complexity of the composition within each rectangle as well as the unlimited space beyond the horizon line in the upper portion of the painting. Continuous white linear areas have been left unpainted to integrate all of the elements in the composition as well as to act as visual accents.

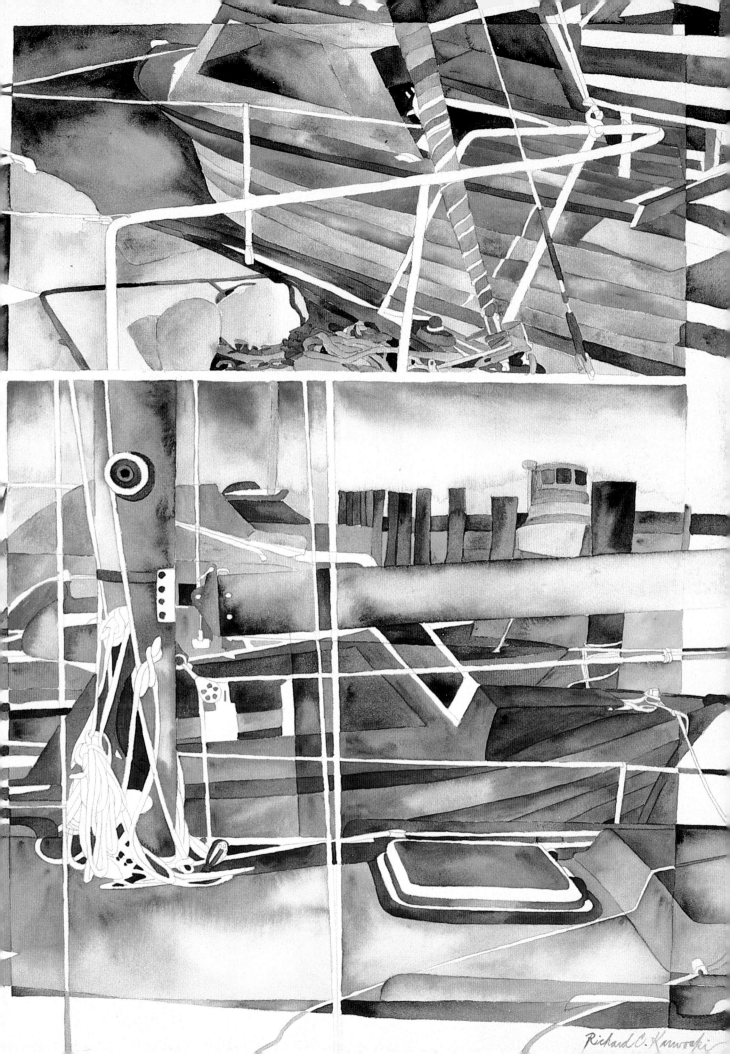

Richard C. Karwoski

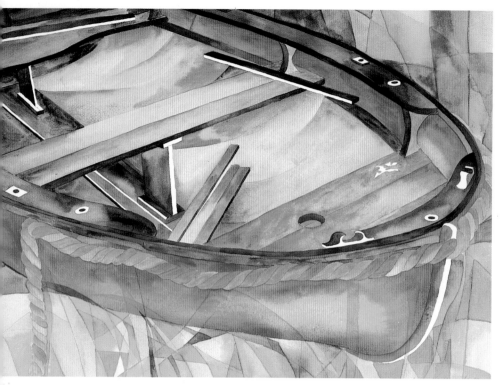

ON DRY DOCK
22" × 30" (55.9 × 76.2 cm),
1982. Private collection.

The boat in this close-up watercolor was on dry land and obviously abandoned by its owner. What fascinated me here was the overall shape of this object and the aging wooden interior against the pale green marshland in the background. Notice the cubistic approach I used to integrate all of the elements in the painting. I used a rather monochromatic color scheme that is more natural-looking than that of the previous example. Note, too, the unpainted white areas I left to accent some of the shapes in the overall composition. The boat in this example looks as if it's floating rather than resting on the grass in the background.

AT THE MARINA
22" × 30" (55.9 × 76.2 cm),
1982. Collection of Ms.
Nancy Stein, New York.

This close-up boat painting was the first in a series of marine paintings that I've done in the last several years. It was done for a group theme show called "Boats, Boats, Boats," held by my gallery in East Hampton in 1982. I had never thought of painting marinas or boats until I had to for this invitational exhibition. What struck me when I looked at this boat in the springtime was how, although it was still wrapped for the winter, it looked almost alive and ready to move at any moment. I also enjoyed drawing and painting all of the tangled lines that seem to suspend the entire boat so it appears to be floating above instead of in the water.

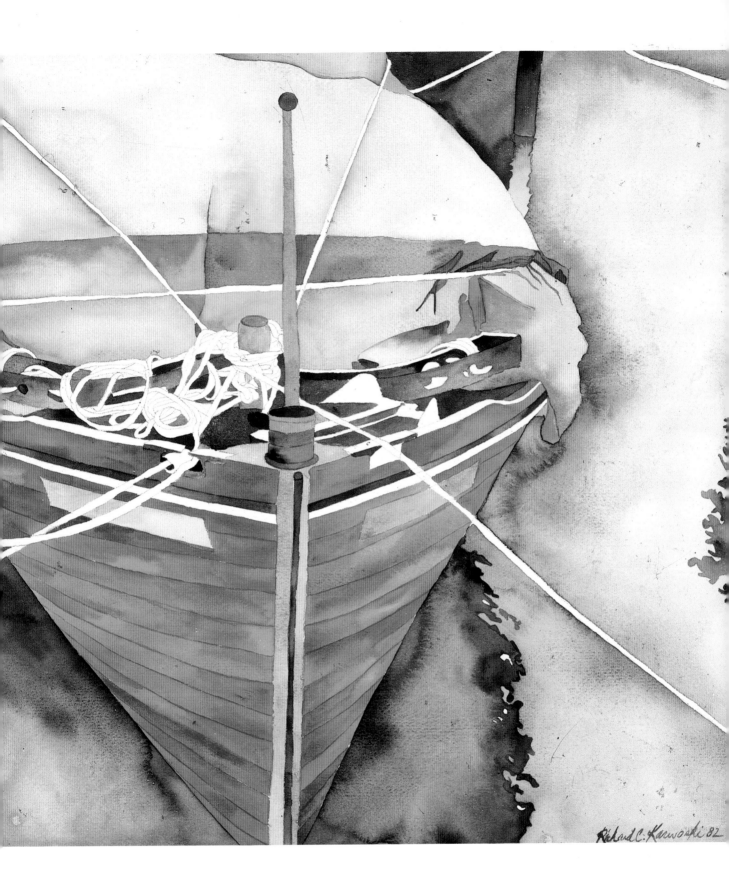

SHORELINE SUBJECTS: WET-ON-DRY TECHNIQUE

The beach offers an abundance of compositional challenges, especially if you have the opportunity to paint on location. If you don't live near a beach, you can use a lake, stream, or other body of water as your subject. When I paint a panoramic landscape, I might look in the obvious direction, toward the horizon, or I might face the other way, toward land. I might also find myself somewhere close to the waterline, looking away from the most obvious view. In this exercise, you will paint panoramic landscapes looking out over the water and back toward the land; then you will use the beach as a natural setting for a still life.

Panoramic Landscape: Looking Toward Land

This composition may incorporate the immediate beach area, including dunes, rocks, greenery, a house or two, and, of course, the sky. Begin with an overall pencil line drawing. When I work on location for this type of painting, I usually situate myself near the water's edge and look away from the body of water in the direction of the land. I might place some of the shore or beach in the foreground, a sand dune with blades of grass in the middle ground, and a house or sea shack in the background. You may want to try a similar approach. For the most part, the drawing is kept fairly simple, with little or no detail

indicated at this stage. Begin painting by blocking in large areas of subject matter, such as land and sky, with a size 10 or 12 round brush. When those areas have dried, use a smaller brush such as a size 5 or 7 to define specific details or textures on the land or over the sky. These details could be rocks or shells, blades of grass, trees, or shingles or wood grain on a building.

I might add that the second stage of this painting could also be completed in the studio provided you feel confident enough to complete the painting from memory.

Panoramic Landscape: Looking Toward The Horizon

This approach to the composition could include specific details, such as blades of grass, trees, or sand dunes, in the foreground; a body of water with boats and perhaps some people in the middle ground; and water and sky in the background.

As before, establish your composition with an overall line drawing done with an HB pencil. You may have to add extensive detail to the foreground before the actual painting is begun.

First, paint in all the primary areas, including the detail in the foreground, with a large round brush. Then use a smaller brush, such as a size 6, to define specific subject matter in the foreground, middle ground, and background.

The Beach Still Life

Along with inspiring views of the dunes, water, and sky, the beach may also provide driftwood, rocks, vegetation, and other natural subject matter for a still life. The integration of these organic objects with the natural beach setting can make an unusual and exciting watercolor composition.

The drawing of this particular composition should emphasize the overall structure and detail of the subject in the foreground. In the case of vegetation, pay particular attention to the leaves, branches, flowers (if any), and, of course, the overall shape. Position what you have chosen on the watercolor sheet so that there is some suggestion of the background and the overall environment; in a case like this, it might be a sand dune or a body of water against the sky. The center of interest, however, will always be what you have chosen to paint in the foreground.

Use the wet-on-dry technique to paint the still life, as you did for the landscapes, but take a different approach. Begin by painting in only the background, using the appropriate washes and colors, and allowing it to dry. Then paint the primary subject matter, using smaller brushes, more intense colors, and contrasting values. Start with the lightest values and colors, then slowly add areas of higher intensity and contrast.

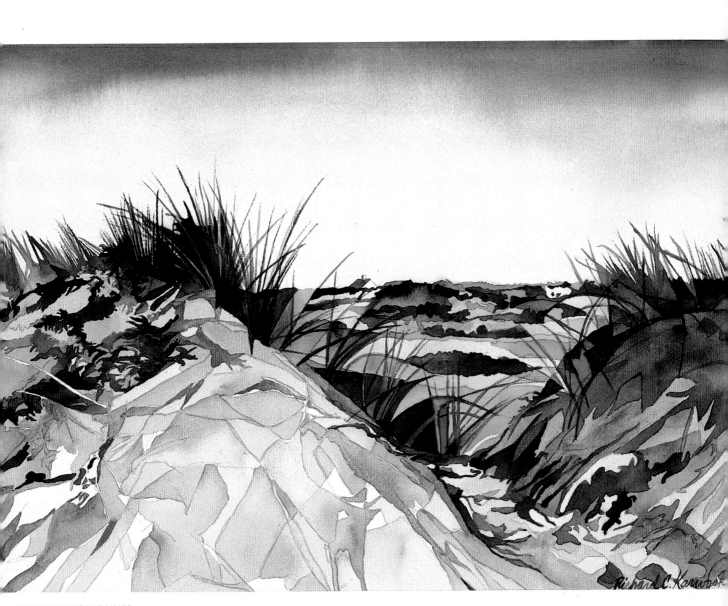

EAST HAMPTON DUNES
15" × 22" (38.1 × 55.9 cm),
1981. Collection of Mr.
Michael Costello, New York.

This composition was done in the early fall of 1981. Looking
toward the land, I was inspired by a section of beach containing
rolling dunes and beach grass, which is characteristic of the
shores along the northeast coast. Notice the value contrast
between the two massive land areas in the foreground and the
rolling-hills landscape in the distance. I scattered areas of
interest throughout the composition, except for the sky, and used
a wide range of cool and warm colors to convey a sense of
depth and deep space all the way to the horizon line.

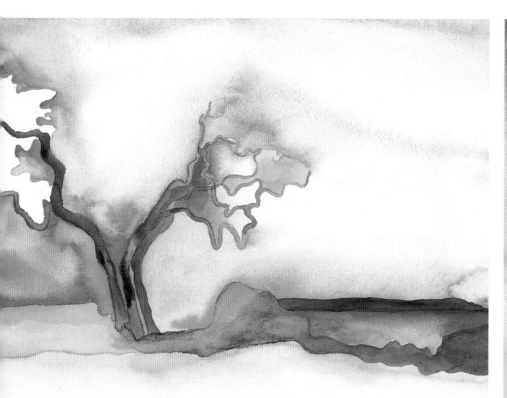

MAUI, HAWAII
9" × 12" (22.9 × 30.5 cm),
1983. Private collection.

This watercolor painting, done on location while I was traveling through the Hawaiian Islands, is an example of the possibilities that exist for capturing a beach setting while looking toward the horizon. Notice that the tree determines the center of interest, but the water along the right edge creates a sense of depth and space in the overall composition. I deliberately didn't paint the leaves on the left side of the tree, because I liked the white shape that was created by the blue sky in the background.

TOWARD NORTHWEST
36" × 44" (91.4 × 111.8 cm),
1985. Private collection.

This is another painting for which I positioned myself on the edge of a shoreline and just looked out beyond to create a watercolor composition that contains a clear foreground, middle ground, and background. In this example, I looked toward the horizon through several blades of grass to see water, land, sky, and a boat in the distance. Because of the scale, I worked with size 12 and 24 brushes for most of the background washes. All of the elements in the foreground were painted last, using smaller brushes and an assortment of greens.

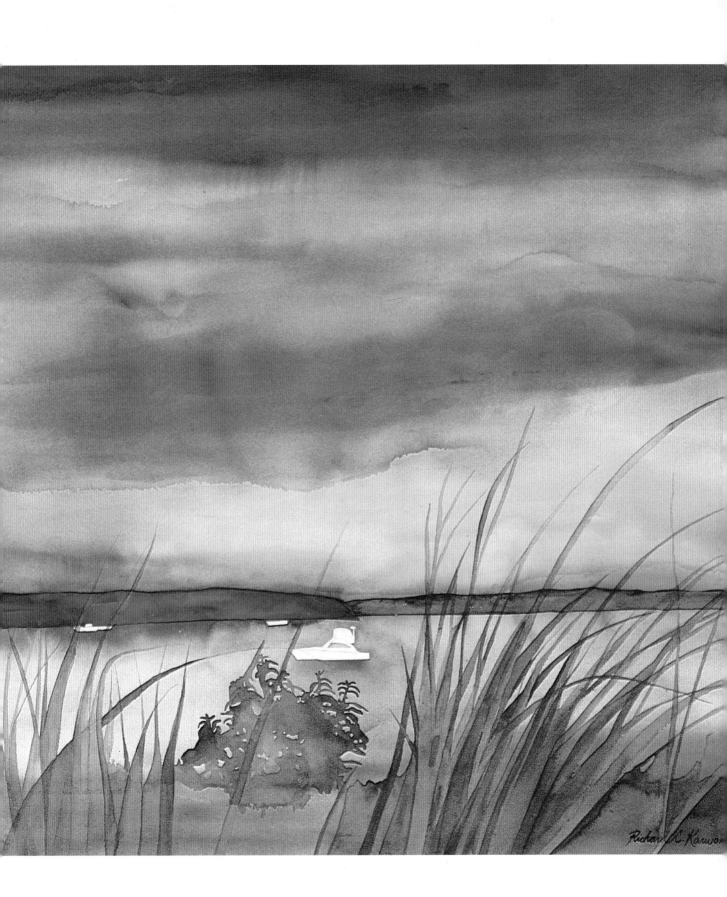

(Right) For this painting, I situated my-self on a beach, looking toward the sand dunes in the distance for my inspiration. I began by drawing my subject matter in pencil on a watercolor sheet, which I held horizontally to capture the panorama of my subject. When I was pleased with the composi-tion, I began to paint the more massive areas with several shades of green, using size 10 and 12 brushes. I used a smaller brush to indicate the row of trees along the horizon line.

(Below) I painted the sky with a com-bination of cadmium yellow light and cobalt blue to create the warm/cool intensity one feels near the shore at the beginning or end of the day. Notice the pure white area that I left unpainted to represent beach sand beyond the fore-ground greenery.

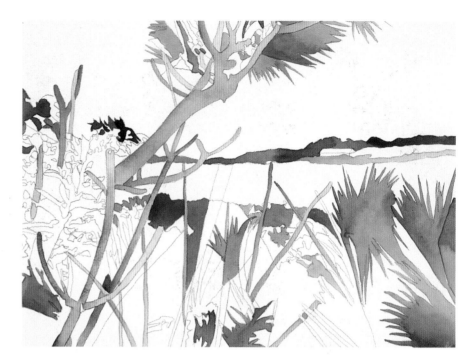

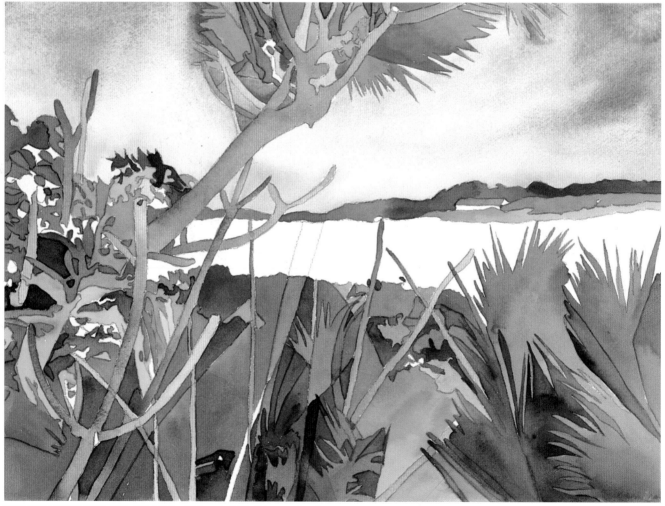

TREES IN THE DUNES, *11" × 15" (27.9 × 38.1 cm), 1987. Private collection.*

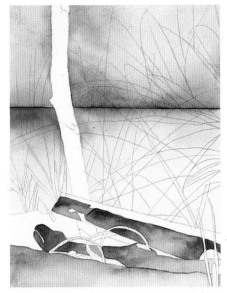

I have discovered that the beach still life doesn't require the actual physical rearranging of objects that the indoor still life does. However, it is important to train the eye to discover inspiring subject matter and a visual point of view that will result in an exciting watercolor composition. In this example, I decided to hold my watercolor sheet vertically to accommodate the tall piece of driftwood rising from the sand, although all the other elements lent themselves more to a horizontal format. There is more visual tension with this kind of approach, because the viewer must relate to a vertical painting even though there are strong horizontal components in the composition. I began painting by applying washes to the background and the major areas of the foreground with a size 10 brush.

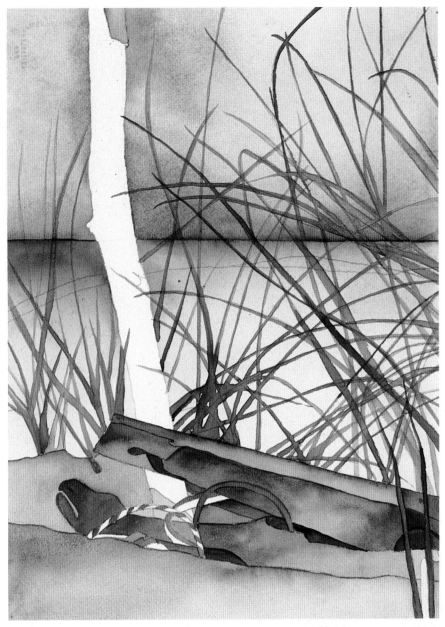

FOUND ON THE BEACH, *11" × 15" (27.9 × 38.1 cm), 1987. Private collection.*

I used smaller brushes and more intense colors to paint specific details on the driftwood, as well as the cadmium orange rope resting on the sand. The last step in this watercolor composition was to paint the tall blades of grass with a combination of sap green and permanent green, applied with a size 3 brush. Note that I chose to leave my center of interest, the vertical piece of driftwood, unpainted.

(Right) I painted this on the beach, looking toward the horizon. Because there were no people on the beach, I made sure that I included the edge of a boat and some tall blades of grass in the foreground to give the overall composition a sense of scale. After I completed the preliminary drawing, I used a size 12 brush to apply washes to the sand, sea, sky, and of course, the boat in the lower left-hand corner.

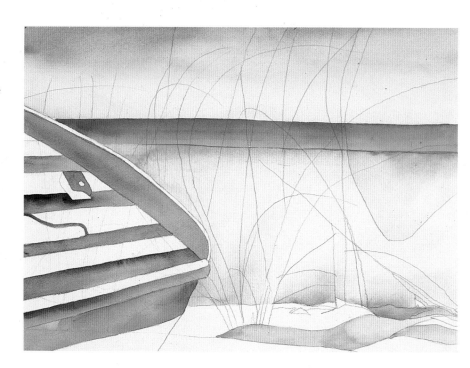

(Below) I completed the boat and, with a size 3 brush, painted the long blades of beach grass over the existing beach sand background. Note the small area of paper I left unpainted to create a sense of depth and space in the lower portion of the composition.

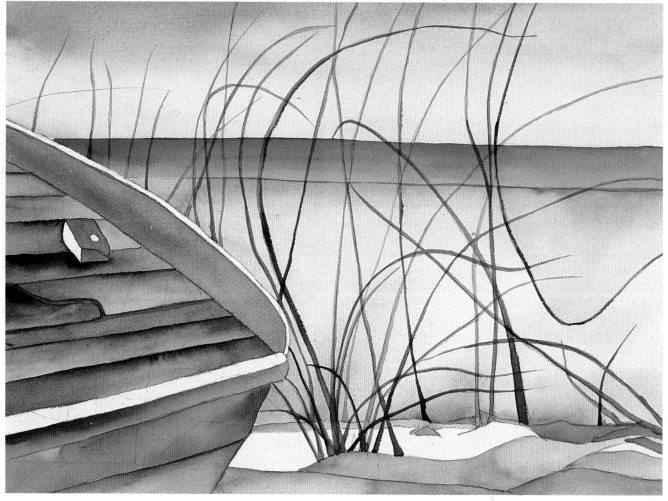

BOAT ON THE BEACH, *11" × 15" (27.9 × 38.1 cm), 1987. Private collection.*

(Right) This watercolor was done on location, inspired by the rocky coastline of Maine. I situated myself on a sandy beach away from the waterline and did a pencil line drawing, then applied an overall wash of yellow ochre and Naples yellow to the lower portion of the composition. I painted in the water with ultramarine blue and cobalt blue, mixing them directly on the watercolor sheet. Using a smaller round brush, I began to paint the individual rocks with burnt umber and Payne's gray, again mixed directly on the paper.

(Below) I completed all the rocks and painted in the sky above with very light washes of blue and yellow. Note the tiny areas of unpainted white paper on the rocks and in the water. The adult and child sitting on a rock in the center of the composition are my center of interest.

MAINE ROCKS, *11" × 15" (27.9 × 38.1 cm), 1987. Private collection.*

BUILDINGS AND HOUSES: A GEOMETRIC COMPOSITION

I find that there is a certain advantage to working from photographs, when I paint buildings and houses. Other than the mere convenience of not having to sit down to paint or draw on some busy street, I have discovered that the photographic reference allows me to simplify the structural forms of buildings and houses so I have a clearer approach to perspective drawing as well as the application of light and dark values when I begin to paint in watercolor.

This exercise is to be done indoors, using the artist's own photographs or slides. It expands the geometric composition of the first exercise into a new format by using actual subject matter and demonstrates one method of working with photographic material.

Whether you're a city, suburban, or country person, buildings and houses can stimulate endless possibilities for watercolor compositions. In this exercise, use slides or photographs that you have taken to act as a springboard for your creative imagination. The paintings of Edward Hopper are excellent sources of inspiration.

Begin by doing an improvisational line drawing in which you simplify the slide or photograph as much as possible. For instance, if I'm drawing a row of houses, the end result will have all the basic shapes of the buildings with windows, doors, and other important features, but little or no other detail. This edited approach to drawing is more geometric; the various structural planes of the buildings

integrate with the sidewalk, street, and sky but are still recognizable. Remember, the slide or photograph is merely a drawing tool that you use, along with the pencil, to stretch and search the boundaries of your mind.

In doing the drawing, make sure that all the dominant areas and lines touch all the edges of the paper in order to create depth and space in what would normally be a shallow picture plane. If you feel a detail or texture is relevant to the composition, add it with a pencil or a small brush after you've painted in all the primary areas on the watercolor sheet.

Use a variety of different-sized brushes to paint in the different shapes and areas in the composition. Treat each plane individually, as described in the chapter on geometric composition, by creating individual areas of dark-to-light or light-to-dark washes and by varying the intensity of color within each area. Mixing your colors directly on the dry or wet paper with the brush allows you to create a great deal of variation in your washes without losing the overall look or impression of the original subject.

Feel free to abandon the colors that may appear either in real life or in your photographs in order to achieve the visual impact you wish to express. You might choose to paint the buildings or houses in a warm, cool, or monochromatic color scheme, or you might limit your palette to one color plus gray in order to convey a particular feeling or time of day.

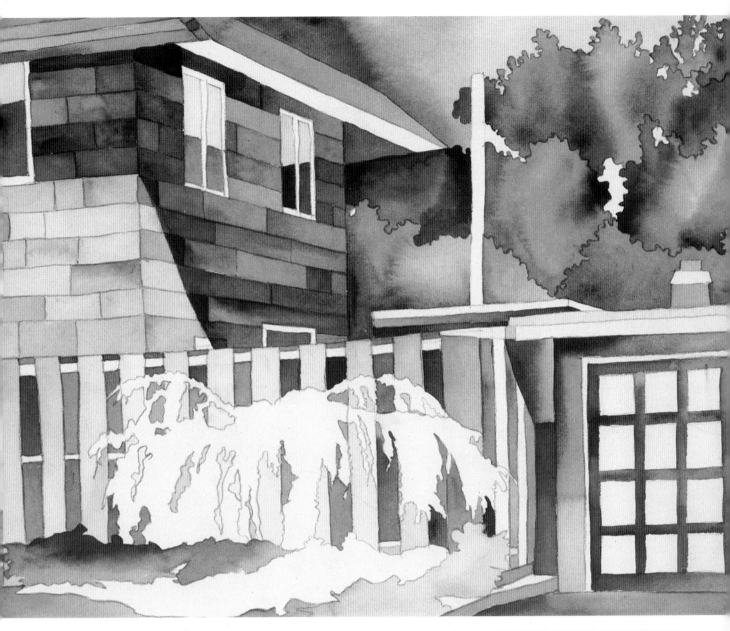

COUNTRY HOUSE
11" × 15" (27.9 × 38.1 cm),
1987. Private collection.

This painting of a country house is a good example of a monochromatic color scheme. In this case, I chose Indian red as my only color. Notice that the contrasting values of the same hue create the illusion that more than one color was used to achieve depth as well as atmosphere in this painting. Areas of unpainted white paper also help to enhance the overall visual impact of this structure.

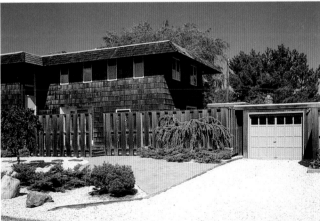

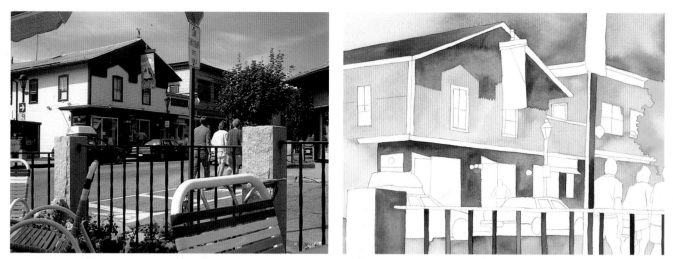

I worked directly from a slide to create the preliminary pencil line drawing, but I simplified and edited my subject as I went along by concentrating on the major horizontal, vertical, and diagonal planes. I avoided indicating any specific detail at this point, reducing the rooftops, windows, and doors of the buildings to geometric planes. I incorporated a fence into the foreground to give the outdoor scene a greater sense of depth and space, and I silhouetted a tree and several figures in the lower right-hand corner of the watercolor sheet. I began painting by applying dark-to-light and light-to-dark washes throughout the composition with brushes of various sizes.

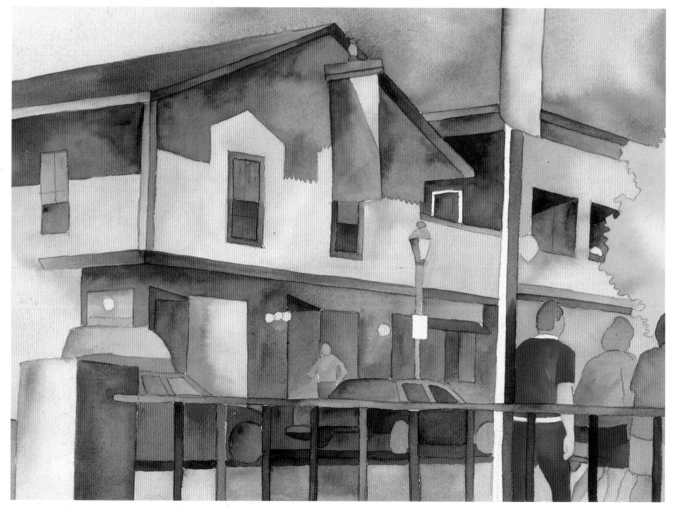

BAR HARBOR STREET, *11" × 15" (27.9 × 38.1 cm), 1987. Private collection.*

I continued to paint in the remainder of the areas in the composition, referring to the slide to help me determine light and dark values as well as any shadows that would enhance the painting. I painted a permanent violet over the existing yellow ochre wash on the buildings and used Payne's gray for some of the windows. Notice that I've heightened the overall appearance of this street scene with colors that don't always correspond to what appears in the slide. I've also left several areas unpainted.

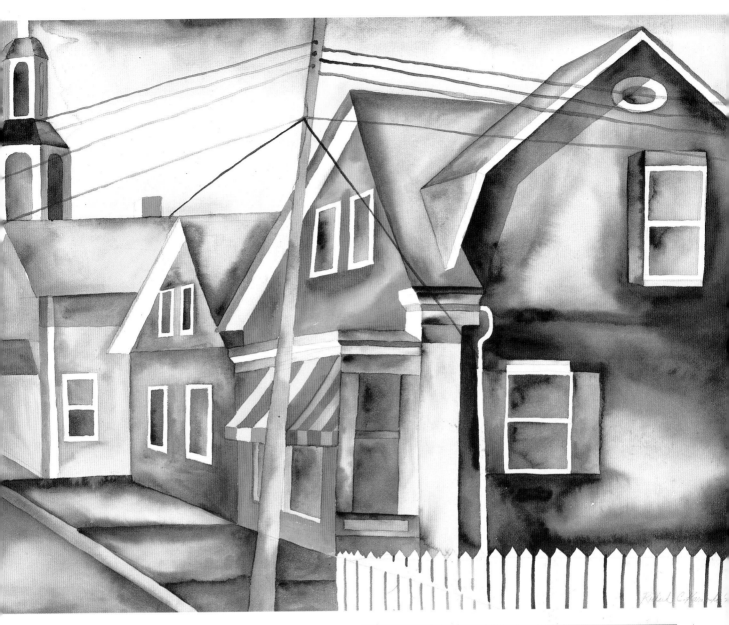

CAPE COD, *22" × 30" (55.9 × 76.2 cm), 1976. Private collection.*

This painting was done from a photograph I had taken of a row of houses in a small town along Cape Cod, Massachusetts. Although the scene was photographed during the summer, I didn't get around to doing the painting until much later in the year. Notice how I altered the houses by simplifying and reducing them to flat planes and simple shapes with little or no texture except for the undulating washes on the exteriors. As you can see, I edited out a great deal of detail, which gives the setting an almost barren appearance. The diagonal telephone pole in the center foreground creates another level of depth and establishes a frame of reference for the viewer. Note the shadow on the building at right and the use of positive white shapes throughout, which gives this composition a sparkle that didn't exist in the actual photograph. I altered the color of the sky by creating a luminous blue and yellow background unlike that in the photograph.

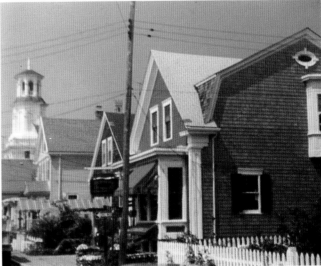

WORKING ON LOCATION

For this exercise, you will capture subject matter without the use of reference material by working on location in the city, in the country, or en route while traveling.

The Cityscape

As in previous exercises, begin with a simple pencil line drawing. If you are a city-dweller and live in a building with a view, the "on location" aspect of this exercise may merely involve setting up a drawing table near a window and looking out at the world below and beyond. However, if this is not your situation, the next best thing is to go outdoors and find a quiet spot in a city park or outdoor cafe where you can draw and paint your subject.

If it is impossible to paint on the spot, complete as much of the drawing as you can on location and then bring it back to the studio to finish from memory. I prefer this course, but I have also stayed with the painting until completion despite distractions like the general public attention that one receives when painting outdoors. If your subject is nearby or convenient to where you live, consider returning with the unfinished painting to review any information omitted from the initial drawing of your subject and refer to snapshots only to refresh your observation.

If working on location in a city environment is new and unfamiliar to you, choose a smaller format such as 9″ × 12″ or 11″ × 15″ for this painting exercise. I usually work on a full-sheet format (22″ × 30″), depending on the conditions and circumstances, but I have also worked on a smaller scale and accomplished the same results.

The approach to the cityscape painting should be quick and spontaneous. Paint in the dominant or primary areas first, paying special attention to light and dark values in order to convey the massiveness of buildings and skyscrapers without fragmenting the composition. Keep the light source in mind; notice where and how the shadows fall depending on the time of day. A strong distinction between the shapes of the actual buildings and the shapes and angles of the shadows will result in a more dramatic cityscape. Shadows may be indicated with Payne's gray, violet, or blue, but painted over the underlying shapes with more translucent washes so that any subject matter underneath may still be visible.

**THROUGH A WINDOW
IN AN AMAGANSETT HOUSE**
*22″ × 30″ (55.9 × 76.2 cm), 1969.
Collection of Mr. Irwin Sarason,
Sagaponack, New York.*

This painting was done on location in the country; I stationed myself at a window to frame and compose the view outdoors. Even though it was drawn and painted indoors, I still categorize this painting as an on-location composition because no photograph or preliminary sketch was used for reference. I recently realized that this window composition planted the seed for my more recent watercolor paintings that utilize either a border or a window theme.

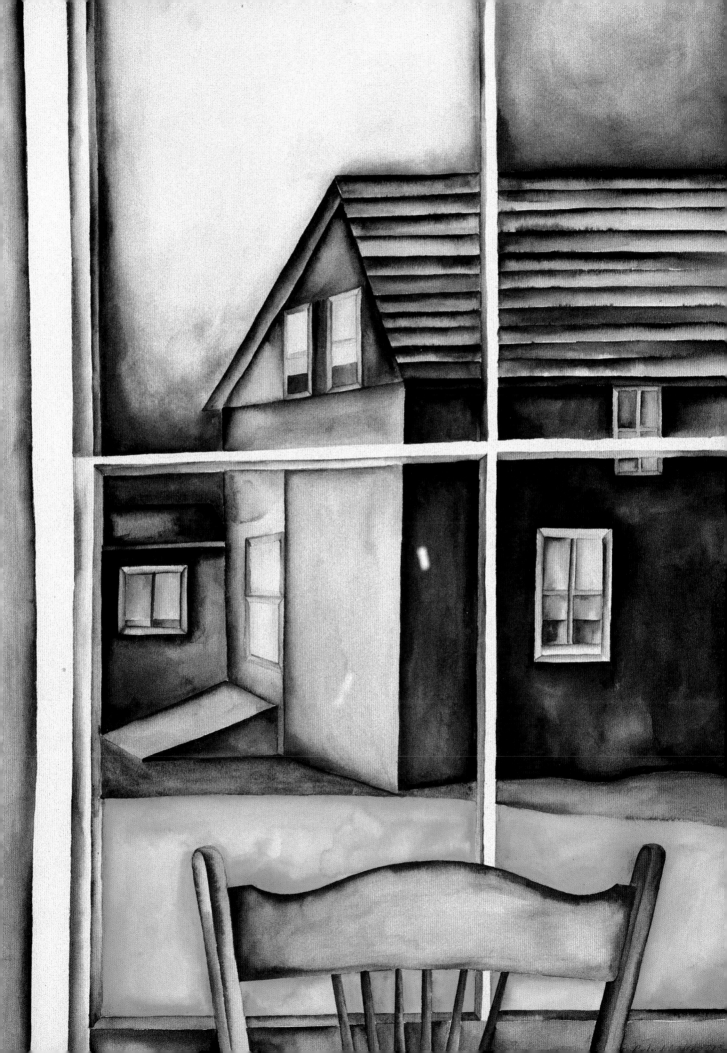

I went outdoors to draw the Old Merchants House, which stands directly across the street from my NoHo studio-loft. As I worked, I sat on a front stoop on the other side of the street and held the watercolor sheet vertically on a lap board. The initial drawing was done quickly, without any preliminary sketches. Although the truck that was parked in front of the building seemed to be an eyesore at first, it eventually became an integral part of the composition. I did the preliminary line drawing outdoors, then returned to the studio to complete the painting from memory. In this case, since I lived across the street from my subject, I could go back and study it again, but in other situations I've had to refer to photographs or slides to refresh my memory. Once I felt completely satisfied with the drawing, I began to paint in the dominant or primary areas, paying special attention to the light and dark values in order to convey the massiveness of the brownstone building without fragmenting the composition.

THE OLD MERCHANTS HOUSE, *11" × 15" (27.9 × 38.1 cm), 1987. Private collection.*

I used a smaller round brush to indicate the contrasting values as well as the shadows and the detail on the facade of the building. Although the color scheme in the painting is more intense than that of the actual scene, the overall look is still one of antiquity and age. The slick, contemporary appearance of the logo on the truck lends an air of past and present to the painting.

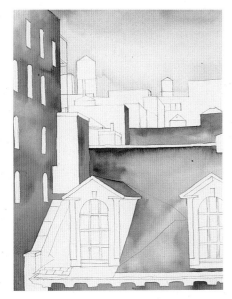

I took my own advice by setting a drawing table by a window and looking out at the world below and beyond. Once again, the subject is the Old Merchants House, but the approach to this composition is panoramic rather than close-up. I chose the rooftop and the dormer windows as my primary subject but decided to include the rest of the buildings in the skyline. I began with a preliminary line drawing, then used a size 12 brush to paint in the massive areas such as the roof, the sides of the building, and the sky. I worked with a rather subdued palette that included burnt sienna, burnt umber, and Payne's gray; the colors in the sky are cobalt blue and cadmium yellow light.

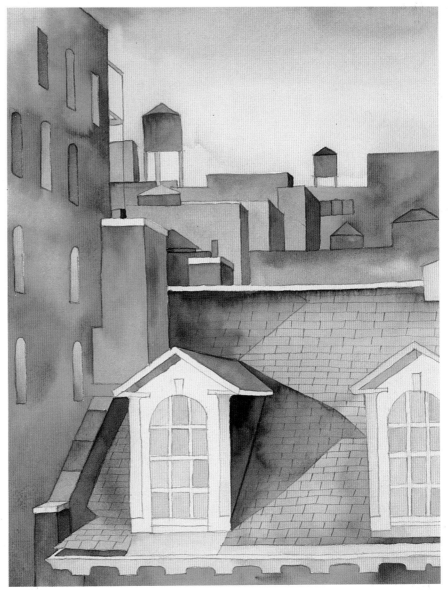

LOOKING NORTH FROM 4TH STREET, *11" × 15" (27.9 × 38.1 cm), 1987. Private collection.*

I completed the painting by adding lighter values to the buildings but left unpainted areas of watercolor paper for highlights and to indicate the light source. Note the Payne's gray wash I added over the existing roof to create a shadow from the dormer window. Because the view I painted was always accessible, I didn't have to refer to a photograph while working on this painting.

The Countryscape

The countryscape painting, unlike the cityscape, allows for a certain amount of privacy when one works on location; in a rural situation, the only distractions are the forces of nature. A barn or a farmhouse on a quiet country road is the ideal subject.

I explore the various views and angles of my subject before starting to draw; if possible, I look at it not only from the front but also from the side and rear. After observing it carefully and choosing the best angle, I situate myself in a shaded area away from any highway or road traffic and begin to draw. If time permits, I work on a large scale, perhaps 15″ × 22″ or 22″ × 30″, but I allow enough time to bring the painting close to completion. If time is limited, I draw the composition in pencil, do some painting, and then finish the rest indoors later. I begin by blocking in the composition with an HB pencil, emphasizing the primary subject matter but incorporating secondary information in the foreground or background. The drawing shouldn't be too extensive but should act as more of an overall structure for the painting. Remember that details may be added, with either a pencil or a brush, once the painting is in progress.

Paint in the background and foreground areas before you do the building, so it will be well integrated into the total composition, rather than appearing "cut out" and unrelated to the setting. The next step is to paint the building itself; this involves not only more time and concentration but also more contrasting washes and values to imitate different materials and textures. If the building happens to be made of unpainted wood, for instance, you might consider a brush technique that imitates the grain. I leave windows, doors, and other features until last; this is fine as long as the general proportions have been indicated in pencil. In fact, I have even completed this part of the painting after returning to the studio.

Painting While Traveling

Some of my fondest memories of painting buildings on location took place en route while I was vacationing in Maine, Cape Cod, southern France, Venice, and Spoleto, Italy.

Using a Winsor and Newton sketcher's watercolor box and a 9″ × 12″ D'Arches watercolor block, I've managed to paint on trains and boats as well as on dry land. The important thing to remember when your time and supplies are limited is to draw and paint on a much smaller scale then normal. For instance, if you usually work on an 11″ × 15″ or 9″ × 12″ format, reduce those sizes by half to 11″ × 7½″ or 9″ × 6″ or even smaller, depending upon the time frame of your travel schedule.

The drawing should be kept as simple and uncomplicated as possible and should take no more than a few minutes. Focus on creating a pleasing composition by utilizing all the edges of the watercolor sheet and establishing an area of interest somewhere near the center.

The painting should also be done quickly but carefully. Just because it is much smaller in size and scale than your other paintings doesn't make it any less significant as a watercolor. Smaller brushes, such as a size 3 or a size 5, are more appropriate for a smaller format, but that doesn't mean that you can't use some of the larger brushes, especially for background washes and general filling-in of large areas of color and value. Again, feel free to stop at a point where you will be able to complete the painting in your hotel room or soon after returning from your travels.

(Right) I did several preliminary sketches for this watercolor before establishing a visual point of view that seemed satisfactory. The final drawing of the snow-covered house and barns was done quickly but carefully on the watercolor sheet with an HB pencil. Because of the weather conditions, I preferred to complete the painting indoors; I could return to the setting another day if I needed more visual information. Once in the studio, I began painting by applying several color washes to the buildings. I mixed cobalt blue and violet directly on the paper to create the wintry color of the sky.

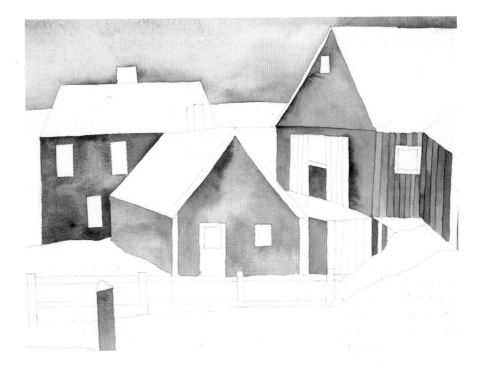

(Below) I completed the painting by adding color washes to the windows, the chimneys, the fences, and the foreground snow. This panoramic painting is a good example of how major areas of white paper can be left unpainted without making the painting appear unfinished.

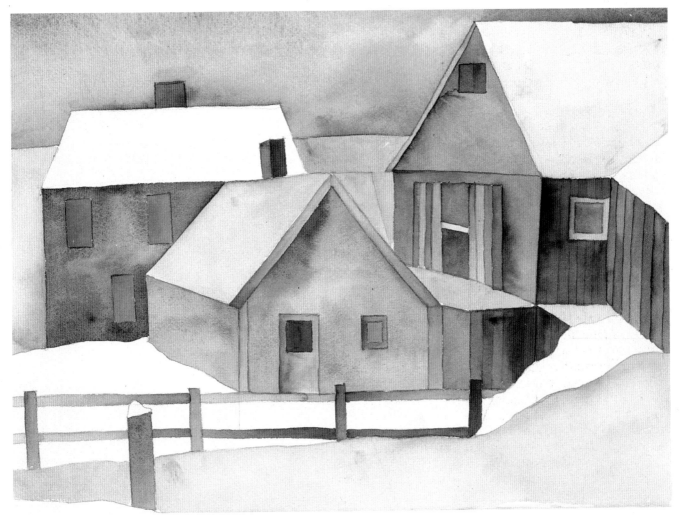

WINTER, *11" × 15" (27.9 × 38.1 cm), 1987. Private collection.*

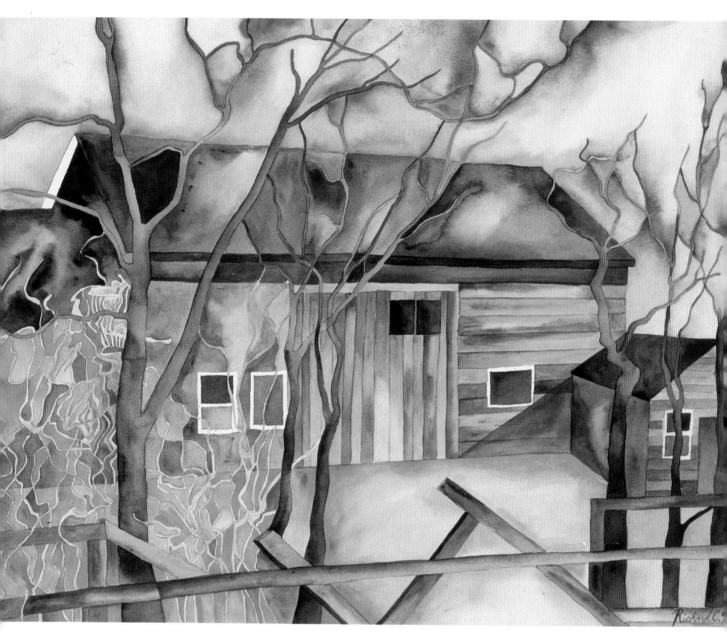

THE HOMESTEAD
22" × 30" (55.9 × 76.2 cm),
1980. Private collection.

This watercolor painting, done on location, was inspired by an invitational exhibition with the same theme as the title. I remember passing this enclave of barns and houses before I actually documented them in a painting. By drawing and simplifying the subject, I was able to come up with a composition that consisted of buildings as well as bushes and trees. Because it was early spring when I did this painting, there appears to be an overall dormant feeling in this countryscape. Notice that my palette consisted primarily of earth colors; for that reason, I chose to add color contrast by using violet washes on the trees.

SPOLETO, ITALY
9" × 12" (22.9 × 30.5 cm),
1970. Private collection.

This very early on-location countryscape was done during the summer of my first trip abroad. While visiting the small hilltop village of Spoleto, Italy, I did this panoramic watercolor painting from the terrace of a small house in which I was staying. Notice the overall fragmented quality of the composition; this reflects the layered bricklike rocks and stones so typical of the houses as well as the streets in this town. Although I categorize this as an "en route" composition, I had ample time to do both the drawing and the painting in one sitting. Observe the distant hills and sky that give the illusion of deep space similar to that in an Italian renaissance painting.

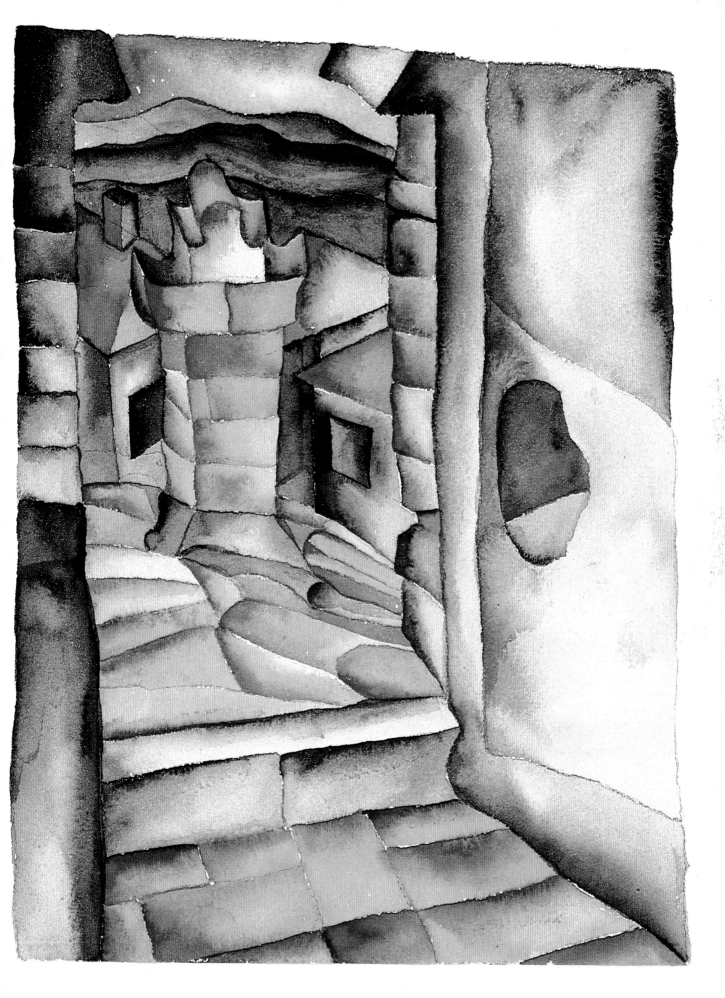

CREATING VARIETY AND VISUAL INTEREST

My fascination with painting house-plants in watercolor began over a decade ago, when I found myself drawing and painting avocado plants that I had grown from pits in my New York loft. The paintings were usually 22″ × 30″, but several were done in larger formats such as 25″ × 38″ and 36″ × 44″. One of these paintings is in the permanent collection of the Conservatory Restaurant at the Mayflower Hotel in New York City.

One appealing aspect of this watercolor composition is the convenience of being able to create it at any moment in the privacy of your home or studio, without any elaborate preparation other than selecting a plant and a light source that will enhance the values and shadows. The approach I prefer when painting a plant like an African violet or an avocado is an extreme close-up that allows the foliage to take over and touch all the edges of the watercolor sheet; I also include some suggestion of the stems, stalks, and flowerpot. For some reason, I usually hold the watercolor sheet vertically. Perhaps that orientation is symbolic of growth, although I've occasionally done a horizontal composition.

If you've never drawn or painted houseplants before, use a vertical format for your first composition.

Position yourself close to the houseplant and observe and then draw the structure of the plant. Begin working somewhere near the center of the sheet, using a pencil line to indicate the contours not only of the leaves and flowers but also of the stems, stalks, and shadows for the most dramatic portrayal of your subject matter. If the veins are prominent, as they are in avocado plants, draw them as well, for that kind of detail will always enhance the overall look of the composition and create added interest. The background can be a blank wall; this will allow for greater visual comprehension. The drawing of the houseplant is complete when all the pencil lines have touched the edges of the watercolor sheet and there is a complete and interesting array of leaves and stems that create the illusion of depth and space in a limited picture plane. One of the most important things to remember about this kind of subject matter, as opposed to the plants discussed in other chapters, is that there are no blossoms or fruit to act as the center of interest. This is especially true of avocado plants—the only variation may be the size and shape of the leaves. Therefore, it's important to create visual variety under these limited conditions.

Begin by painting the largest leaves, using a large brush such as a size 10 or 12 to apply the dominant color, perhaps a sap green, to the watercolor sheet. Let the values in the washes vary from dark to light. You can also begin by wetting a leaf area with pure water, then adding pigment to create a wash and additional greens, yellows, and blues for color variety and dimension. After most of the leaves have been painted, start working on the stems and stalks with a smaller brush such as a size 5 or 7. If any veins in the leaves have been left unpainted, don't feel that those areas have to be filled in with pigment; they may remain white to act as accents or highlights. The last aspect to paint in the indoor plant composition is the background. I have left the white of the paper unpainted on occasion, but I've also done the background in a single color such as violet, cadmium orange, or Winsor blue. I feel that in the case of houseplants, it's not necessary to indicate a neutral background—especially if you are painting a plant, such as an avocado, that shows little color variety and has few flowers or none at all. In this case, the background color acts to enhance the shapes in the foreground; it is important to the composition.

I chose a cluster of leaves and branches on an avocado plant for my subject. My pencil line drawing filled as much of the space as possible with lines and shapes. Because there is no real center of interest, I strove for as much visual variety as possible, despite the limitations of the subject. I began to paint the largest leaves first with sap green, using various light and dark washes all over the watercolor sheet.

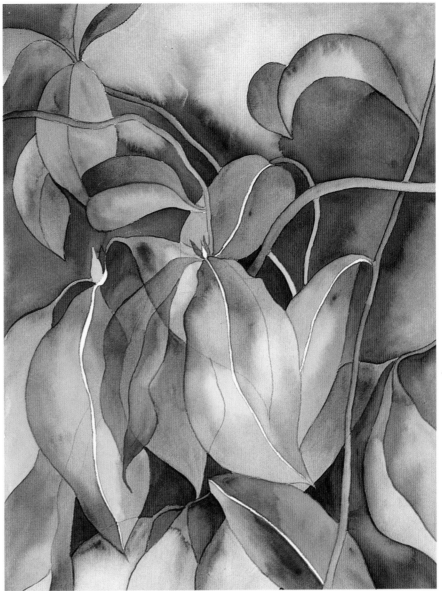

AVOCADO ON PURPLE, *11" × 15" (27.9 × 38.1 cm), 1987. Private collection.*

I continued to paint all the leaves and stems with additional greens, plus blues and yellows for color variety. I chose a violet hue for the background and created an overall dark-and-light wash with a size 12 brush, keeping the deeper values near the center and the lower portion of the composition.

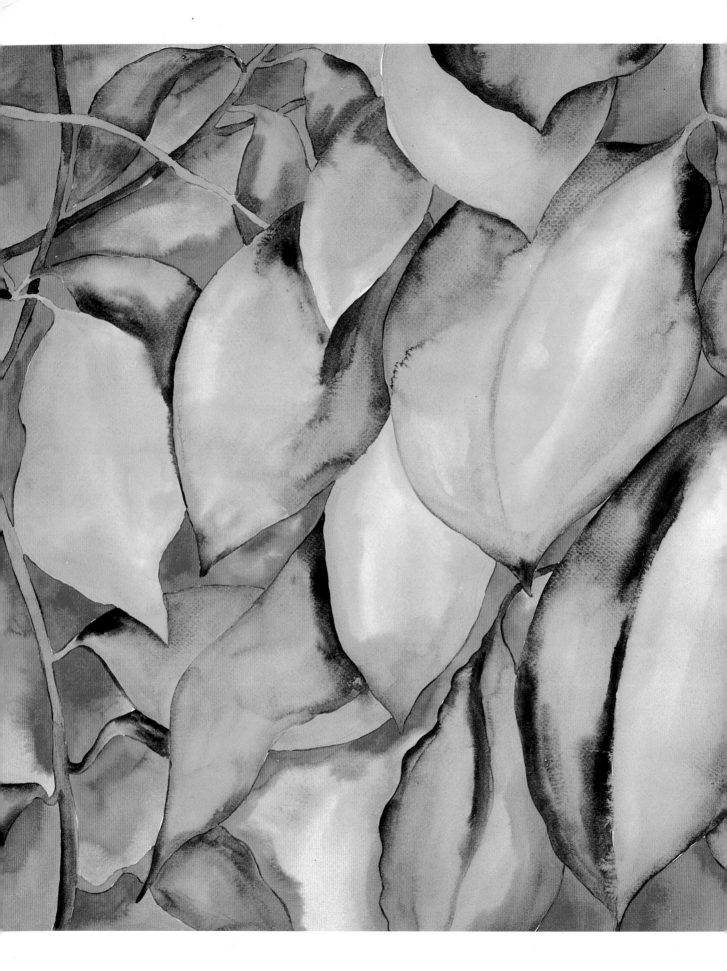

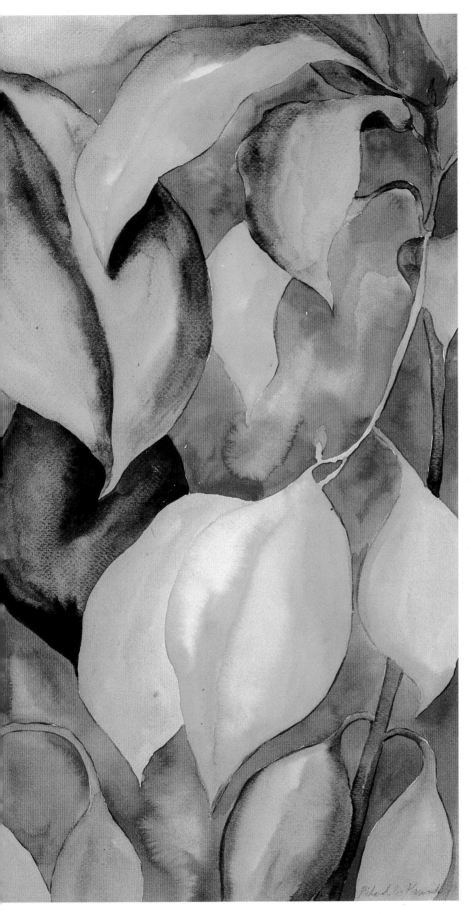

AVOCADO LEAVES ON ORANGE
25" × 38" (63.5 × 96.5 cm),
1977. Private collection.

This painting was inspired by a six-foot avocado plant that I've grown from a pit; it dominates the living portion of my loft. I held the large watercolor sheet horizontally so the avocado stems would seem to be growing up from the bottom of the painting. I worked with a wide variety of greens, yellows, and blues and used a wash of cadmium red medium and cadmium orange for the background color.

FLOWERING PLANTS: TWO STILL LIFES

My trip to the Hawaiian Islands several years ago inspired a series of watercolor paintings depicting tropical plants. I did most of the paintings in the solitude of my studio after I returned home, however; I had taken hundreds of slides and photographs that I later used as references and sources of information for this particular series. You don't have to run out to your travel agent and book a flight to Hawaii in order to create such a series of paintings; simply go to your nearest florist, greenhouse, or public botanical garden and either draw and paint on location or photograph your subject matter for future use.

The Close-up Composition

Whether you work on location or from a photograph, the approach to the close-up painting is the same. Block in the line drawing with an HB pencil, making certain that it touches all the edges of the paper. As in the houseplant composition, there may not be a focal point or a center of interest, but in the case of tropical plants there usually is. Place it somewhere near the middle of the sheet for the best results. The only background to consider when doing the drawing may be other leaves from other plants; integrate them into the composition along with the primary subject matter.

The watercolor painting of the outdoor plant or plants may be done on location (if possible) or indoors. If you work in the studio, refer to slides or photographs but aim for an individualistic interpretation, not a photographic likeness.

Begin by painting the leaves, stems and flowers in the foreground with a large brush, such as a size 10 or 12. When most of the primary areas have been painted, begin adding details with smaller brushes. Don't do them all at once; alternate between the details and the large areas. If the subject matter you have chosen has a strong light source, add an additional element of shadows as a last stage after the primary image has been painted. I have used a violet or a blue to indicate the shadow effects by painting over the existing imagery to convey atmosphere and depth. A background consisting of other plants or just space could also be handled by adding blue or violet to create shadows for greater depth or by leaving the white of the paper unpainted. The latter approach would suggest bright sun and daylight; the former would convey dawn or nightfall.

The Panoramic Composition

The panoramic approach to tropical plants on location or from slides and photographs may be done on any size paper; the format can be either horizontal or vertical. Consider the center of interest before you begin to draw the composition; if the plants that you have chosen to paint contain no flowers, isolate several leaves in the foreground, somewhere near the center of the sheet, to serve as a focus. The middle ground and background could consist of other plants, perhaps with a suggestion of space or sky near the top of the watercolor sheet. When you have completed a preliminary drawing that seems pleasing to the eye, begin to paint. Whether this exercise is done on location or from reference material, the pencil line may be added or taken away at any point in the painting process.

Beginning somewhere near the middle of the pencil composition, use a size 10 or 12 brush to paint in the lightest values in the background, middle ground, and foreground. Work from light to dark values throughout the painting, mixing colors and washes directly on the watercolor sheet. Change to a smaller brush as the painting nears completion and save all details and color accents, except the unpainted white areas, for the last stage. Any shadows that are to be indicated can be painted in; again, they are usually done in a blue or a violet after the rest of the painting has been completed.

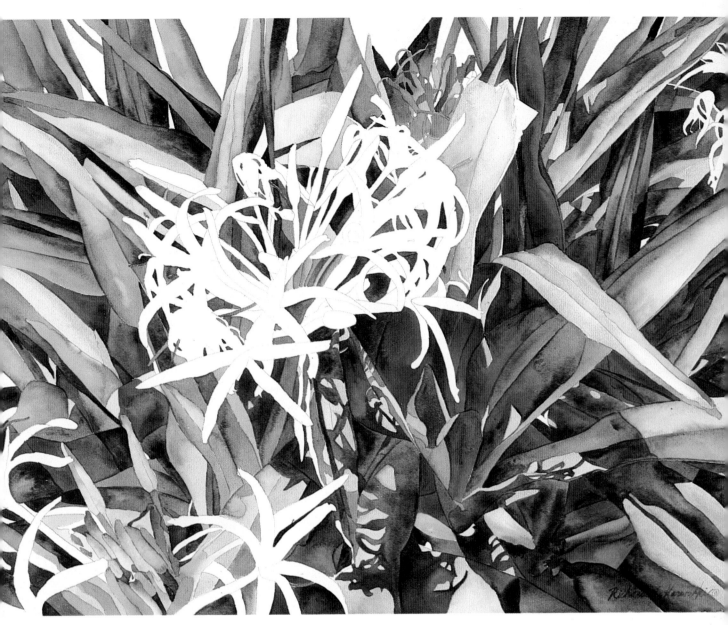

TROPICAL SERIES NO. 1
22" × 30" (55.9 × 76.2 cm),
1983. Private collection.

This painting is the first in a series of about a dozen to date that were done of tropical plants and foliage; they were inspired by my trip to the Hawaiian Islands. It's a good example of a close-up composition in which the tropical plant in bloom dominates the entire surface of the watercolor sheet, except for unpainted white areas along the upper edges of the paper. I worked with a variety of greens, blues, and purples to achieve a feeling of denseness and massiveness in this painting, but the area of interest, the blooming flowers, was defined by leaving unpainted areas of white on the watercolor sheet. Notice the cadmium orange shape near the upper portion of the plant. This accent is totally out of harmony with the rest of the color scheme but is necessary to the painting, for it draws the viewer's eye to the center of interest in the composition.

1 I referred to a slide I took while visiting the Hawaiian Islands several years ago for this close-up composition of tropical plants. I selected a flower as the center of interest and incorporated the leaves of the plant in the background. After completing the preliminary line drawing, I began to paint the flower and several of the leaves, making sure to touch the edges of the watercolor sheet.

2 I continued painting, using several greens, including Hooker's green, sap green, and viridian for the leaves and stems of the plant. I also retained several linear unpainted areas as visual highlights.

3 I finished the leaves on the plant and painted in several small flower buds with cadmium yellow medium. For the background, I chose violet to suggest the fragments of sky appearing through the leaves at upper right and for the shadows in the other areas.

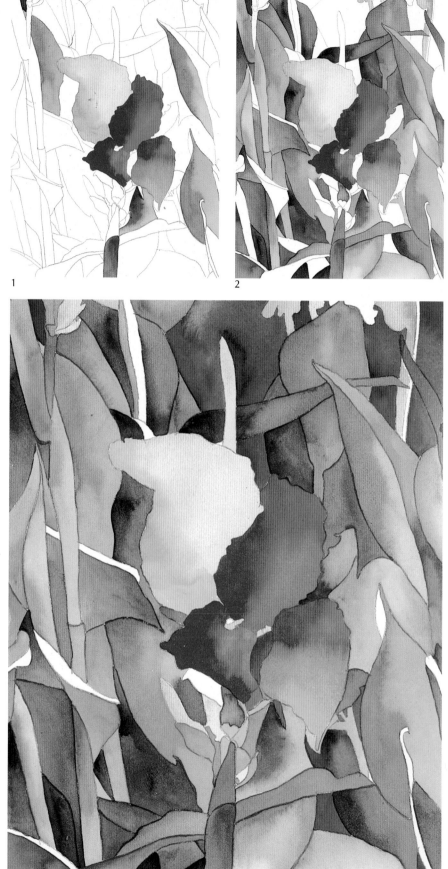

1

2

3

TROPICAL NO. 12, *11" × 15" (27.9 × 38.1 cm), 1987. Private collection.*

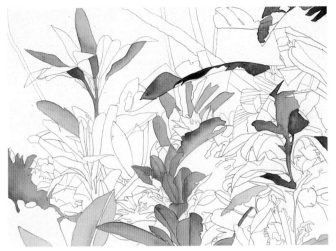

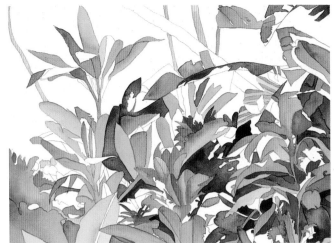

I utilized all of the edges of the paper for this overall composition, which is based on a slide, but kept a definite center of interest in mind—the orange flora just above the bottom edge of the painting. The middle ground consisted of other plants, and the background would eventually be the sky. I began to paint in a fragmented way with a size 10 brush, making sure I touched all the edges of the watercolor sheet.

I continued to paint the variety of plants in this composition with various greens and blues. I also switched to smaller size 3 and 6 brushes in order to indicate specific details such as the red flower that suddenly appears in the center of the painting. As I painted, I kept in mind the areas that I would leave unpainted to serve as highlights on the foliage as well as branches in the background.

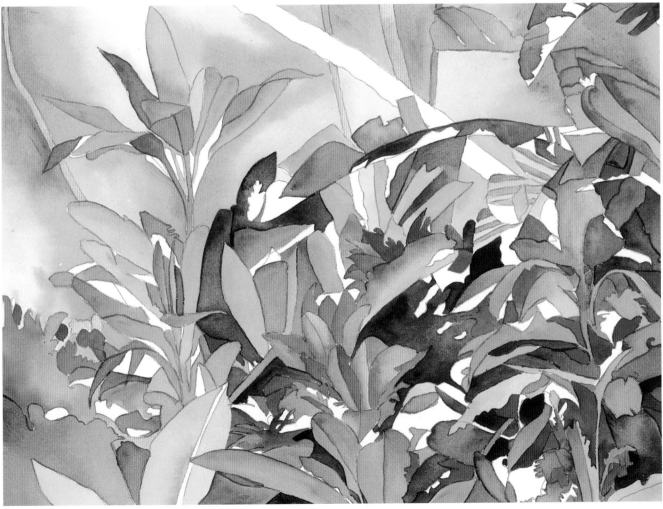

TROPICAL NO. 13, *11" × 15" (27.9 × 38.1 cm), 1987. Private collection.*

I painted the much darker leaves in the background with darker values of green. Using a large brush, I painted the sky with an overall turquoise blue, varying the light and dark washes throughout. I left the diagonal branch unpainted to allow for subject variety in the composition.

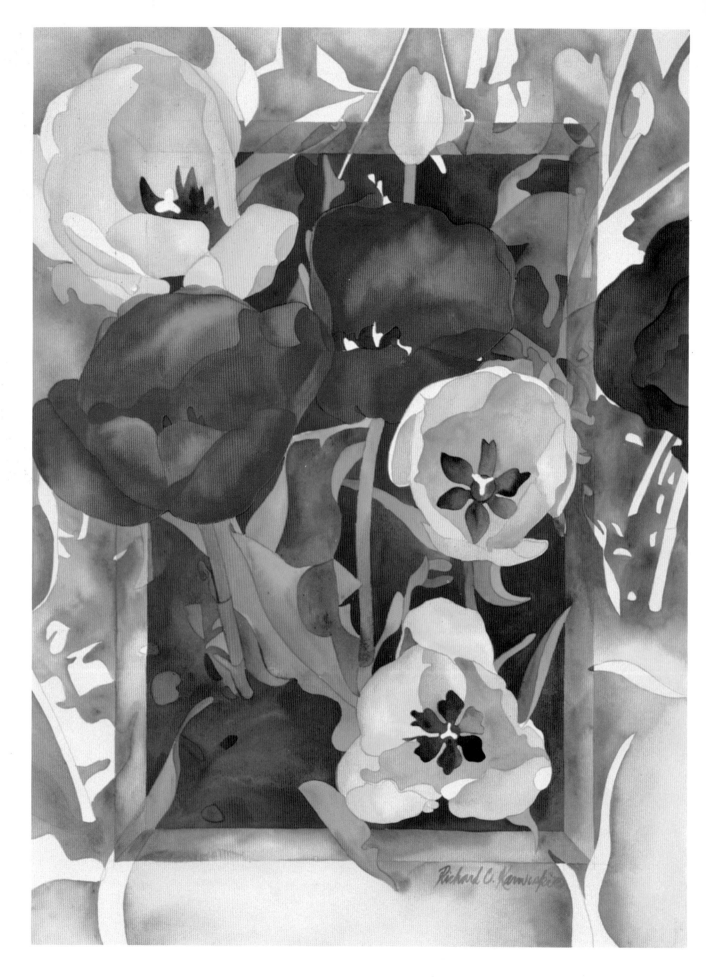

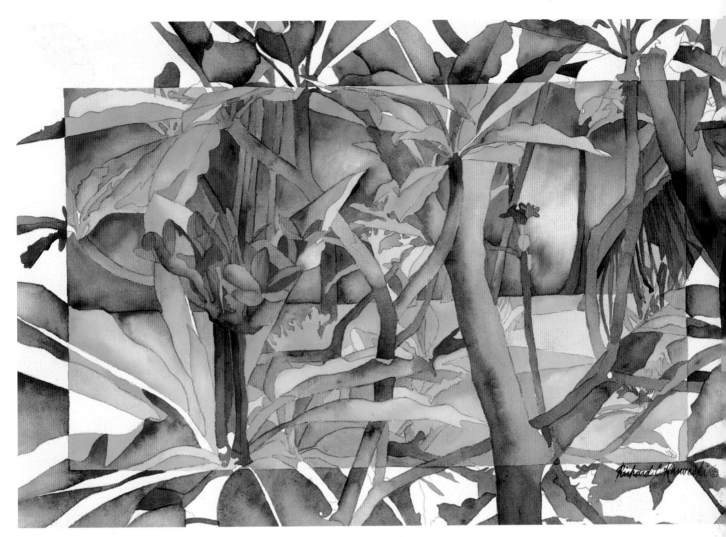

TROPICAL NO. 110
15″ × 22″ (38.1 × 55.9 cm),
1984. Private collection.

This panoramic approach to an outdoor plant composition was inspired by blooming flowers and tropical foliage, including several tree trunks and branches. Notice that I've begun to incorporate the gray border that has been characteristic of my more recent watercolor compositions. Though I began to experiment with this concept as early as 1983, it didn't come into fruition until the following year. To me, the gray borders are symbolic of the past as opposed to the present, which is represented by the colored areas in the composition. A critic reviewing a solo exhibition I had the year this painting was done described this new direction as "the duality of life."

TULIPS NO. 2
22″ × 30″ (55.9 × 76.2 cm),
1987. Private collection.

Tulips are a subject that I've only recently discovered, although I have always been fascinated by their shapes and colors. In this close-up composition of a tulip plant, I took certain liberties by simplifying the leaves and concentrating more on the individual flowers. Again I incorporated a window motif, using a cobalt blue border. I left several white areas of unpainted paper for highlights. Notice that the tulips seem to be reaching out as they protrude from the window-frame.

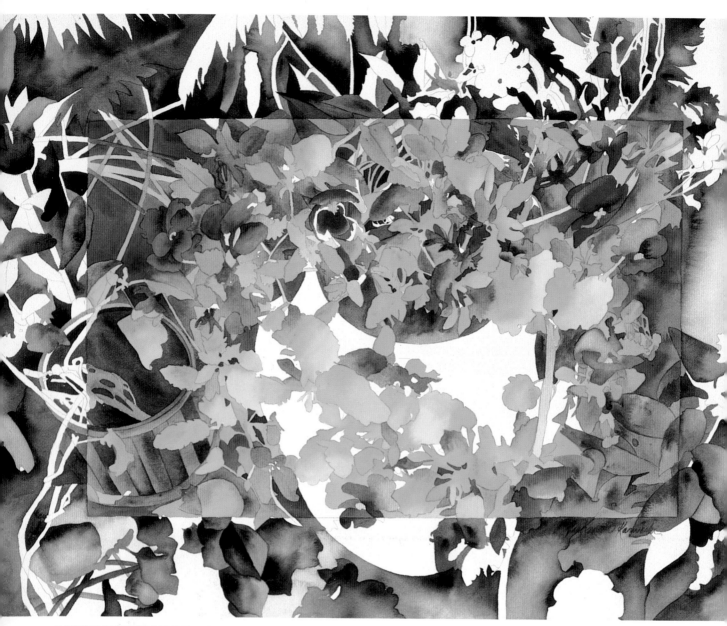

FLOWERS ON TOILSOME LANE
22" × 30" (55.9 × 76.2 cm), 1985.
Collection of Ms. Aniko Nemeth, New York.

Although the subject matter was not a tropical plant but merely a
pot of pansies growing outdoors on a patio, this painting is a
good example of a panoramic approach to an outdoor plant as
well as a continuation of the border composition. Notice that I
left the unpainted watercolor sheet to define the overall shape of
the flowerpot as well as the more fragmented white areas in the
gray border.

DOUBLE WINDOW SERIES NO. 1
30" × 44" (76.2 × 101.6 cm), 1986. Private collection.

This more recent work incorporates two different images, a
panoramic landscape and a close-up of a zinnia, in the same
painting. In this series, the border has now become a double
window-frame.

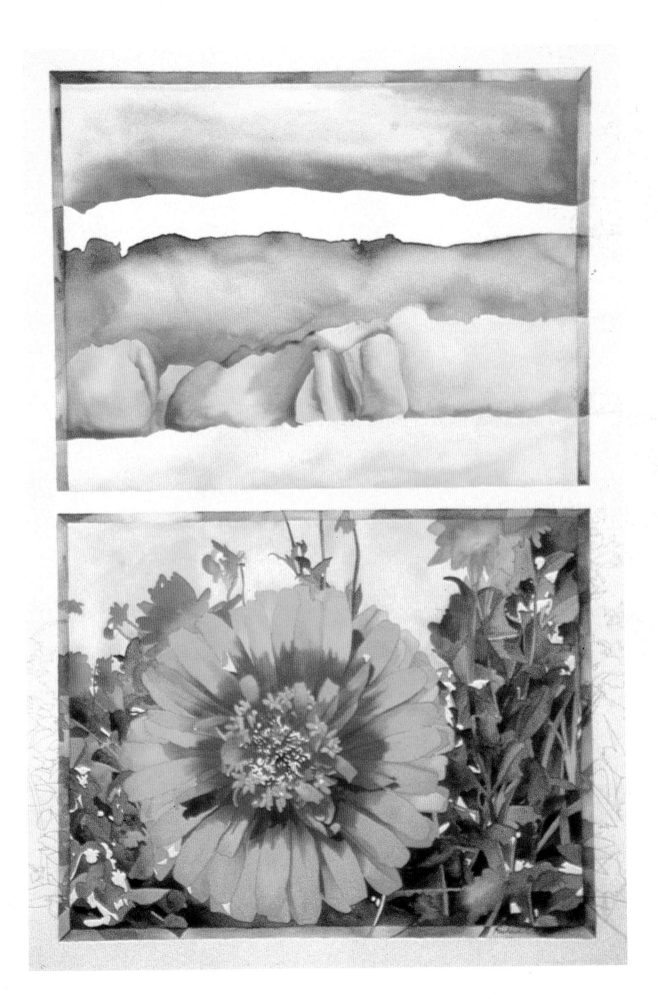

SUNFLOWERS: LUMINOUS COLORS IN NATURE

Like Vincent van Gogh in his lifetime, I have been fascinated with sunflowers in various stages of growth and decline for over a decade. I've done several dozen watercolor paintings of young, mature, and aging sunflowers and all the interesting shadows that the leaves and stalks often cast on the wall of a building or on the ground. Whether you work on location or from a slide or photograph that you have taken, the sunflower is a very challenging and intriguing subject.

Begin by isolating either a single flower with some suggestion of stem and leaves or several sunflower plants on a single sheet to create an overall composition. If the subject is just a single sunflower, I hold the watercolor sheet vertically, but if there are several plants, I use a horizontal format so they appear to grow up in a row from the bottom of the watercolor sheet. In addition to the flowers, stems, and leaves, I also incorporate the shapes of the shadows that are cast by the plant into the composition.

As I begin to paint, I concentrate first on the golden hues of the petals, using a medium-size brush such as a size 5 or 7 and a palette consisting of lemon yellow, cadmium yellow light, cadmium orange, yellow ochre, and Naples yellow. I create the color and value variations that I need for the color transitions within a single petal and flower by mixing the colors on the watercolor sheet. After I have completed the flowers, I begin to paint the stems and stalks, leaving the background shadows until last. I find that a sap green is usually a good color choice to begin with, but other greens and yellows may also be incorporated into the stems and leaves. The veins on the leaves of the sunflowers, like those of the avocado plant, are well-defined enough to be indicated by unpainted areas of paper.

The shadows are generally done with Winsor blue or phthalo violet, applied with a large round brush such as a size 10 or 12. Sometimes I wet the shadow area with pure water and then add pigment to the unpainted area.

Although sunflowers have been a personal passion of mine, other outdoor plants may also be used for this exercise. Continue to explore and paint the endless possibilities of the natural environment.

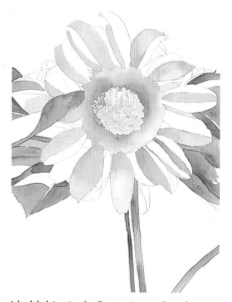

I held this single flower in my hand as I drew. I find that the sunflower is an interesting subject because of its overall dynamic size, shape, and color, especially when it is isolated on a sheet of watercolor paper. For this composition, I first did a preliminary pencil line drawing utilizing all the edges as well as the space in the background. Then I applied the initial watercolor washes to the petals, stems, and leaves, using a combination of lemon yellow, cadmium yellow medium, yellow ochre, and Naples yellow for the flower and sap green for the rest of the plant.

SMALL SUNFLOWER
11" × 15" (27.9 × 38.1 cm),
1987. Private collection.

I chose turquoise blue for the background, although I've done other single-sunflower compositions in which I left the background unpainted or just indicated the shadows with violet or blue.

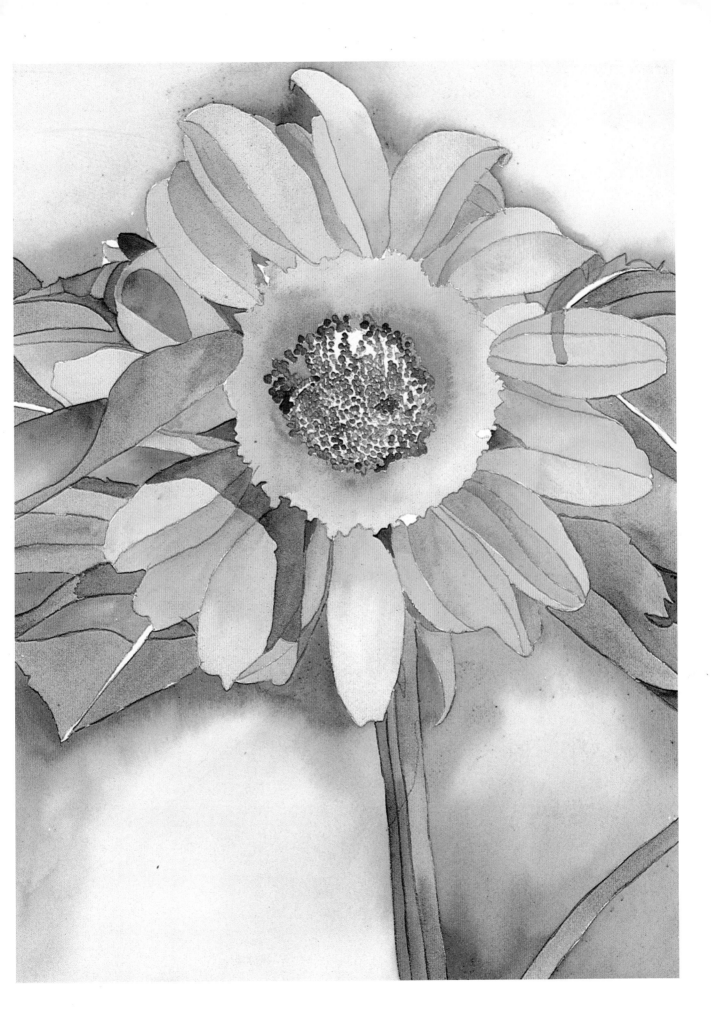

(Right) For the panoramic sunflower composition, I held the watercolor sheet vertically so the sunflower stalks would appear to be growing up from the bottom of the painting. I drew the stems, leaves, and flowers and outlined the shapes of the shadows that these elements cast against a stark white wall. I began to paint by working in a fragmented way all over the surface of the composition.

(Below) I continued to paint the remaining stalks, leaves, and flowers. The shadows were done with a size 10 brush by wetting the shadow area with pure water and then adding pigment. I used phthalo violet to achieve the shadow quality I wanted for this composition.

DANCING FLOWERS, *11" × 15" (27.9 × 38.1 cm), 1987. Private collection.*

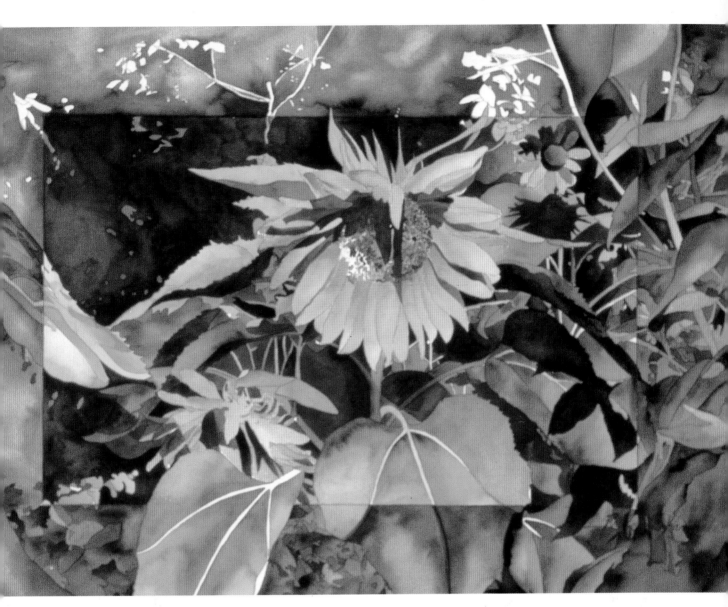

LATE SUNFLOWERS NO. 1
22″ × 30″ (55.9 × 76.2 cm),
1987. Private collection.

This more recent series was inspired by how rich and full the
sunflowers look just before they begin to wilt at the end of the
summer. This composition is a continuation of the ongoing
border series but has certain new elements, such as the leaves
that overlap and extend beyond the color area. To make the
background dense with foliage, I overpainted it with a second
wash of a deeper value to create an almost mysterious
atmosphere.

Overleaf
SUNFLOWERS '80
44″ × 60″ (111.8 × 152.4 cm),
1980. Private collection.

This mammoth approach to the pan-
oramic sunflower composition was in-
spired by the sunflowers growing up
against the stark white walls of the
garage near the foot of my property line
in East Hampton. What fascinated and
inspired me here was not only the
different sizes of sunflowers but also the
shadows they cast against the white
background. I primarily used Winsor
blue in various degrees of light and dark
washes to capture the luminosity that
appears on the surface of the shadows.

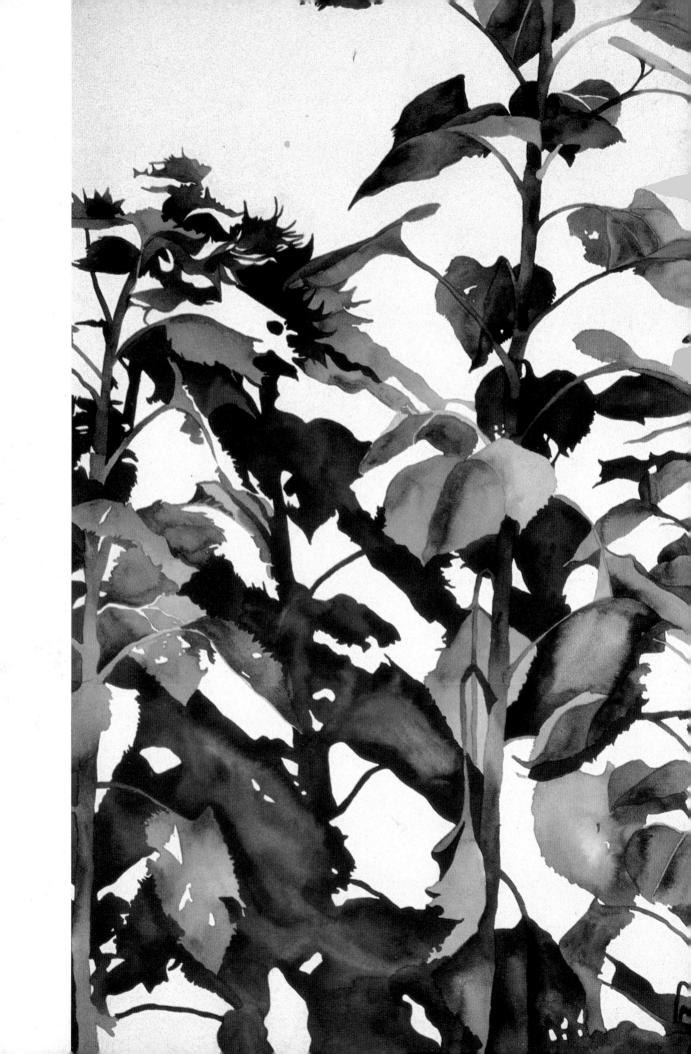

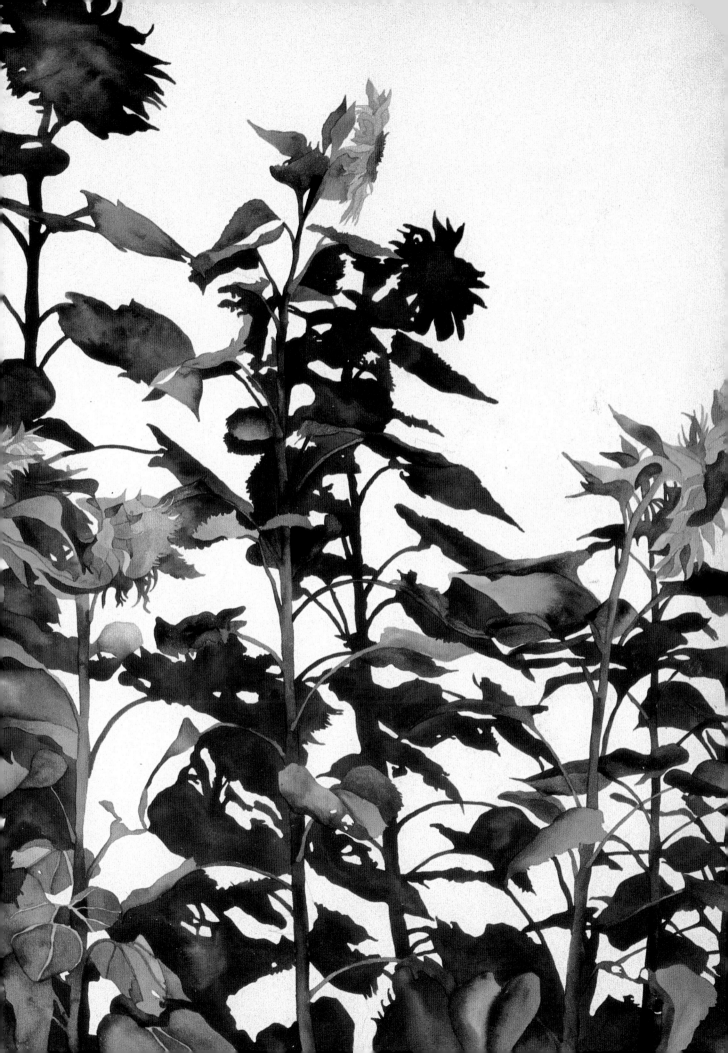

QUESTIONS AND ANSWERS

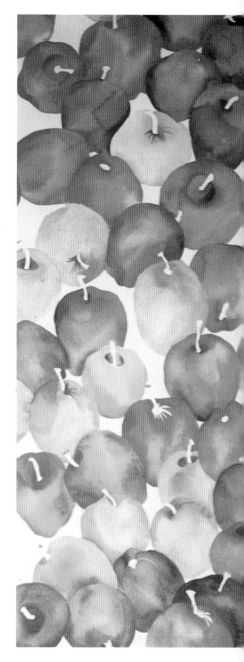

What's the difference between working with a round brush and a flat brush?
I feel that when working in watercolor one has more control when painting with a round brush. Thin and thick strokes can be painted with the same brush. There is more flexibility; the width of a line or shape can be adjusted by varying the pressure on the brush or changing its position.

What is smooth paper good for, as opposed to rough or cold-press paper?
It's good for pen and ink work, because the pen point moves smoothly across the surface without getting caught, as it might on rougher paper. Smooth paper is also good for some watercolor techniques, such as drybrush or stippling for which a smoother, less absorbent surface is desirable.

Why do you sometimes use pan colors? Are they any better in quality or intensity?
That depends on the color. I find that blues and greens are more intense in the pan style than in the tube style; on the other hand, reds and yellows are more intense in tube form. The warm colors are easier to handle in pan form; cool colors are easier to handle in tube

form. It's possible to combine the two types of paint if you want to.

When using tube watercolors, do you have to squeeze out the color and then add a drop of water?
If the paint is very stiff, I will add a drop or two of water to the mound of paint on my palette. The consistency of the paint in the tube will vary depending on the color and the brand. I don't dilute the colors into washes on the palette; that's done on the painting surface itself, either by working on a wet surface or by adding water to the paint on the paper.

What is scrubbing?
Scrubbing is applying pressure to the watercolor sheet with a brush and not allowing the wash to flow.

Should I keep wetting the paper as it dries?
Yes, keep the paper moist, especially if you're painting outdoors. You may have to keep going back over it and make sure that you work very quickly.

Does that mean adding clean water?
Use clean water if you want to thin the wash. If you want to make it darker, then go back over it with a concentrated wash.

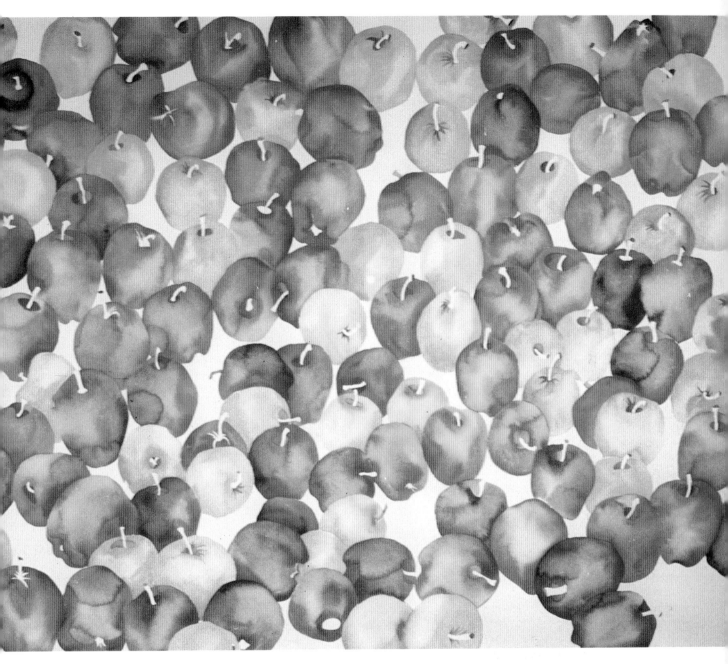

RED AND YELLOW APPLES,
44" × 72" (111.8 × 182.9 cm), 1976.
Collection of the Conservatory Restaurant, New York.

This was the first large-scale painting I ever did; it was painted
on an oversized sheet taken from a long roll of D'Arches paper.
I laid the paper completely flat on a long dining table as I drew
and painted, moving around the table so I could reach all parts
of the painting. Although there are over two hundred apples in
this composition, I actually worked from only three yellow and
three red apples, turning them and changing their positions to
give the impression that no two were alike in shape and color.
The background was left unpainted because of the complexity
of the composition.

What happens if my paper dries faster than I can paint?
That usually doesn't happen unless you're working on a very large area; in that case, I suggest standing up as you work. I can work more quickly while standing, and I seem to have more control that way.

If there's too much water on the watercolor sheet, how can it be removed?
Absorb the excess with the corner of a tissue or paper towel.

Do you ever suggest that one mix colors on the palette?
I don't, because I mix directly on the watercolor sheet. Generally speaking, to keep your color fresh, it's better to mix directly on the paper. There are, however, always exceptions. There are no rules for making art; those that do exist are frequently broken.

If I don't use a test sheet, how do I avoid choosing the wrong color?
Karwoski says there is no such thing as a wrong color. If it's wrong in your mind then it's wrong in the mind of the person looking at it. If it's right in your mind, it's right in the mind of the viewer. You're the best and final judge. If you feel it's wrong, then you have to change it.

If I don't try a color on the test sheet first but put it right on the painting, and it turns out to be wrong, how do I get it off?
Well, first you try to make it work even if it looks wrong. If that doesn't succeed, you can absorb some of the pigment with a wet paper towel. But I must add that this has never actually happened to me—I've never put a wrong color down, so I'm not speaking from experience.

If you want to make a green, do you mix yellow and blue directly on the paper?
Yes.

Should all the greens be done at once?
Not necessarily; some artists work that way, but I don't.

Do you ever leave consistent and even pigment in a given area?

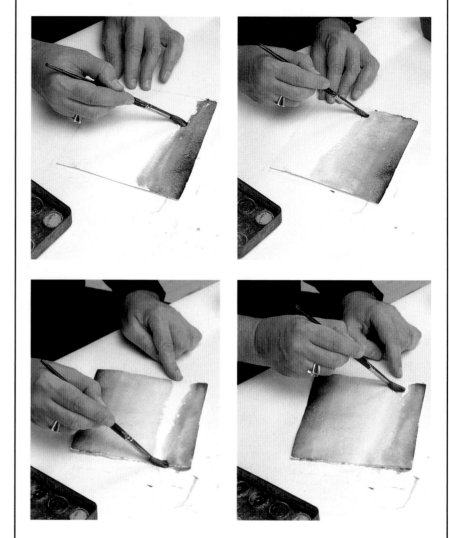

No, I don't want it to be handled so the color looks flat. The idea is to create transparent and translucent washes. Even if I'm only working with a single color, I vary the lightness and darkness to create a feeling of depth and variety. A color can be lightened by adding water to the wash or reducing pressure on the brush; it can be darkened by adding more pigment to the wash or increasing pressure on the brush. Here, I began with a dark wash at one end of the paper and let the color get lighter as I brushed it out toward the center; then I stopped, turned the paper around, and worked the same way from the other end. The resulting wash is varied and interesting and suggests transparency and depth.

How should I darken colors?
Always darken with another color.
Don't darken with gray or black;
they often kill the original color or
make it muddy. Instead, use a
concentrated wash of another color.

*If I want to make an area dark
green, do I mix green paint with red
and blue?*
Yes, you can darken the green with
blue, red, or purple, mixing the
colors directly on the watercolor
sheet, as always. Do not use black,
as it will kill your colors.

*How can colors be muted so
they're not too intense?*
Add some water to lighten and
soften them.

*If I don't like an area I've painted,
how can I change it?*
If you're not happy with an area
you've painted, you can paint over
it without rewetting the paper if it's
still moist. If it has dried, dampen
the paper; it needn't be as wet as it
would be for a first application of
wet-on-wet color. If you try to paint
over a dry area, your brushmarks
will show. Use a less diluted wash
for the second coat, so the color
will be more intense.

*When doing a boat basin or sea-
scape, how can I paint light masts
over dark water?*
If you want the masts to be white,
use the white of the paper, but if
they are going to be a color, such
as blue, green, or brown, paint over
the background colors.

*Does water appear different in the
distance than up close?*
Yes, it tends to be darker in the
distance than in the foreground; as
it recedes from the viewer, its color
becomes more intense and there is
more variation in value, which
makes it appear three-dimensional.

*If I don't stretch my paper, how do I
keep it flat after it dries?*
It may be flattened out by placing it
between several sheets of clean
newsprint, applying pressure and
weight on the top, and allowing it to
sit overnight.

Do you ever suggest that one mix colors on the palette?

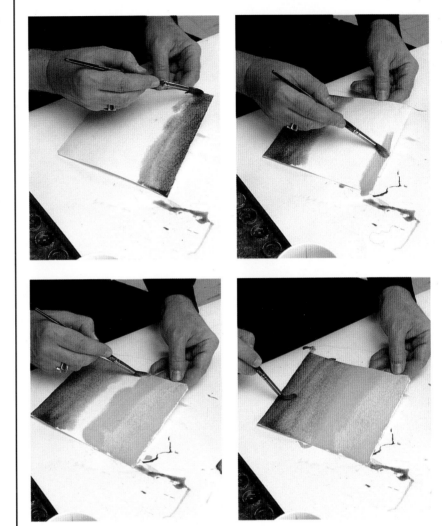

I don't, because I mix directly on the watercolor paper by
bringing areas of different colors together to create a new
color. Here, for instance, I applied a red wash to one part of
the paper and a yellow wash to another area, then brought
the washes together and let them mingle to produce not one
but several orange hues. This technique produces washes of
constantly changing color. When colors are mixed ahead of
time in big batches on the palette, the result is often a flat
wash with little variation.

Generally speaking, to keep your color fresh, it's better to
mix directly on the paper. There are, however, always
exceptions. There are no rules for doing art; those that do
exist are frequently broken.

Is it acceptable to take poetic license when painting?
Yes, you may edit and distort. Some people, when they first begin to paint, get too involved with the drawing and try to render every detail exactly as it appears. That's not necessary; the idea is not to do a photographic likeness (although there's nothing wrong with that) but a personal interpretation.

How long does a painting take you to do?
Each painting varies. A great deal depends on the intricacy of the composition. A painting in the fruit and floral series does not take as long as one in the landscape series because it has a less complex composition.

Do you ever do a small sketch first?
I hardly ever start with a sketch. My objection is that all your creative energy and spontaneity goes into the small sketch, and then when it comes time to do the actual painting, there is little or no enthusiasm left. You're spent, so to speak.

Do you ever stretch your paper?
No, but some artists do, and it's perfectly permissible to do so.

Do you work on a flat table?
Yes, I like the way the paint flows when the paper is lying flat.

How do you keep control over a large watercolor sheet?
I stand up when I work on paper that is 36″ × 44″ or larger. I can work faster and have more control over the washes and the composition that way.

Do you work upside down?
Yes, if a painting is too large to reach across, I set it on the table and move around it as I work. That is the method I used for *Red and Yellow Apples* (pages 132–33), which measures 44″ × 72″.

Do you draw from the right side of the brain?
I've been told I do. I work instinctively, going with whatever comes naturally, without relying on fixed notions of how a painting looks.

How can colors be muted so they're not too intense?

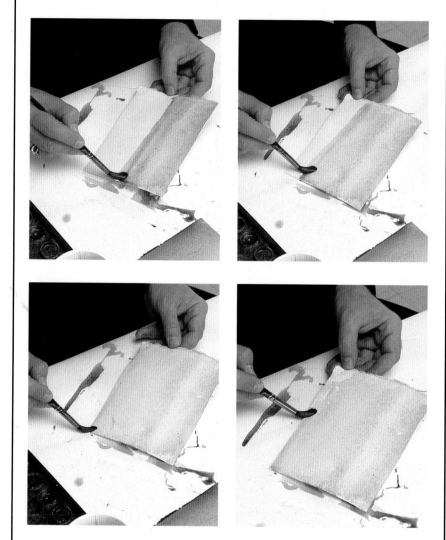

Add some water to reduce the concentration of the wash; this lightens and softens the color. Often I lighten washes that are still wet on the paper by adding brushfuls of clear water to the area I'm working on, which creates new values and color intensities. Diluting the wash on the paper rather than on the palette keeps the colors fresh and creates more color and value variation.

It's a good idea to begin painting with less pigment than you think you'll need—you can always come back with more pigment on the brush to make the color deeper or more intense. It's always easier to darken a color than to lighten it.

Do you always leave the preliminary pencil line visible?
Yes, that's characteristic of my work. I use the pencil line to provide the structure for the painting, to highlight details, and to define forms. Sometimes I paint over the line; other times, I let it show, perhaps to define forms in an area of unpainted white paper. For many years, people questioned my technique of leaving pencil lines, because we were always told to erase them when we were in school. Nonetheless, because they are works on paper, watercolors are considered by most museums to be drawings. At the Museum of Modern Art, for instance, the permanent collection of watercolors is in the department of drawings.

Do you have an idea of the color scheme when you begin to paint?
No, I don't have a preconceived color scheme; rather, I feel my way as I go along. That's why I find watercolor painting so magical and surprising.

Do you have a background color in mind when beginning a still-life composition?
Yes, I have a color in mind, but I keep the background fairly neutral and generally use just one color, such as gray or blue. I usually paint the primary subject matter first and then the background, but once in a while I'll do it in reverse.

If you paint the background first, surround the subject matter with the darkest, most intense color, so the main subject will be more accented, more defined. Then soften the color. Keep varying the values; you might make the lower part of the painting dark and the upper part light. Work quickly so the washes don't dry. You may wet the paper first, if you find that easier. Review the techniques you used in the cool and warm geometric paintings.

Do you wet your paper before you begin painting?
Sometimes I do, depending on the situation. I wet the surface when I

Do you wet your paper before you begin painting?

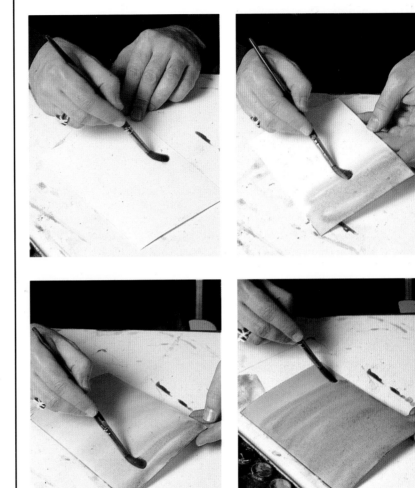

Sometimes I do, depending on the situation. If I want the colors to flow smoothly, I wet the entire area with clean water and then brush in the paint. In general, paint applied to a wet surface spreads and flows easily, whereas paint applied to a dry surface requires more brushwork.

Sometimes I use both wet-in-wet and wet-on-dry techniques in the same painting. In my large flower paintings, for instance, I often use wet-in-wet for some petals, wet-on-dry for others, to add variety. And when I paint sunsets, as on pages 80–85, I use wet-in-wet for the large areas of smoothly blended color and then go back once the paint has dried and add the finer details wet-on-dry. Thus, I am able to exploit the best qualities of both techniques.

want the colors to flow together—when I paint a sunset or reflections on water, for instance. When I'm doing a large flower painting, I might use wet-on-wet technique for some of the petals, for variety. In general, paint applied to a wet surface spreads and flows easily, whereas paint applied to a dry surface requires more brushwork.

Why do you mix color on the watercolor paper instead of on a test sheet?
The colors retain their intensity better when mixed directly on the paper. I began working this way when I was studying painting with Richard Lindner at Pratt Institute. I asked him to evaluate a watercolor painting that I was working on; he replied, "The painting is okay, but your test sheet is wonderful." The colors on the test sheet were much more luminous and varied than those in my painting. Ever since that day, I have mixed my colors on the painting itself, rather than mixing them on a palette and testing them on a separate sheet.

Do you ever leave consistent and even pigment in a given area?
No, I don't want it to be handled so the color looks flat. The idea is to create transparent and translucent washes.

Why do you work all over the watercolor sheet?
To maintain a consistent image throughout the composition. It's important to work all over the painting because the artist's psyche changes as rapidly as the work in progress, and consistency of style requires that the artist work on all areas of the composition continually.

When you're painting a watercolor, do you work from dark to light or from light to dark?
I paint both ways, although I have no particular methodology. It's really based on what I feel comfortable doing. I may begin with the lightest area of a building by painting it a pale yellow and, when it dries, adding a shadow and a roof in a gray or a blue or purple over

When you're painting a watercolor, do you work from dark to light or from light to dark?

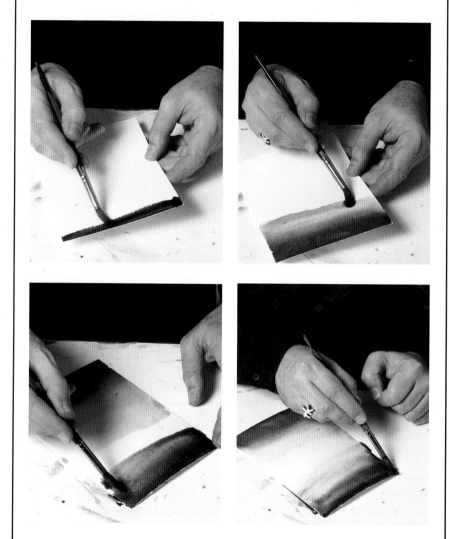

I paint both ways, although I have no particular methodology; it's really based on what I feel comfortable doing. When I'm applying a wash to an area, I might begin with a fairly dark wash and then lighten the color as I go by applying less pressure to the brush, or I might start with a lighter application and then bear down harder on the brush to darken the color. In terms of the painting as a whole, I might begin with the lightest area of a building by painting it a pale yellow and, when it dries, adding a shadow and a roof in gray, blue, or purple over the pale yellow, or I might work in reverse by doing the dark areas first and leaving some areas of the watercolor sheet unpainted.

the pale yellow. But it's also possible to work in reverse by doing the dark areas first and leaving some areas of the watercolor sheet unpainted.

Do you ever work with India ink for additional detail?
Some artists highlight details by drawing over the painting with a pen or brush and India ink. I don't do this, but if you feel comfortable with it, go ahead.

Do you ever use a dry brush?
I very seldom use a dry brush—I just don't care for that technique. If you like it, though, there's no reason not to use it.

If you were painting a single object, such as a big rose, would you consider the background before the foreground?
If the background is a simple wash, sometimes I'll paint it first, just for a change of pace.

What is the difference between working in watercolor and working in oils?
I work more spontaneously in watercolor than in oil; I usually need to do sketches in pencil or charcoal or even a small watercolor before doing an oil painting. Oil painting also seems more physical—usually I stand when I do an oil painting and sit when I do a watercolor, so it's a different kind of physical as well as mental experience.

When I paint in oils, I use turpentine to create washes; the paint has a very different feel from watercolors. And because the canvas is upright, the paint tends to run and drip, which creates another kind of quality and style. I usually lay watercolors flat while working on them. I find that I can't create the same luminosity with oil or acrylic that I can with watercolor.

An oil painting on canvas usually has a higher market value than a comparable watercolor on paper. Oils don't fade or discolor as quickly as watercolors. That's why museums are very conscientious about the exposure to light given to works on paper.

If you want to make a green, do you mix yellow and blue directly on the paper?

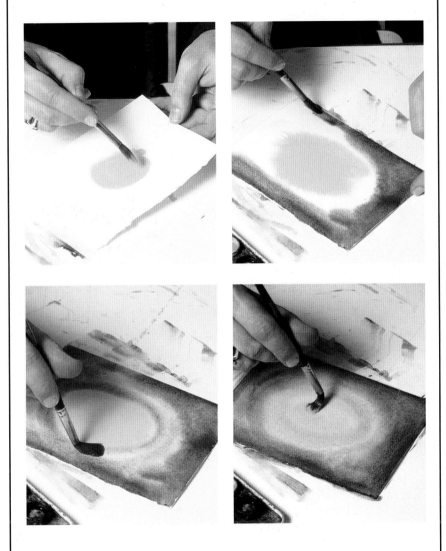

Yes, I feel the color is more varied and luminous when mixed this way than when it is mixed in a single, homogeneous batch on the palette and then transferred to the paper. In the example here, I began by applying an area of yellow, then an area of blue, to the paper; while both colors were still wet, I brushed them together and let them mingle to form the new color. I smoothed out the transition, then brushed some of the green into the center of the yellow area to create a new, subtler color.

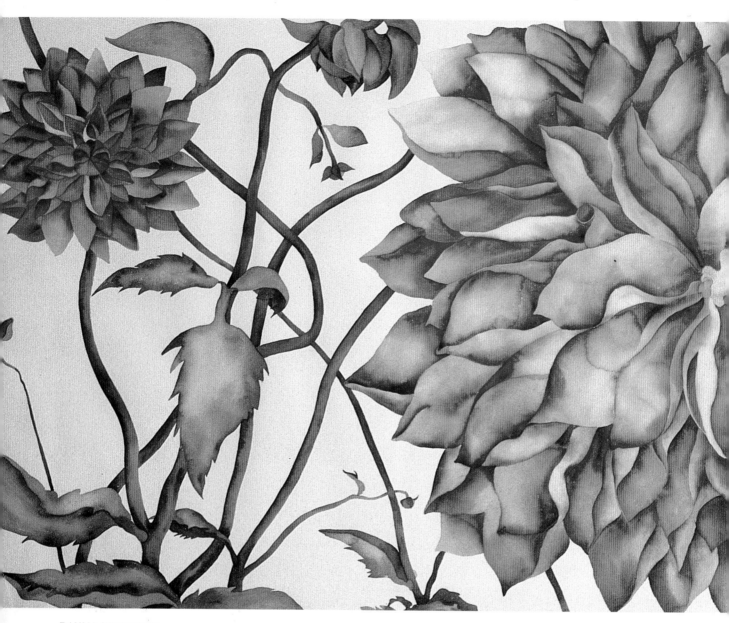

DAHLIA SYMPHONY,
44″ × 120″ (111.8 × 304.8 cm), 1978
Private Collection.

This is the largest watercolor painting I've ever done. For the
drawing stage of the composition, I placed the watercolor sheet
on a long, flat dining table and eventually tacked it up on a
wall. While standing and drawing the composition I was able
to step back and be more objective about size, proportion, and
my center of interest. The actual dahlias were drawn from
cuttings that I had placed in a vase of water so they would last
long enough for me to draw and paint them. The actual
painting took close to a week to complete; I worked every day,
using a wide variety of round brushes and a palette that
included a number of reds, purples, and greens. My decision
to leave the background white was based on the intricate and
complex composition and the color intensity of the flowers.

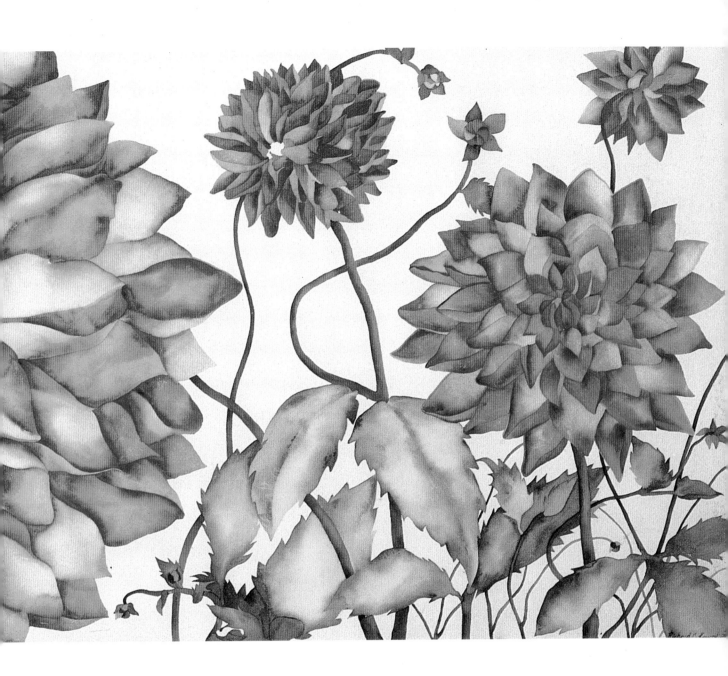

INDEX

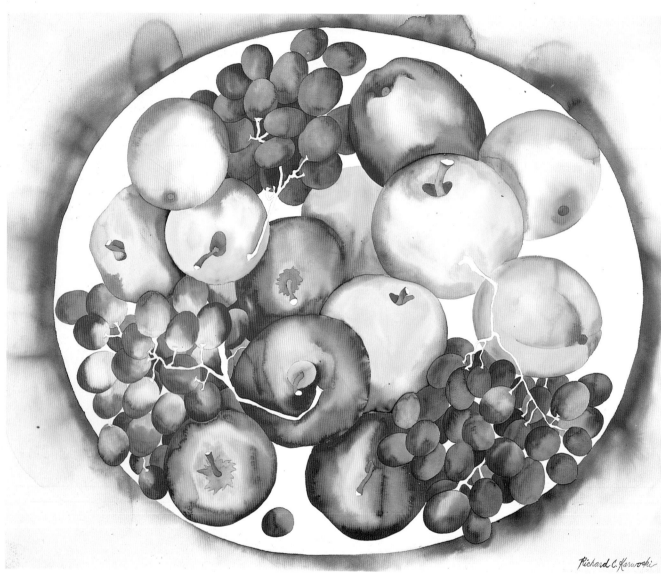

FRUIT PLATE, *36" × 44" (91.4 × 111.8 cm), 1980. Private collection.*

Edited by Brigid A. Mast
Designed by Bob Fillie
Graphic production by Ellen Greene